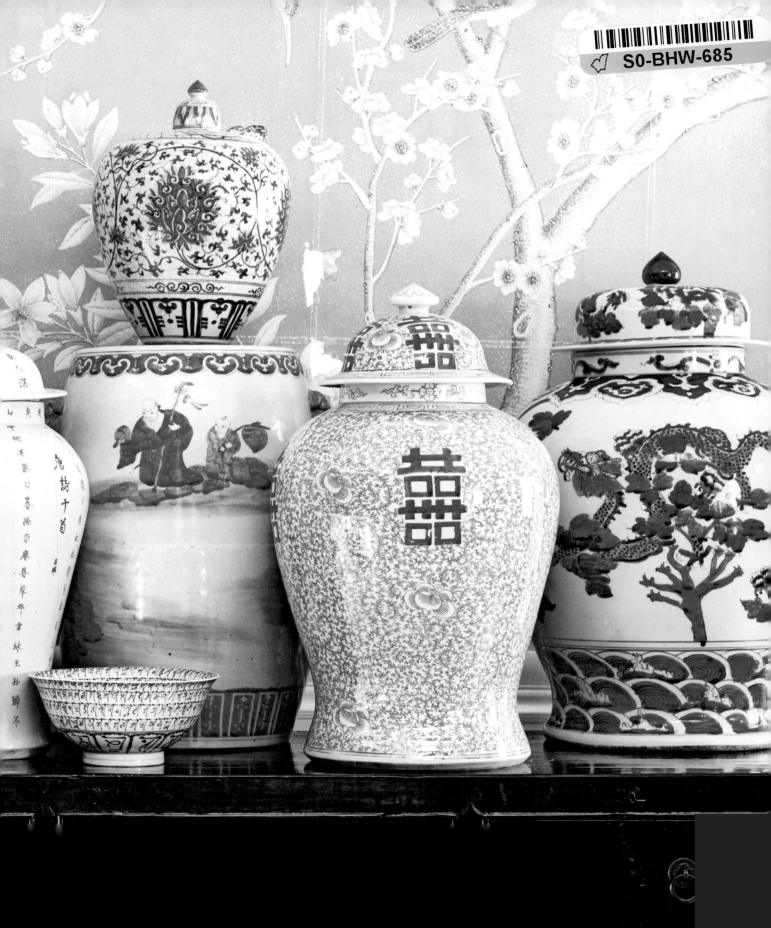

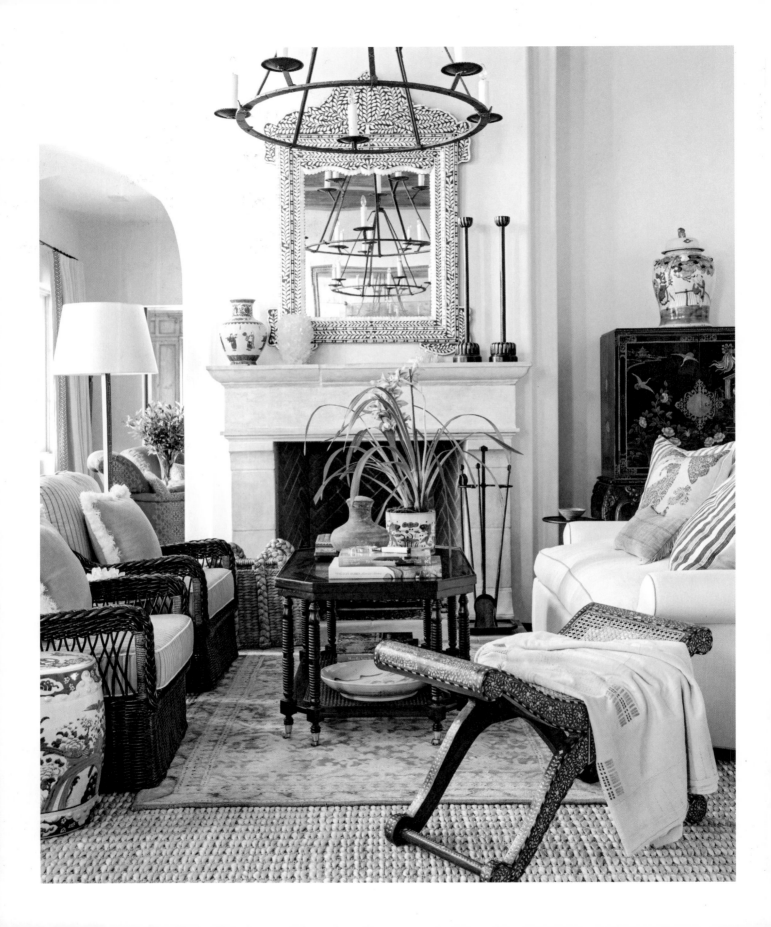

BEAUTIFUL

All-American Decorating
and Timeless Style

RIZZOLI
NEW YORK

New York · Paris · London · Milan

BEAUTIFUL

ALL-AMERICAN DECORATING
AND TIMELESS STYLE

MARK D. SIKES

FOREWORD BY NANCY MEYERS
PHOTOGRAPHY BY AMY NEUNSINGER
TEXT BY CAITLIN LEFFEL

I'd like to dedicate my first book
to the memory of my grandparents,
Mr. and Mrs. Donald Borror.
They taught me to work hard, be true to myself,
do what I love, and dream big.

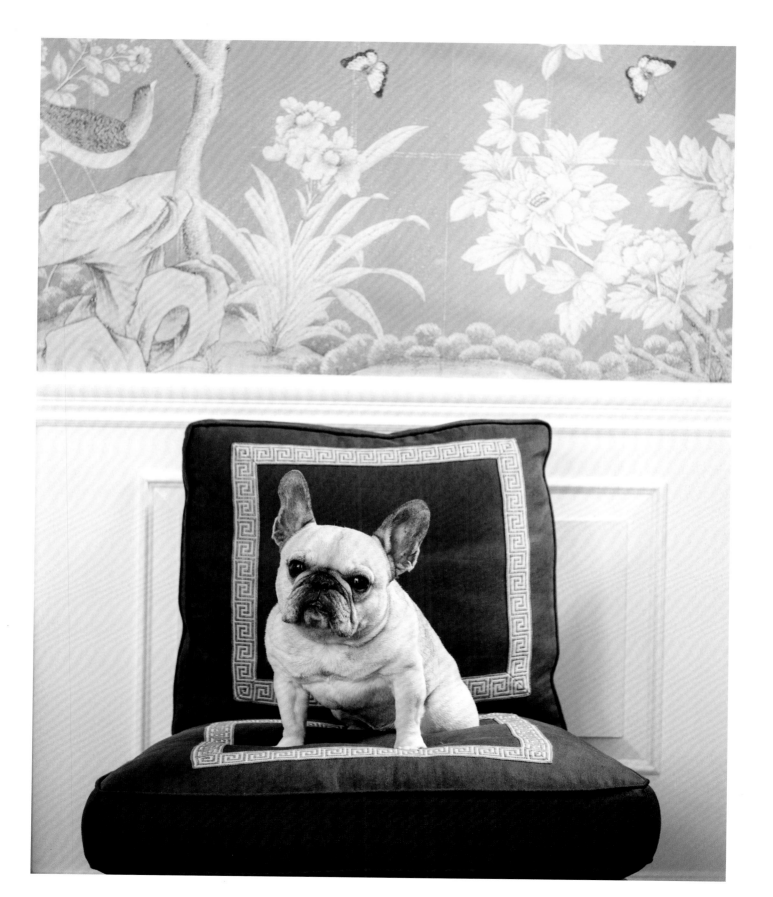

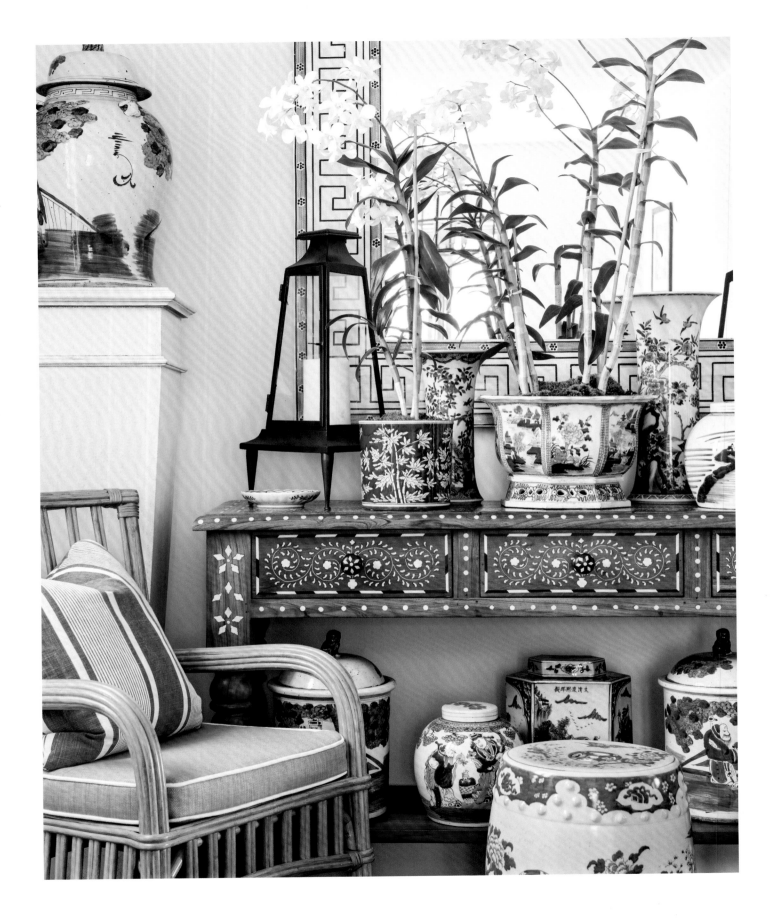

CONTENTS

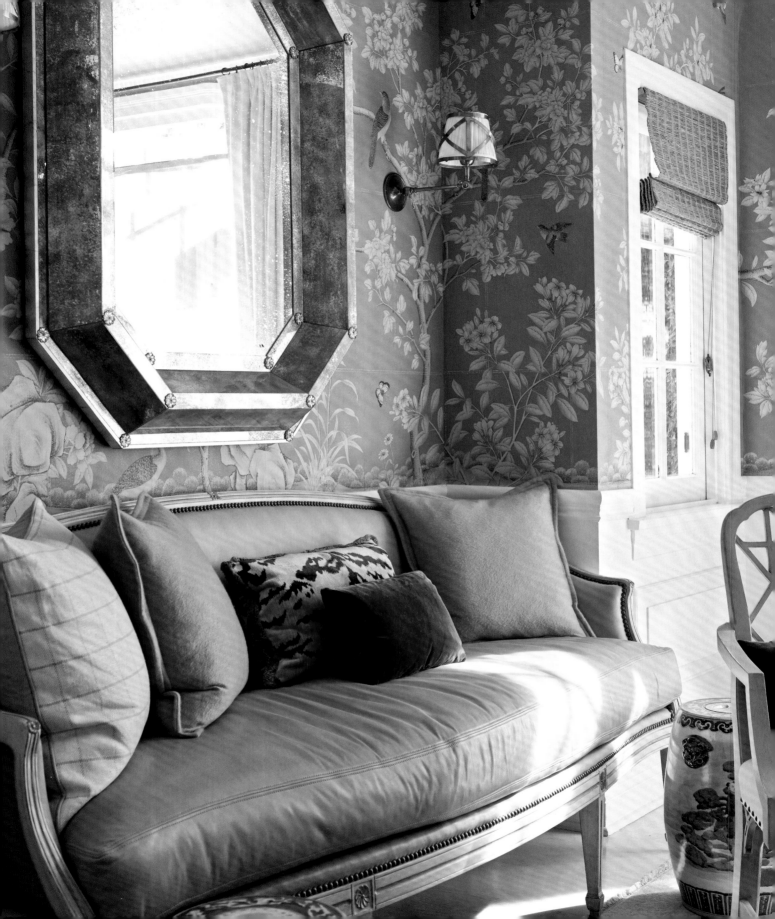

FOREWORD

I suppose I now believe in fate. How else can I explain how I met the wonderfully talented Mark Sikes? It was a warm afternoon in May and I was walking on La Cienega Boulevard in Los Angeles with my newly married daughter, Annie. Annie had just bought her first home, and I very quickly went from mother of the bride to the bride's first decorator. I was a bit panicked about my new job title but tried not to show it.

Annie was holding a bag of fabric samples that we had spent the better part of the day collecting. We were chatting and window-shopping as we passed by a showroom window being dressed for the annual Legends of La Cienega event. Inside the window, a man on a ladder was holding a framed drawing as a slim, dark-haired young man with a gray sweatshirt tied around his waist, T-shirt, khakis, and Belgian loafers stood outside the shop quietly giving him direction. Something about this young man reminded me of old Hollywood. There was a certain grace in his demeanor, a confidence in the way he looked at what he was creating.

Annie and I stopped to watch as this beautiful display was coming together. And then I noticed something inside the window. I squinted at the fabrics on the sofa, then the fabric on the walls, then the pillows. I poked Annie with my elbow and nodded toward the window. Most of the fabrics in the bag she was holding were the exact same

In the Hollywood Hills, a leather settee is dappled by the beautiful California light that filters through bamboo shades (opposite). PREVIOUS: A collection of blue-and-white ceramics mingle with an Anglo-Indian bone-inlay console. A rattan chair with a striped pillow continues the blue-white-neutral theme. PAGE 5: Lily (a.k.a. HRH Lily) perches on a slipper chair in my dining room, in front of Gracie chinoiserie wallpaper.

ones being used in this incredibly chic display. Annie and I both turned to the handsome young man with the shock of dark hair falling on his forehead. He really reminded me of someone. Was it a young Gene Kelly? Anyway, he noticed us and smiled. We showed him what we had in our bag. He stopped what he was doing, walked over to us, looked at all of our fabrics, instantly placed the best ones together, and like all talented designers who instinctively know what goes with what, he enabled us to see our choices through his eyes and suddenly we saw the big picture. Mark gently moved aside what didn't work and generously told us where to get everything else we could possibly want to go with our selections before returning his gaze to the window. No introductions, no shaking of hands—he just connected with us and saved two non-pros weeks of work.

At this point, we were hooked. We planted ourselves on the sidewalk and continued to watch Mark as he worked. He turned back to us and asked if we thought the drawings about to be hung should be stacked or placed side-by-side. Not that he needed our opinion. He's just that gracious and easygoing and, after all, we had just bonded. It was then that we introduced ourselves. That was a little over three years ago, and our back-and-forth conversations and collaborations have never stopped.

Mark grew up in Decatur, Illinois, and Nashville, Tennessee. This patchwork of homes and gardens started Mark's lifelong love affair with architecture and decor. He recalls that when he was a boy, he spent hours poring over shelter and fashion magazines in the local library. He was studying the works of the great interior designers—Billy Baldwin, Mark Hampton, Albert Hadley, and Michael Taylor—and brilliant designers of the fashion world like Bill Blass and Oscar de la Renta. Men whose homes were as legendary and as beautiful as the clothes they designed. Mark admits he was *obsessed* with how people lived and how they dressed and read everything on the subject he could get his hands on, and over the years he developed an incredible eye for fabrics, color, fashion, and design.

After college, Mark worked in San Francisco as a retail creative exec for brands like Banana Republic and Pottery Barn, but his passion for interiors led him to make the

move to Los Angeles. There he created his sensational blog, *Mark D. Sikes: Chic People, Glamorous Places, Stylish Things*. It's the blog of a fan devoted to all that's beautiful. Mark curates photos with an exquisite sense of detail that show us each and every day the world as he sees it. How beauty can be everywhere—in a rambling white house, in a striped umbrella on a quiet beach, in a soft skirt billowing in a summer wind. The student has now become the teacher. Mark's blog features the work of his peers and reminds us of the greats whose work he now knows by heart. His blog is more than chic people, glamorous places, and stylish things. It's pure Mark, it's a love affair with beauty, it's an education.

Mark bought a home in the Hollywood Hills with his partner, Michael Griffin, and got a chance to do what he loved—create a home in the style he calls "Elegant California." Mark's house quickly landed on the cover of *House Beautiful*. Mark's home dazzles you as you pass from room to room. Like Mark, it's inventive and inviting. He's found the harmony in mixing casual with formal, traditional with modern, masculine with feminine. His home is bursting with style, yet still feels very comfortable and warm, a place where friends gather and his dog, Lily (who has her own Instagram account), can stretch out on any piece of furniture she chooses. And of course, in Mark's house, as in almost all of his work, the color blue takes center stage. Blue and white is the hashtag of Mark's life. I asked him where this love of blue came from, and he said, "The sky, water, my parents' blue house . . . It just makes me happy." Mark has devoted pages and pages on his blog to the nuances of the color blue. And in each new iteration, he allows you to see the color in ways you've never quite seen it before.

And now, the *Beautiful* book. With this wonderful new book, Mark goes beyond the blog. He not only shows us, for the first time, the sublime work he's been doing, but

shares his views on how classic can look fresh, and how style and comfort go hand-in-hand, and, maybe the most fun of all (besides the oohing and aahing you're sure to do over the rooms he's created), Mark takes us behind the scenes to his mood boards and his inspiration. He gives us his unique take on style and how we need staples not only in our wardrobes but in our homes as well. He compares a classic look of a white shirt, denim, and a striped boatneck with a classically designed room of natural fiber rugs, a slipper chair, and, of course, *something blue*. Mark is doing for the reader what he did for me and my daughter that day on La Cienega Boulevard. He's sharing what he knows and opening your eyes to beautiful possibilities.

Mark is a gentle soul with a mind that works so fast you have to push yourself just to keep up. He can look at an empty space and just "get it," immediately seeing its full and glorious potential. And he's always aware it is your home and that it needs to reflect who you are and how you want to live and dream. But perhaps even more valuable than that big brain, which I rely on endlessly, is the sweetness and kindness Mark shows to absolutely everyone around him. If you're lucky enough to be his friend, then, as I have learned, you're his friend for life. I'm so happy to have made it into that club. What a pleasure it is for me to be able to introduce you to the bountiful and beautiful world of Mark D. Sikes.

—*Nancy Meyers*

The seamless transition between indoors and outdoors is one of the most appealing qualities of California homes; the corner of this living room opens to the garden. On the skirted octagonal table is an eclectic mix of accessories: bone-inlay and tortoiseshell boxes, a blue-and-white bowl, and an ivory urn. The tufted banquette is flanked by Galerie des Lampes reading lights and sits under a framed chinoiserie panel.

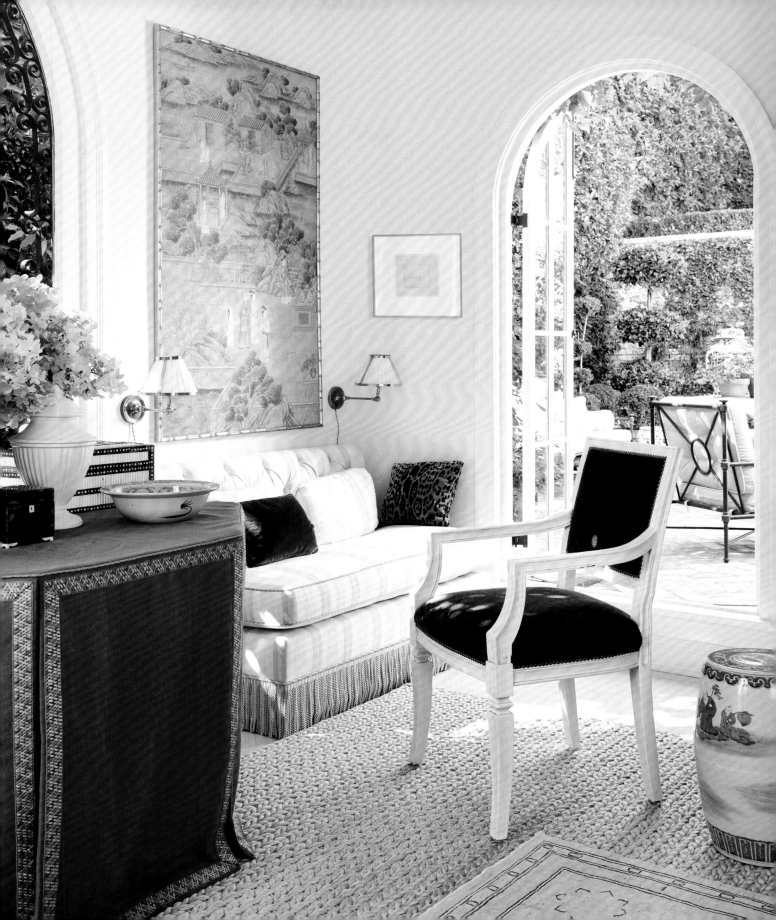

INTRODUCTION

Beauty has been a defining feature of my life and work for as long as I can remember. As a child, when I visited people's houses, I would always pick out my favorite things to describe later to my parents. When we went to church or to dinner, I'd take note of the women who had "style" and memorize every detail of their outfits. And as a voracious reader of books and magazines, for years I filed away images from design, fashion, art, gardening, and culture to create a mental catalogue of beauty, from a Slim Aarons photo of Oscar de la Renta sitting on a garden stool outside his Dominican Republic home, surrounded by wicker and ikat, to Jackie Kennedy summering on Capri, wearing jeans, a red T-shirt, and a chambray scarf wrapped around her hair; from Bunny Williams's home La Colina in the Dominican Republic to Hubert de Givenchy's French beach house Le Clos Fiorentina. And I've always gravitated toward the pairing of blue and white—no matter the image or context, if something is blue and white, it's a given that I love it.

In addition to these "snapshots" of beauty that I've been collecting from books, magazines, and films, my style also reflects where I've lived and worked: the homey straightforwardness of the Midwest and the genteel traditions of the South, the two

A seventeenth-century ceramic platter sitting atop an eighteenth-century chinoiserie entry table. FOLLOWING: This Montecito living room is filled with an eclectic yet comfortable mix of furnishings: bronze chandeliers, wicker armchairs, blue-and-white ceramics and upholstery, hurricane lamps, pedestals, a natural fiber rug, and bone-inlay antiques. A simple palette of blue, white, neutrals, and green holds everything together. Beyond the curtains, the Pacific Ocean beckons.

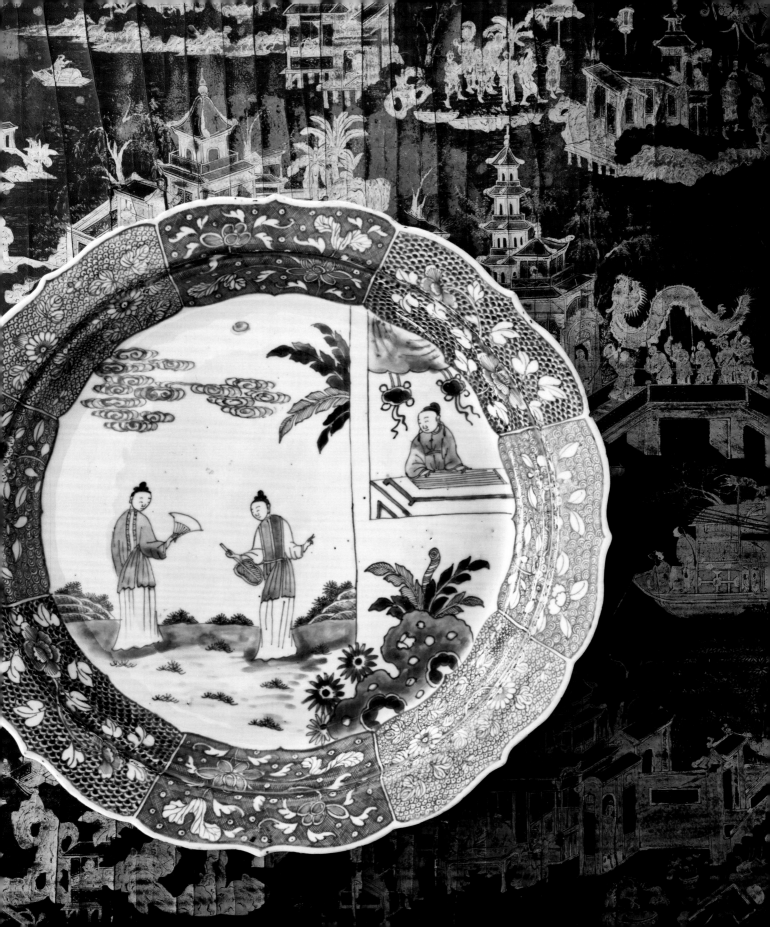

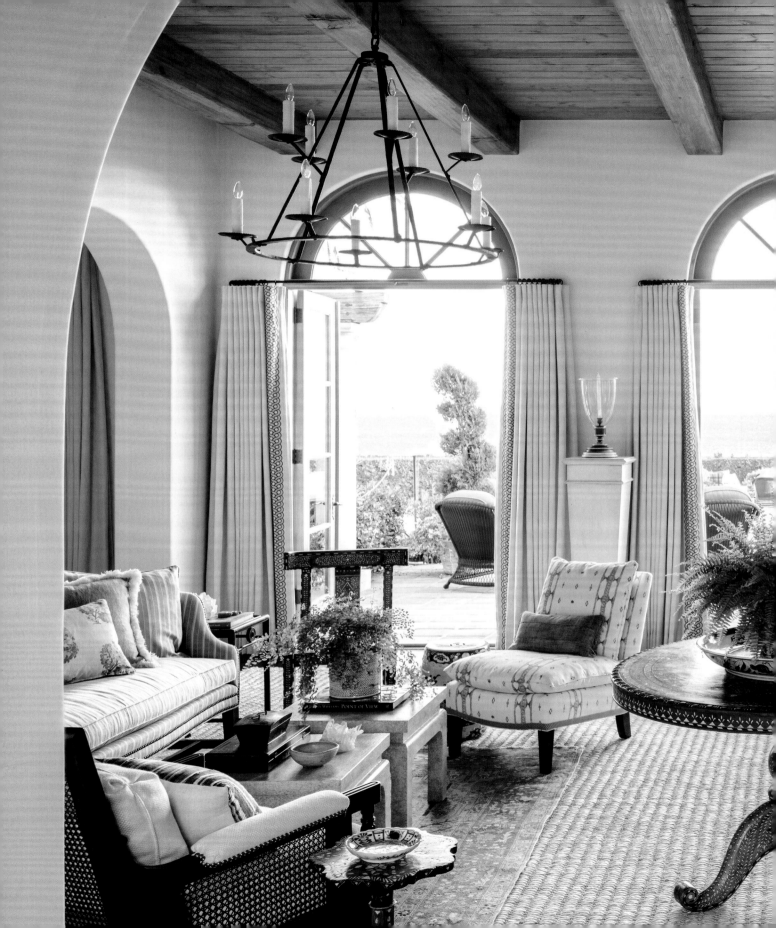

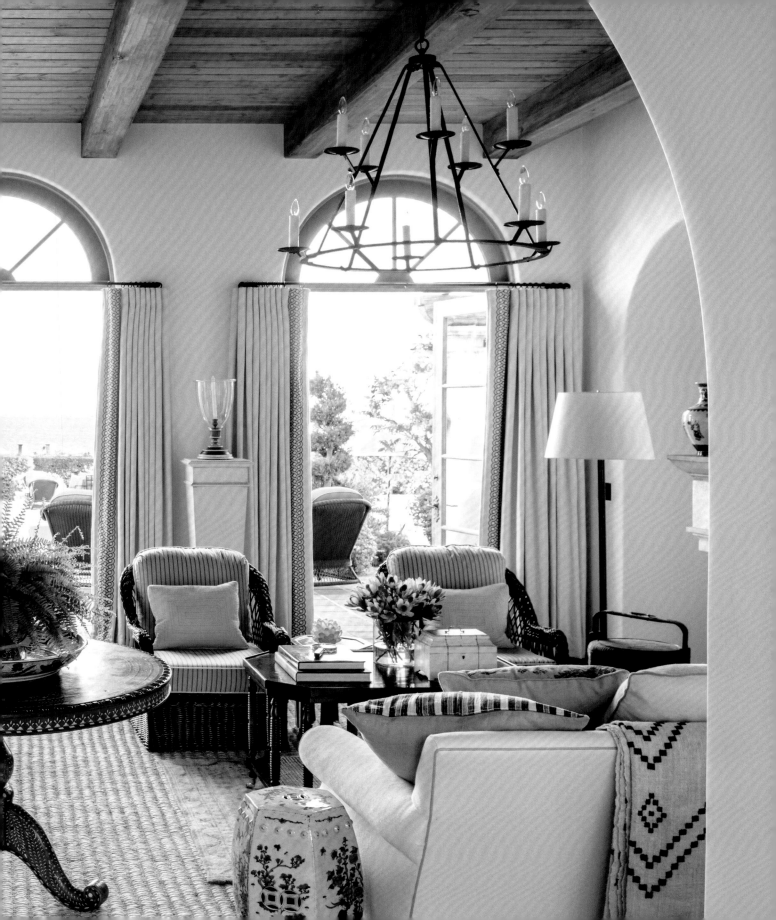

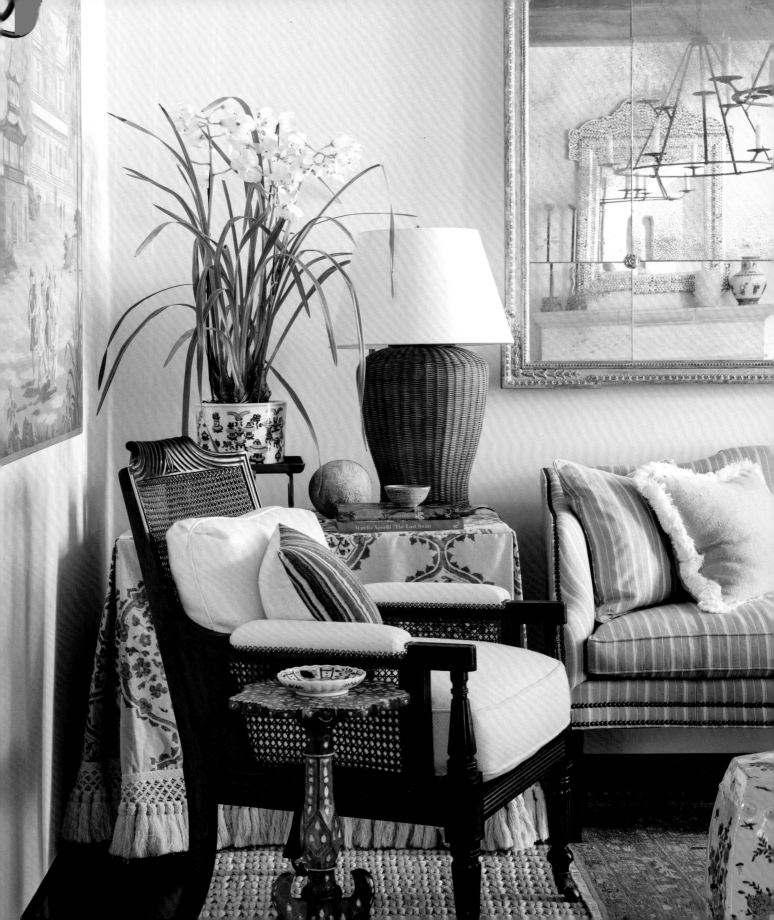

places where I spent my childhood, as well as the cosmopolitan city life of New York and San Francisco that I came to know as an adult, and the relaxed, indoor/outdoor spirit of Los Angeles, where I live now. Having been exposed to so many different lifestyles has helped me find beauty in many distinct and varied environments.

In addition to giving me the title of the book, "beautiful" also gave me the inspiration for its organization. Rather than showing one house after another, or organizing the chapters by rooms, I knew right from the beginning that I wanted to group the work around my favorite color stories. "Blue and White Forever" speaks to my first love of all things blue and white. "Timeless Neutrals" is my ode to classic Hollywood. "Garden Green" is about my love for the beauty in nature. "Always Blue" shows a softer, more ladylike side of my favorite color. "Natural Territory" connects to *Out of Africa,* my favorite movie, referencing travel, adventure, and escape. "Beautiful Brights" celebrates the happiness of color. "Sun-Faded Hues" is a love affair with the natural wonders of the beach and, of course, a chambray shirt. And "Red My Way" is shorthand for glamour, full of allusions to couture and fashion.

For many years now I've lived in what is essentially a uniform. Day in and day out, you'll find me in white jeans, a blue button-down shirt, and Belgians. When I go out for dinner, I might add a navy blazer. When I design an interior, I use the same

The table in the corner of this
Montecito living room is covered in Robert Kime fabric. On top are a Soane Britain rattan lamp and a blue-and-white cachepot holding an orchid. The Italian gilt-framed mirror reflects ceramics on the mantel across the room. FOLLOWING, LEFT: Beautiful layering of wicker, blue-and-white striped upholstery, and an Anglo-Indian side table. Underneath, a woven abaca rug by Merida is layered with an antique rug. FOLLOWING, RIGHT: An eighteenth-century chinoiserie armoire flanked by a Moroccan mirror and a custom hand-painted scene by John Rosselli Antiques.

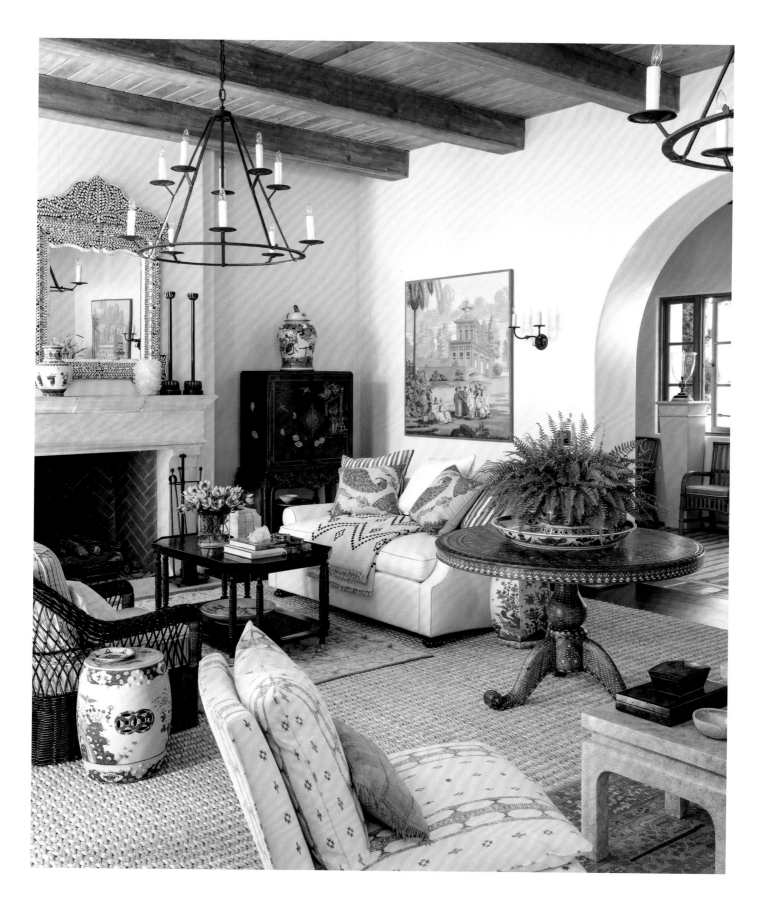

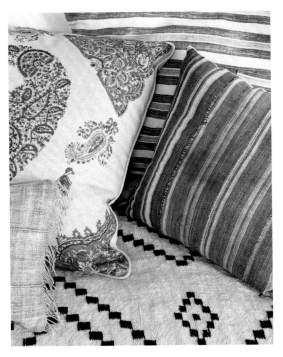

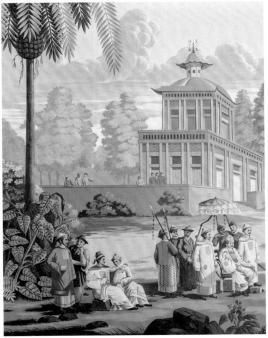

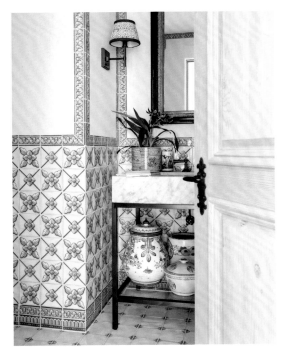

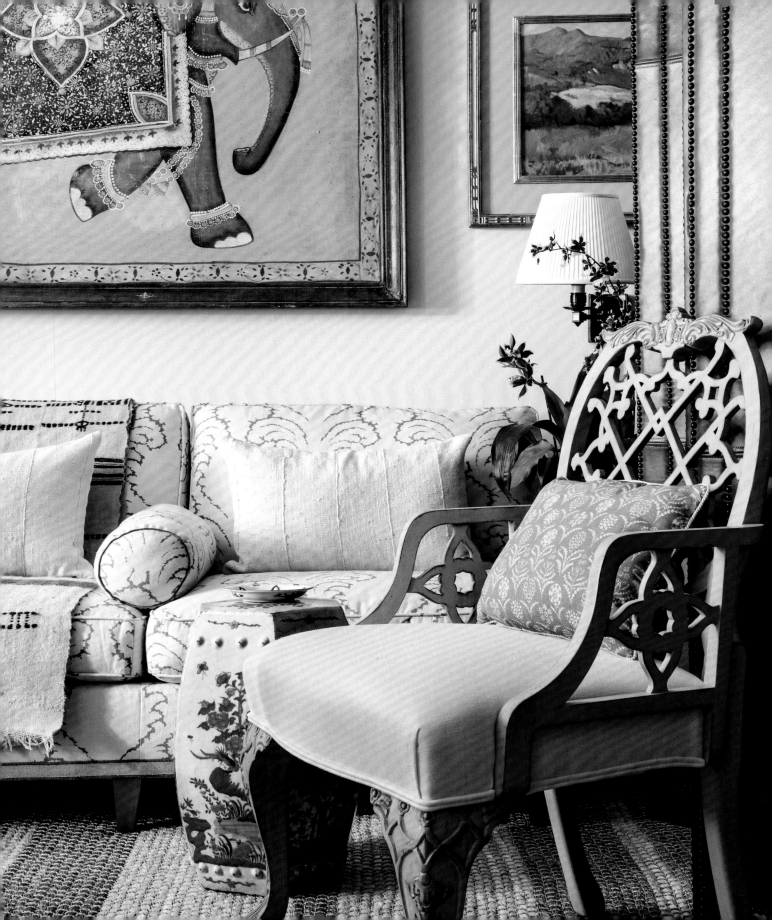

timeless approaches and elements. Layering is essential, whether it be a natural fiber rug under a dhurrie, or an assortment of wood, shagreen, and bone-inlay boxes. Pattern is also key, whether it is my beloved stripes, or a hand-painted chinoiserie wallpaper. Finally, there are the details, whether silk tape, bullion, or braided cord—things that are sometimes thought of as fussy, but that can be welcome and necessary additions to pull many textures and layers together.

In the end, the part of decorating I enjoy most is the relationship I develop with my clients. Creating homes that reflect them and make them happy provides the ultimate sense of fulfillment. When I enter a client's home, the first question I ask myself is, "What would make this space most beautiful?" The elements you see on the following pages are my answers over and over again because of their easy, universal appeal and because of how their simple beauty translates into everyday joy. When you let yourself be inspired by an idea, a style, or a hashtag, you can bring beauty into any home, no matter the size, type, or location. The clothes we wear, the places we travel, the art and decor in our homes—at the end of the day, it all goes back to my firm belief that if you live with beauty, happiness follows.

French side chairs with nail-head trim offer neutral contrast against colorful Iksel wallpaper in a Pacific Palisades dining room. PREVIOUS, LEFT: Some of my favorite things: blue-and-white ceramics, indigo stripes, greenery, and a John Rosselli painted scene. PREVIOUS, RIGHT: Blue-and-white garden stools often find their way into my rooms. FOLLOWING: I love books so much that many dining rooms I design double as libraries. The custom bronze-and-parchment chandelier provides ample reading light, while the banquette along the wall is perfectly placed for reading.

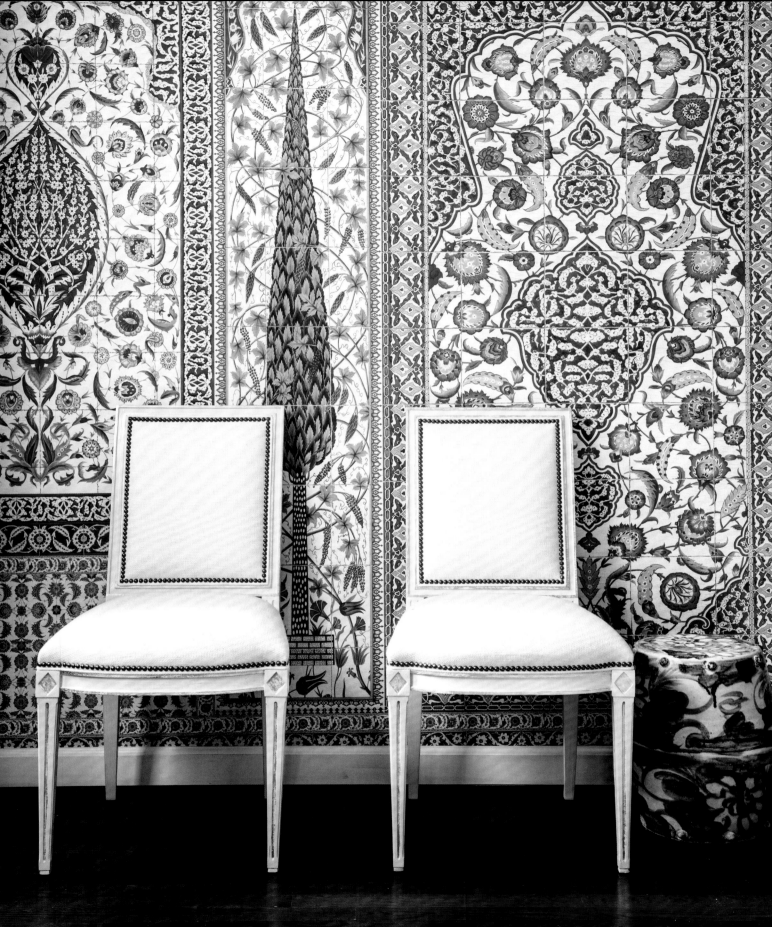

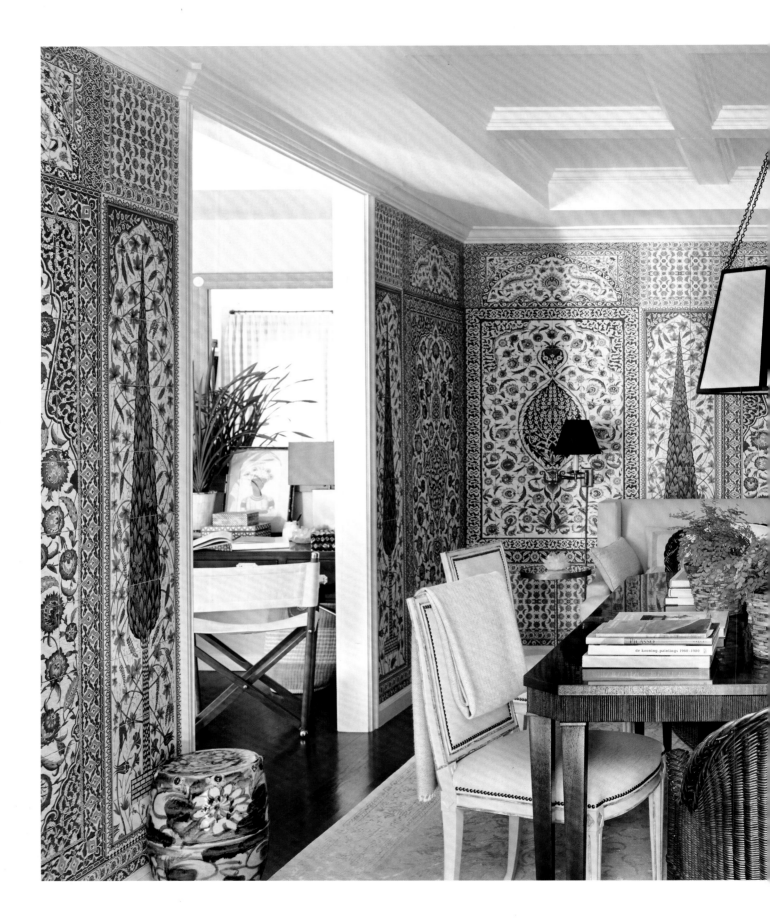

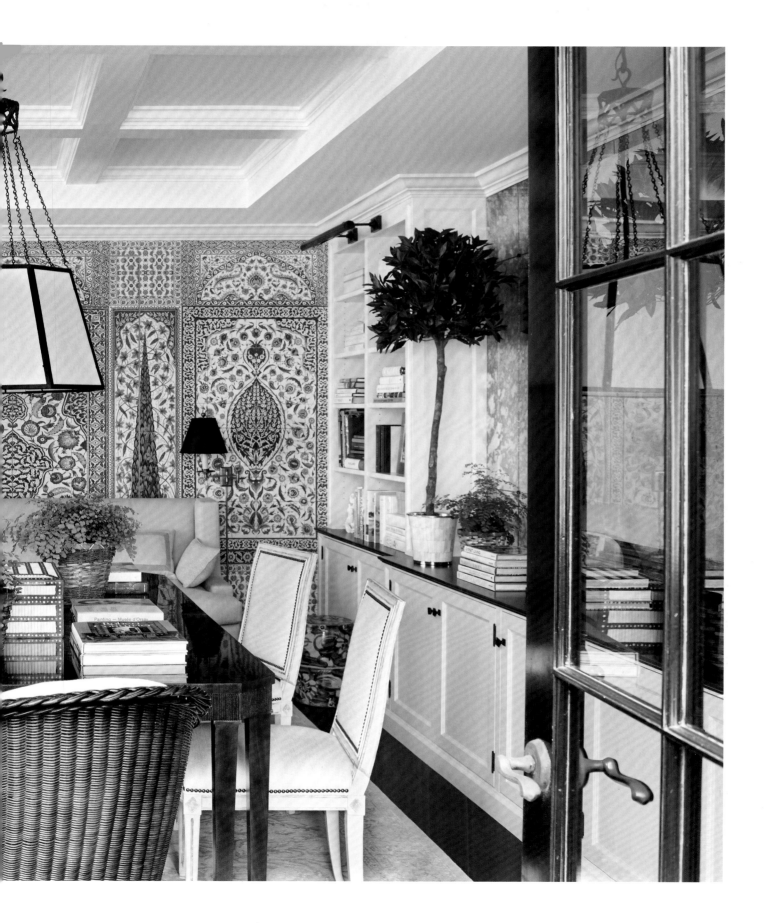

BLUE AND WHITE FOREVER
ENDLESS STRIPES AND INDIGO DREAMS

CARLTON 2

all it the
Lloyd Wr
said, "It's like
Fallingwater in Jamaica"

E veryone who has ever met me knows that I am truly passionate about blue and white. This pairing is my biggest inspiration, my constant companion. In fashion, I love blue and white for its straightforwardness and ease. White jeans and a chambray shirt. A blue blazer over a crisp white button-down. Navy pea coats with wide-legged sailor pants. It is a beautiful, classic pairing that thrives on contrast and the associations of a life lived well, immune to the whims of fashion and time. (Think of the timeless chic of James Dean in the striped boat neck of Breton fishermen, or Jane Birkin in a white tee and denim bell-bottoms.)

In a home, this easy pairing offers a similar sense of comfortable elegance and enduring appeal. Blue's allusions to water—from the deep sea hue of a swath of indigo to the cool, swimming pool-tone of washed linen slipcovers—contrast with white's brightness to create a perfect base for a pool house, seaside retreat, or lakefront cottage. This pair fills any space with freshness and crispness, as well as an air of relaxation, recalling striped beach umbrellas, leisurely summer days, and nautical adventures.

My love affair with blue and white began many years ago when I first visited John Rosselli Antiques and experienced his abundant mix of all things blue and white. I'm endlessly inspired by the exhilarating variety of materials and decorative pieces that naturally embrace this pairing. There are blue-and-white ceramics and tiles from

This detail of the main room of a California pool house demonstrates beautifully how—even with a simple color palette—you can create depth by layering textures and patterns. FOLLOWING: The deep indigo of the sofas anchors a varied assortment of blue-and-white patterns in this airy living room. Paisley curtains, batik print and indigo pillowcases, an embroidered throw, and the striped upholstery on the rush-seated armchairs are unified by the common color story.

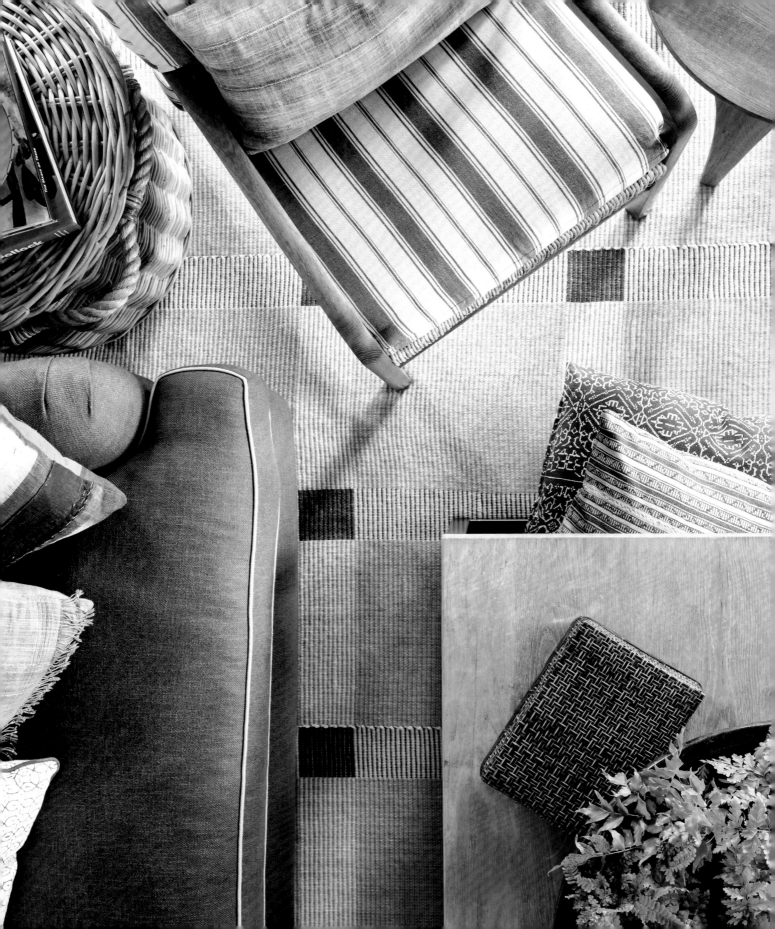

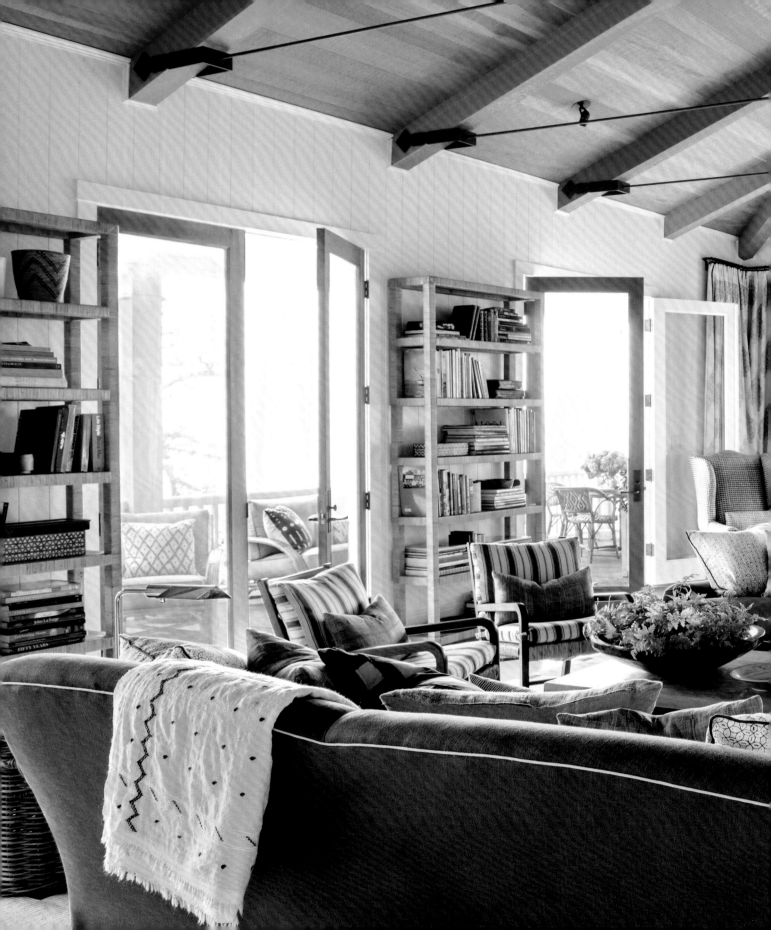

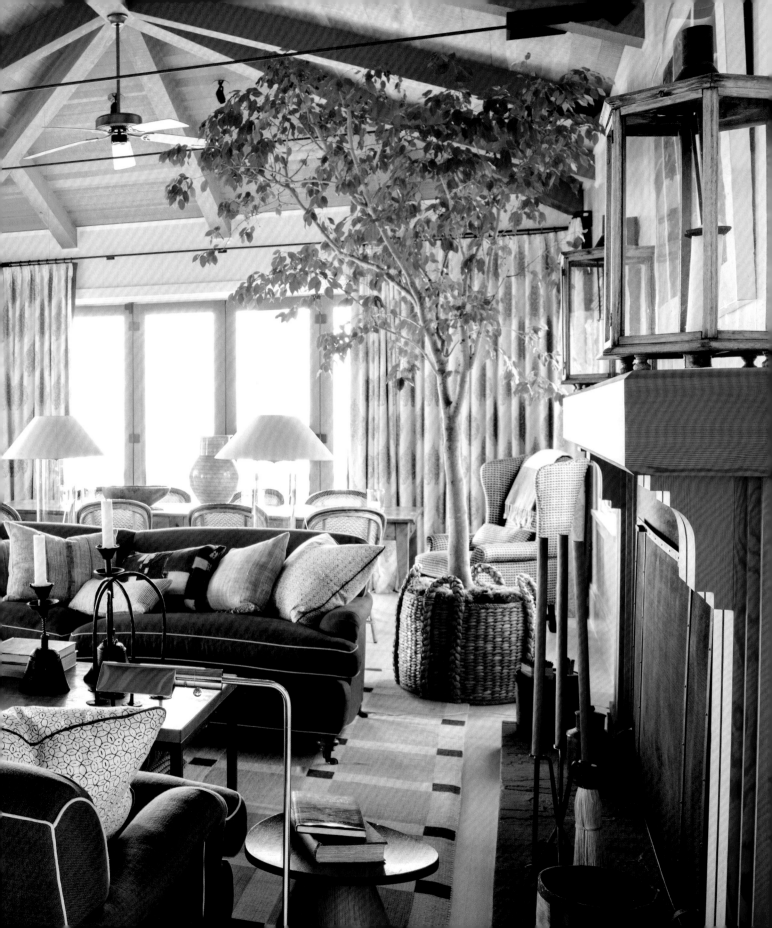

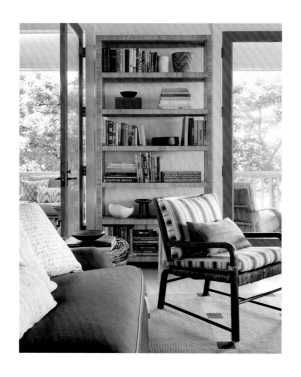

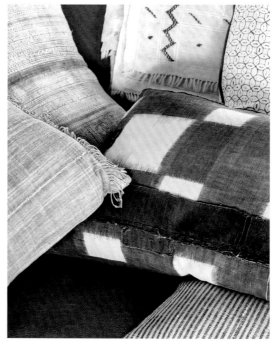

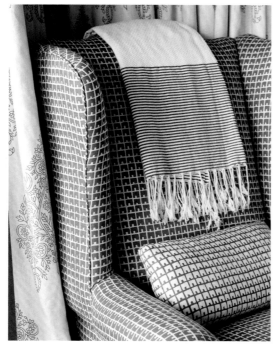

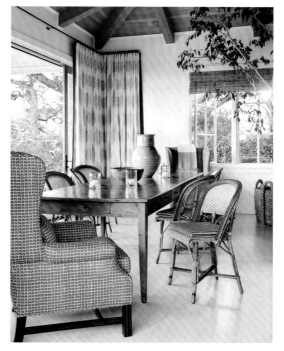

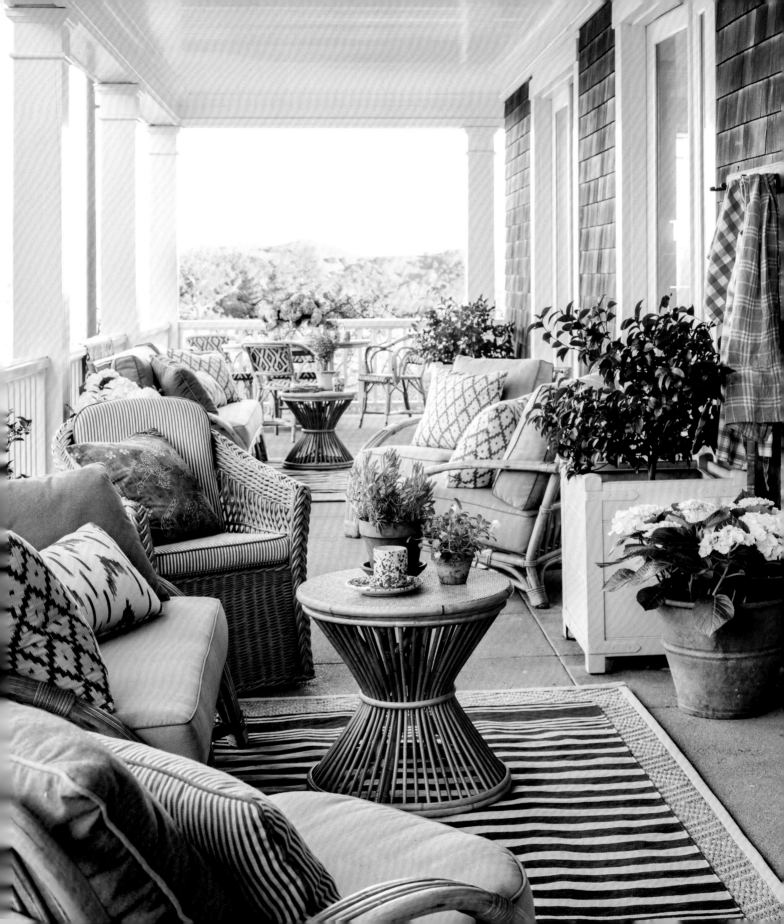

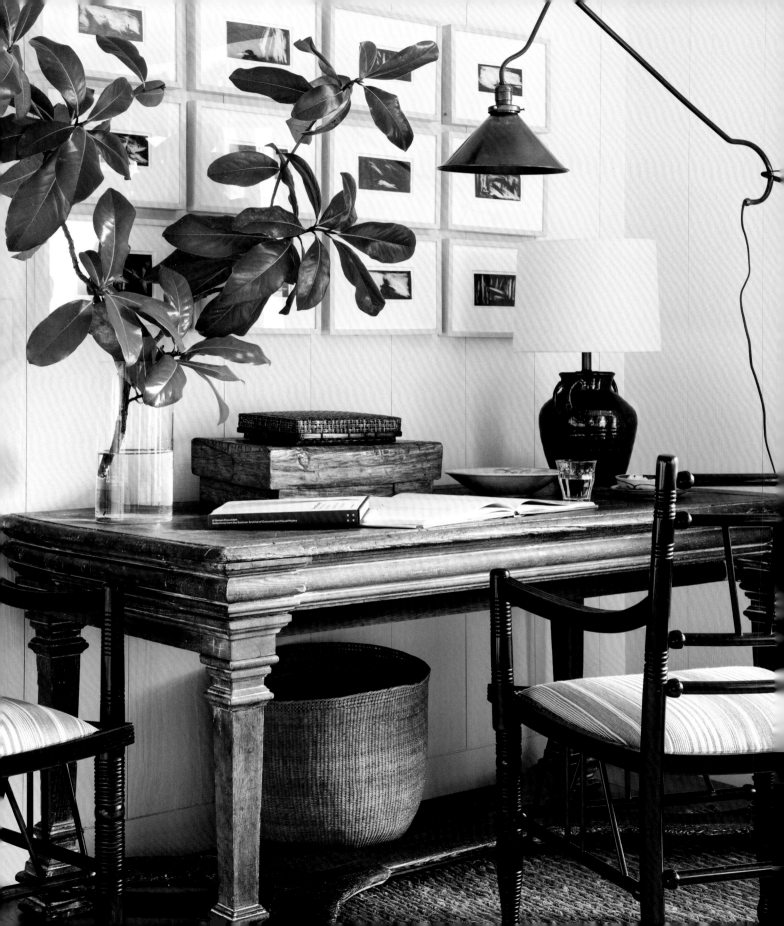

Thebes chairs upholstered in
blue-and-white stripes and Chinese porcelain continue the color story in a study area (opposite).
ABOVE: Wood and rattan boxes store pens and paper. PREVIOUS LEFT, CLOCKWISE FROM TOP LEFT:
Colorful book spines add pops of color in a sea of blue. Throw pillows in different patterns but similar
hues work well together. The wingback chair is modernized with blue-and-white check. PREVIOUS,
RIGHT: Throughout, I used materials that work both indoors and out, such as wicker and ikat.

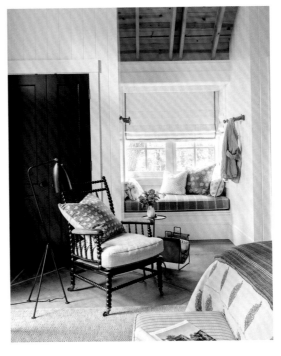

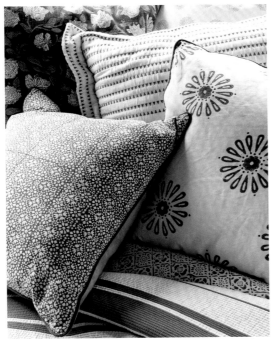

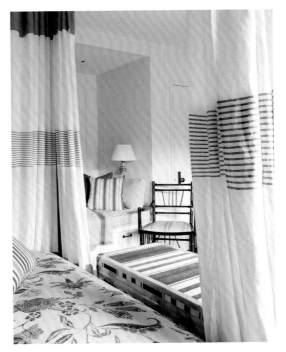

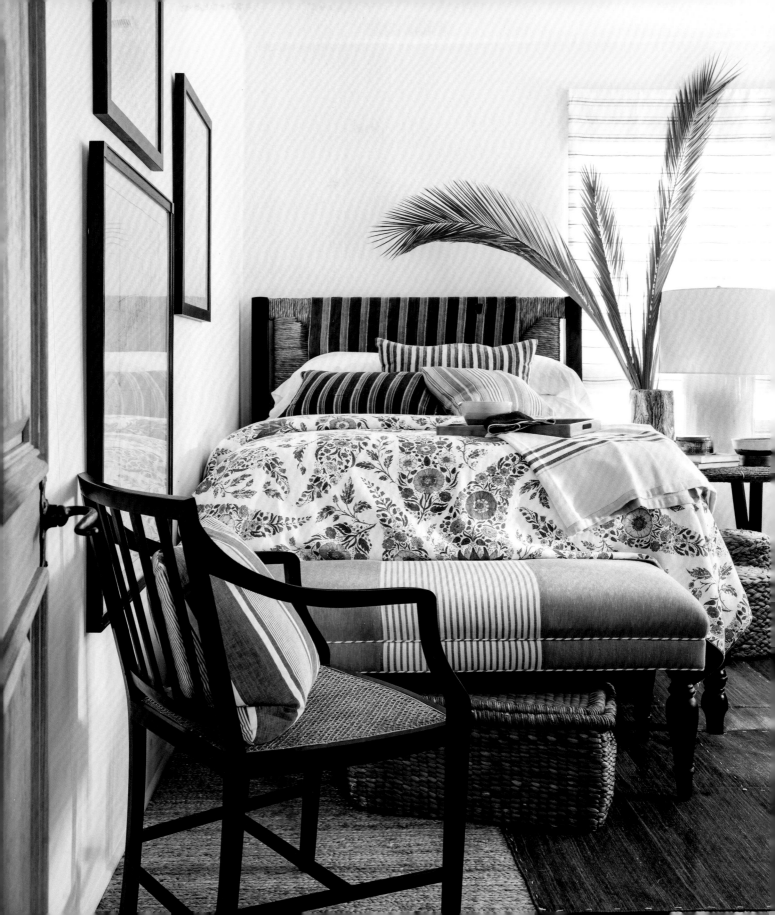

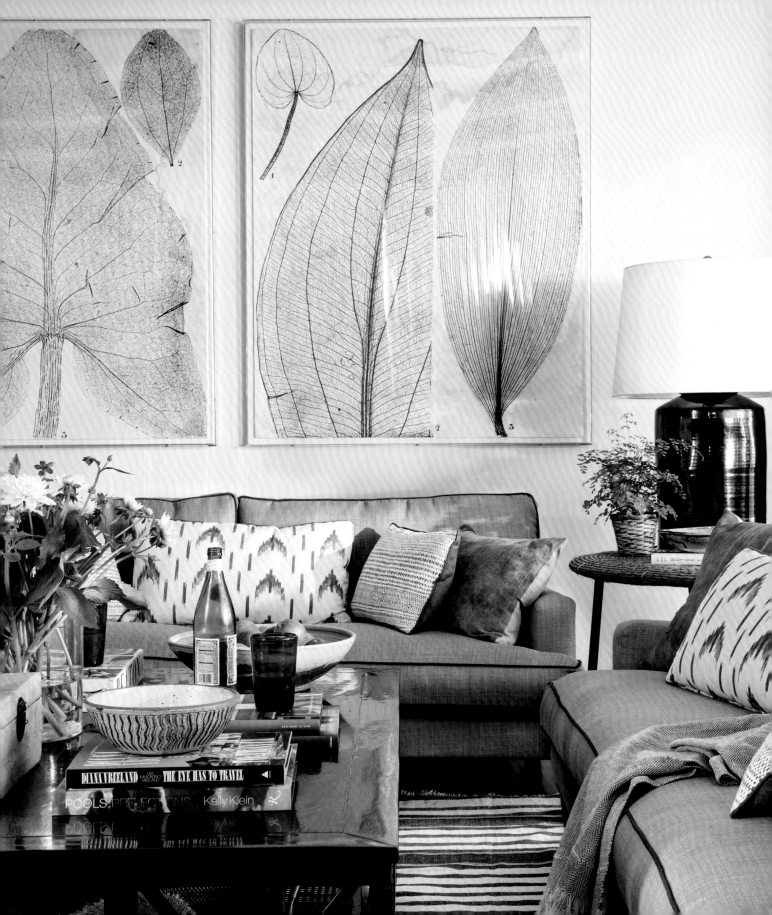

Mexico, Portugal, and Morocco. There's the deep inky blue of indigo in a rug or dhurrie or in an Indian-inspired pattern printed on wallpaper or on a set of curtains. There's the nautical look of navy and white stripes, which can be used anywhere from sofas to throw pillows to wallcoverings. And then the beautiful comfort of pale blue linen, its soft, sun-bleached appearance inviting you to curl up with a good book.

And yet, because of their strong, simple clarity, these colors also work as an excellent canvas for some of my other favorite elements. Blue and white offer the ideal backdrop for items in neutral colors, such as baskets, wood boxes, rattan chairs, and natural-fiber rugs. In addition to creating gentle contrast, natural materials ground blue and white, as if reminding the stripes and prints that they share their hues with water, sky, and clouds. Hurricane lamps with large candles play up references to the sea, while ceramics in pale or neutral colors temper stripes with softness.

Color can also mingle happily in a room full of blue and white. Bright pink or purple flowers, such as delphiniums, lush green plants, or a bowl of ripe fruit can liven this staple and add a focal point to a sea of blue. But because the color pairing is the real theme, I lean more toward creating drama through materials and detail: mixing a block-printed bedspread with blue-and-white paisley throw pillows and a striped rug in a bedroom, for instance, or in a living room, pairing a deep English rolled-arm sofa upholstered in washed indigo and contrasting piping with striped throws and wicker armchairs with blue and white ikat cushions. Stunning in their simplicity, but as comfortable as a pair of jeans, these rooms feel both casual and inviting. They are spaces that welcome leisure and long weekends. To me, there is nothing more beautiful than a lifestyle of blue and white.

The leaf prints over the sofa highlight the room's verdant, organic feel. PREVIOUS, LEFT, CLOCKWISE FROM TOP LEFT: The wooden oar in the entryway of this cottage underscores the room's nautical allusions. Black accents provide contrast. Cheery stripes greet guests upon rising. Batik and striped throw pillows. PREVIOUS, RIGHT: My favorite part of this room: the indigo patchwork rug over the jute carpet.

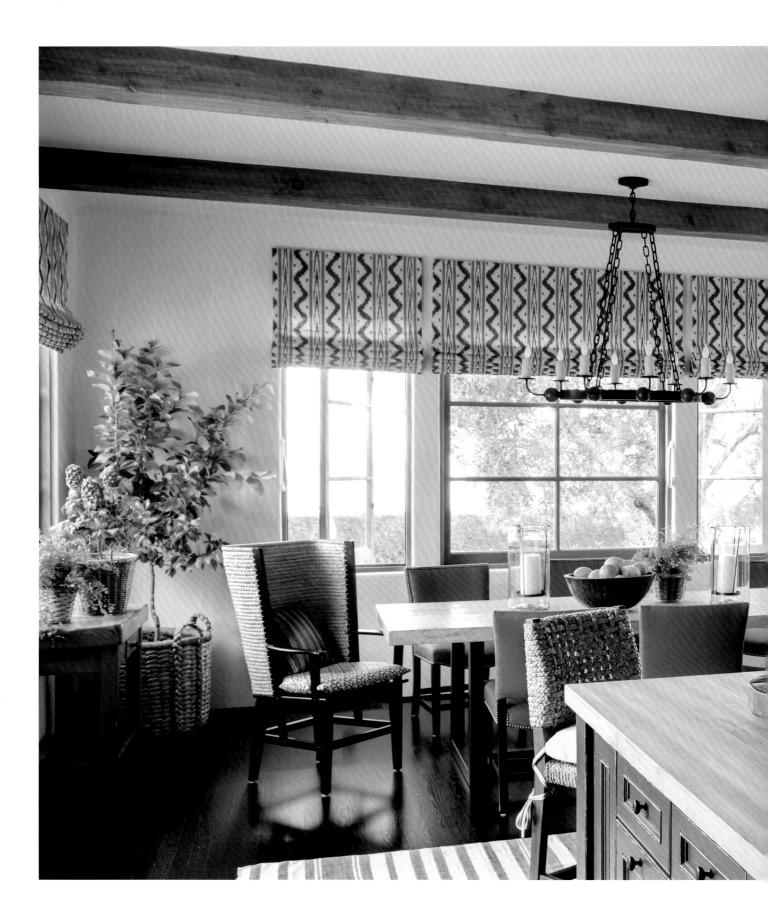

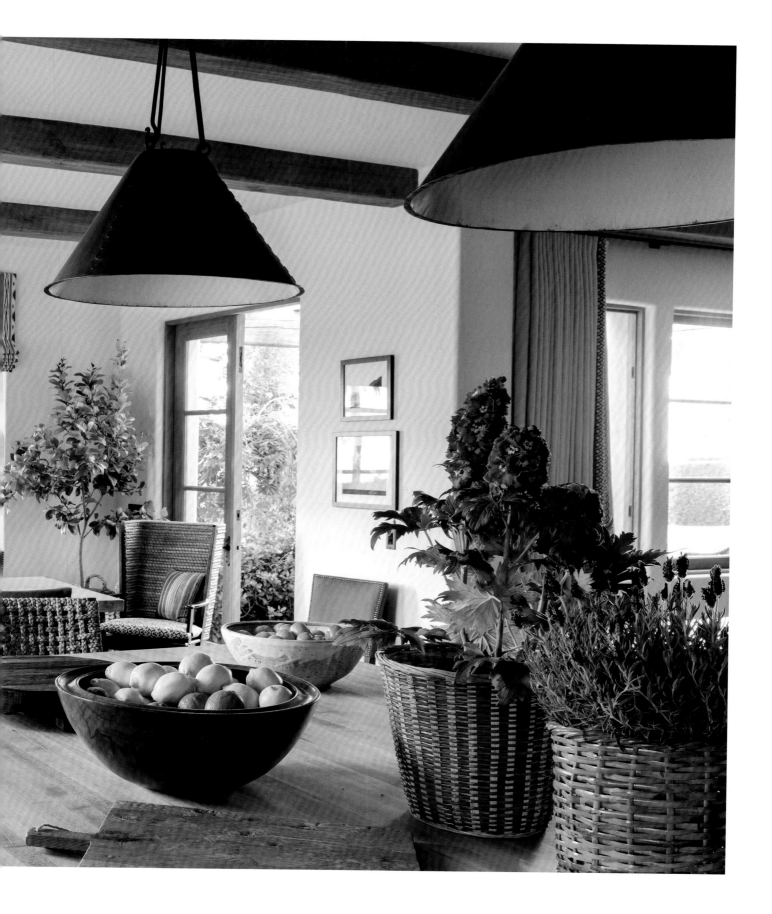

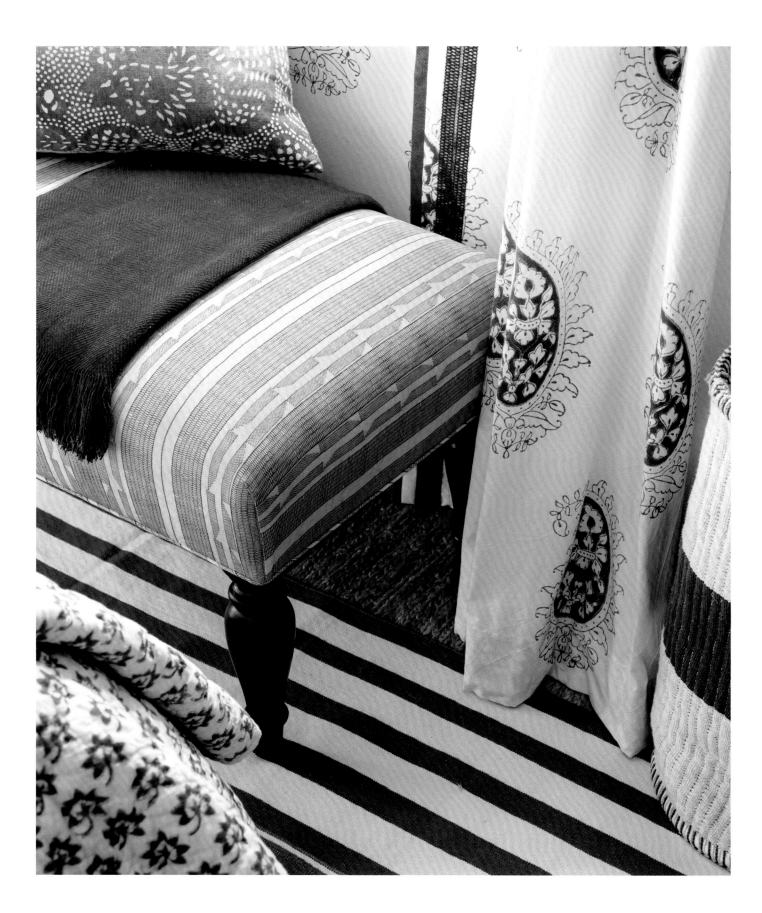

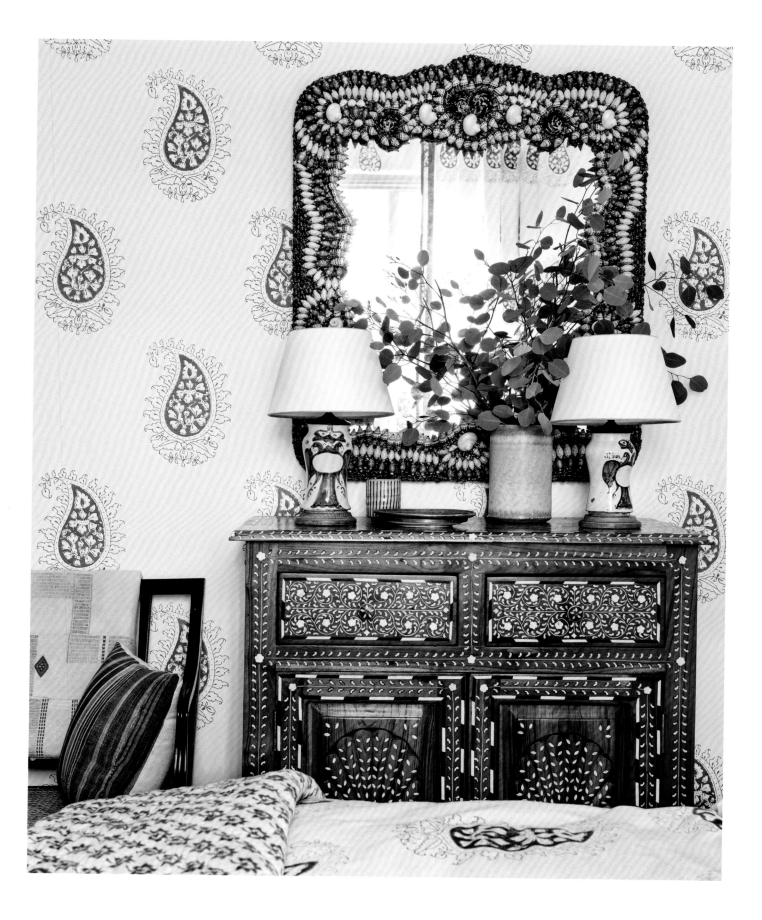

This room features indigo block-printed textiles from Les Indiennes. I love the impact of the paisley fabric on walls and bed. PREVIOUS, LEFT: Every corner of this room is filled with contrast and texture. PREVIOUS, RIGHT: The stunning shell mirror over the bone-inlay cabinet reinforces this room's sense of the sea. The painted ceramic lamps are from South America. PAGES 42-43: The woven rush host and hostess chairs at the breakfast table are softened by ikat-patterned cushions and striped pillows. The woven rope of the barstools is repeated in the tree pots by the breakfast table.

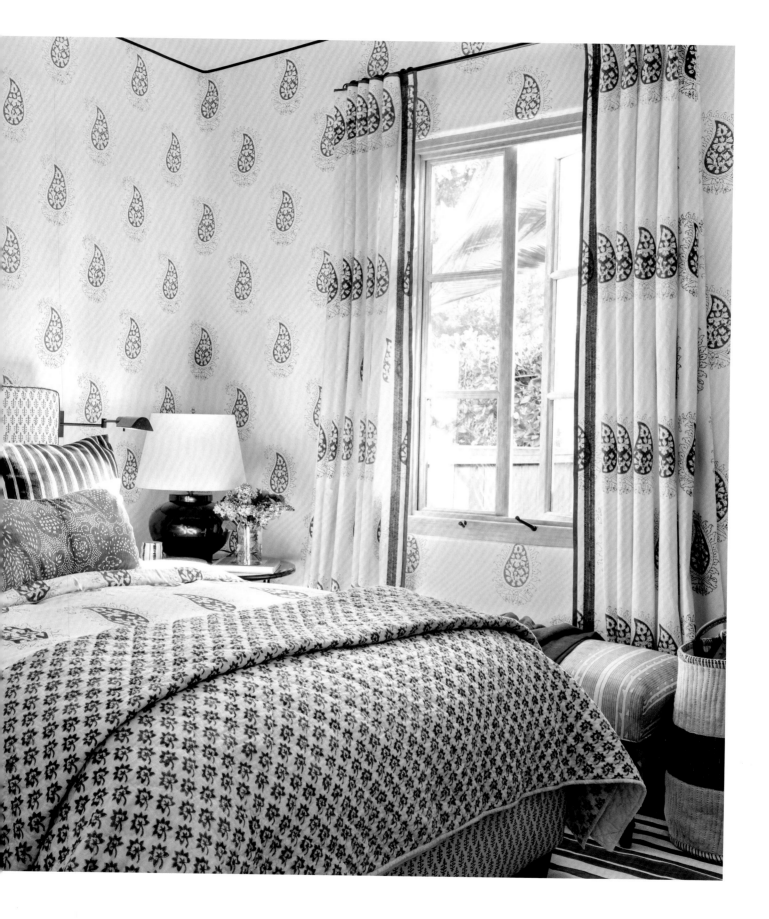

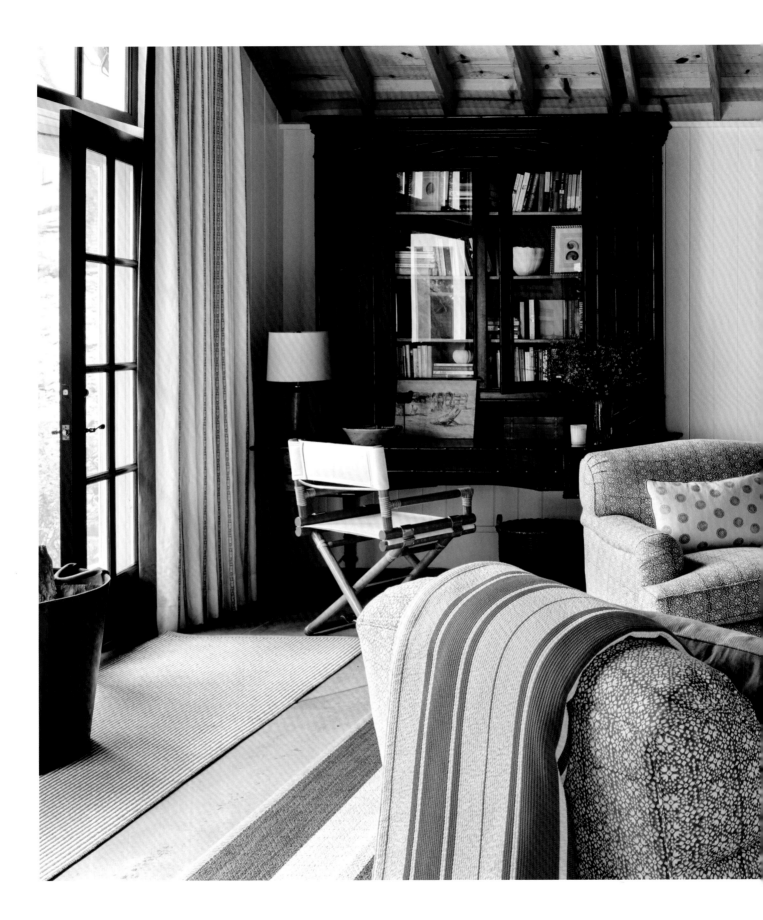

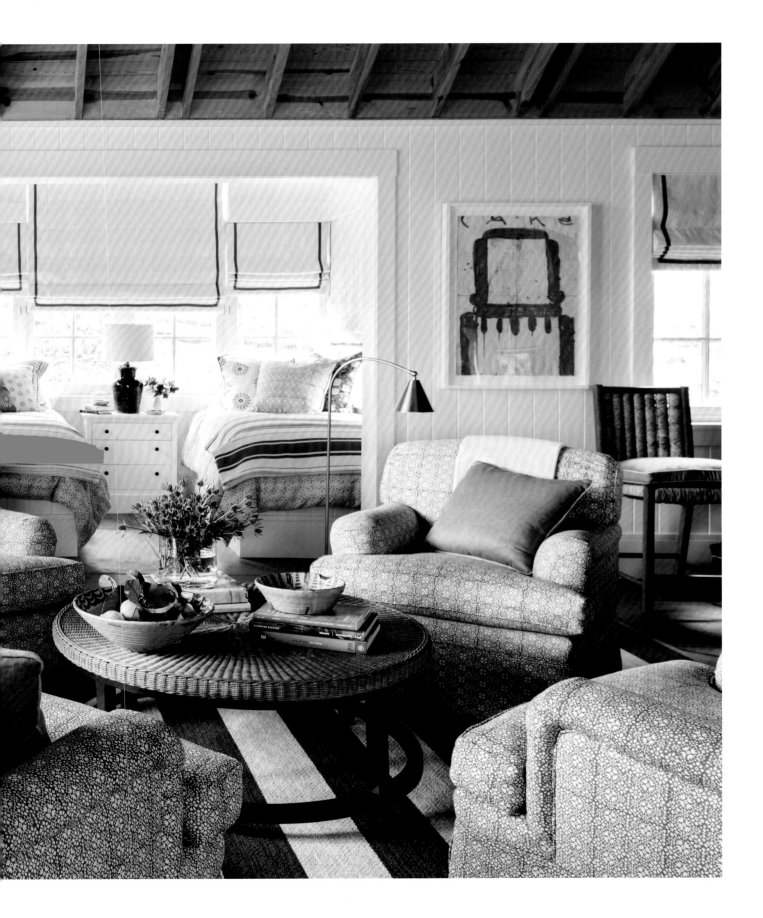

The simple beauty of layered

stripes (above). OPPOSITE: An abstract print gives the cottage dining area some personality while keeping true to the color story. PREVIOUS: In this one-room cottage, I used blue-and-white stripes in several ways: on a simple, classic window treatment in the sitting area; on blankets in the sitting room and on the beds; and in the rug.

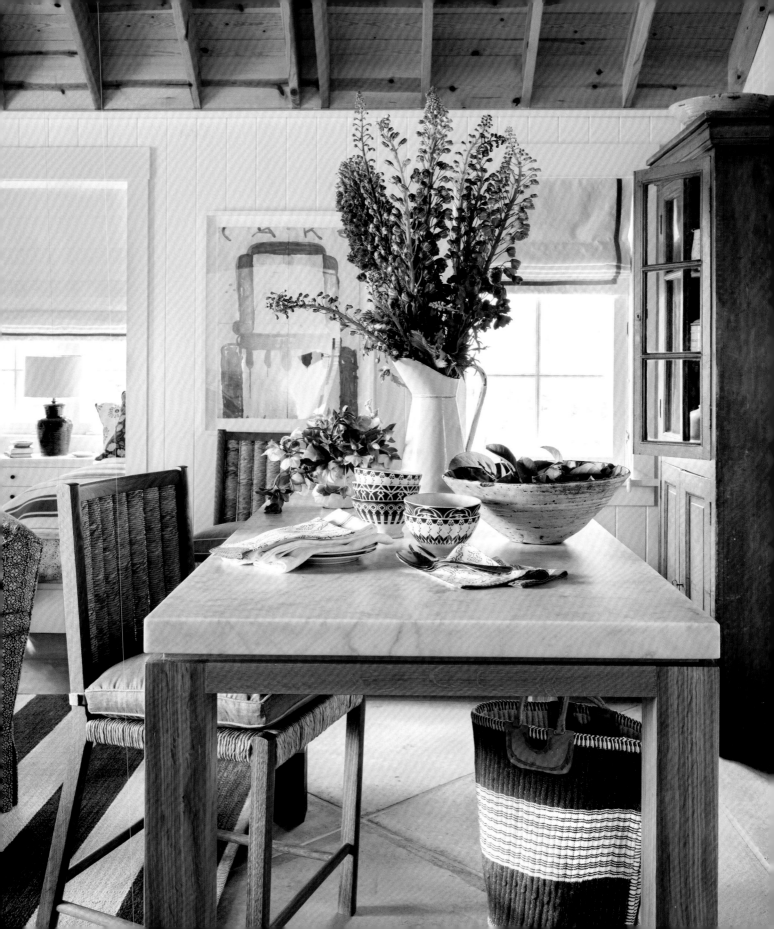

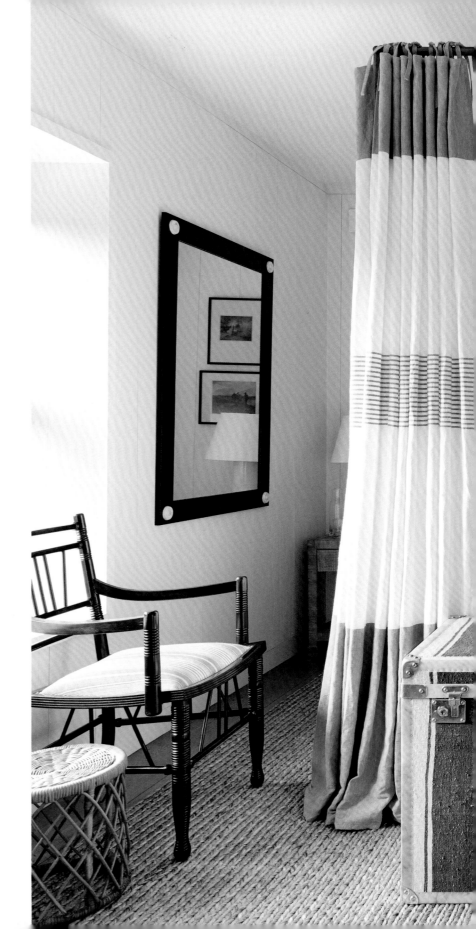

This pool house bedroom seems all-American, but actually the striped trunk at the foot of the bed is made in England with a blue-and-white striped dhurrie. The drapes around the bed are Italian; running the stripes vertically adds variety and depth.

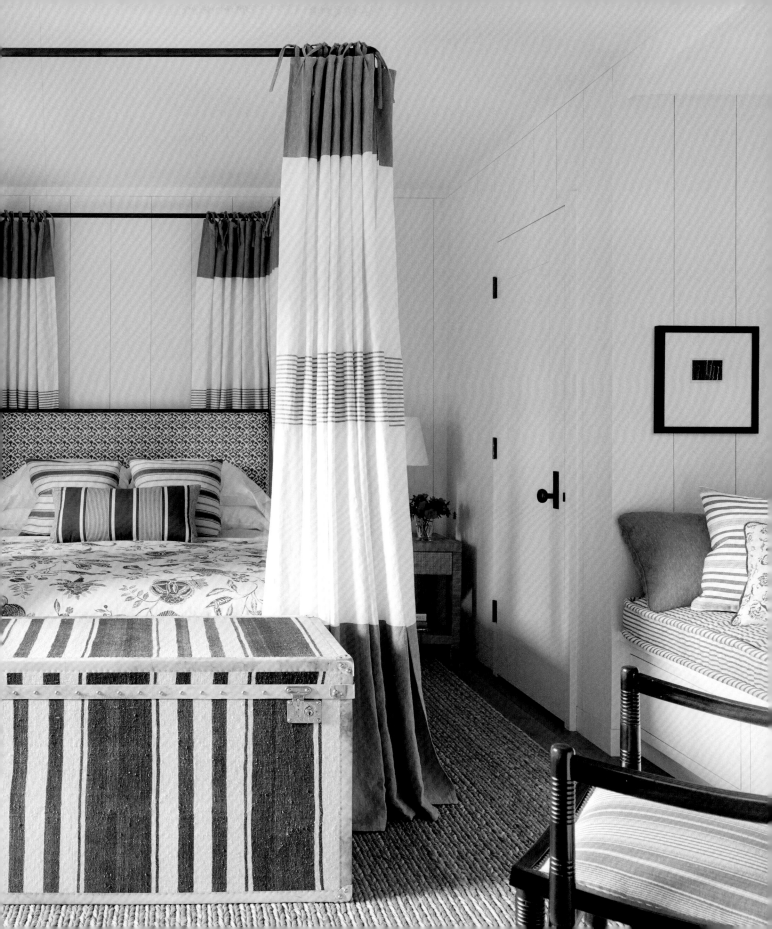

TIMELESS NEUTRALS
OLD HOLLYWOOD MEETS CALIFORNIA EASE

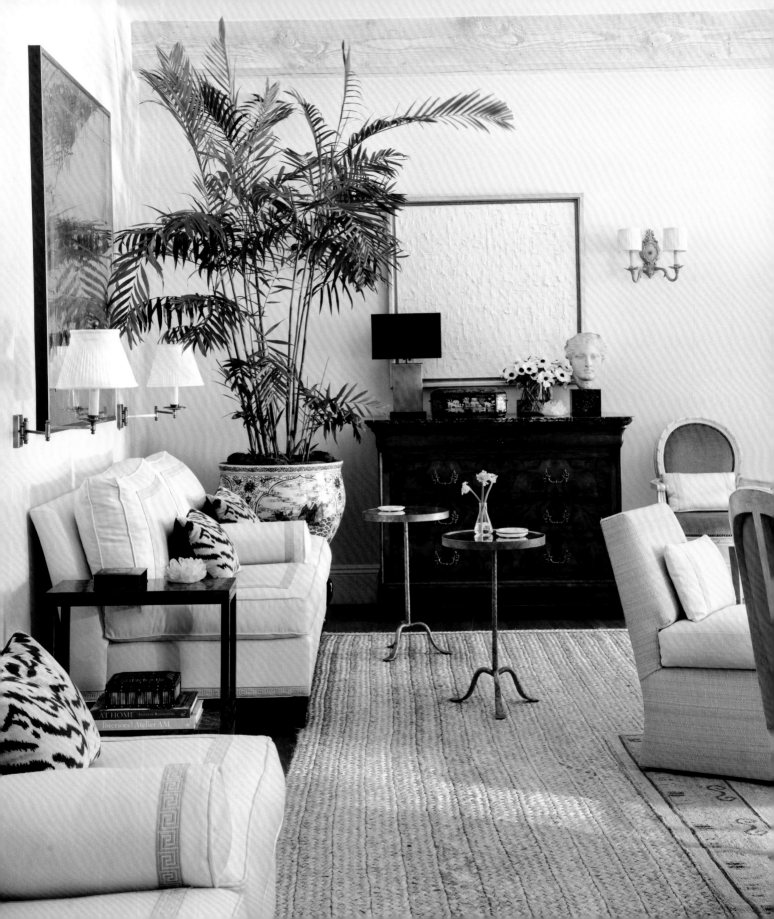

Gary Cooper, dashing in a flannel suit and tie, pocket square perfectly folded. Lauren Bacall in an ivory silk blouse, two strands of pearls draped around her beautiful neck. Katharine Hepburn sporting her signature menswear look, a camel hair blazer over a crisp white button-down. The sartorial style of old Hollywood has a vivid glamour that is still beautifully breathtaking today. The straightforward, put-together look of that era feels as alluring and timeless as a good cashmere sweater and communicates a lifestyle filled with cocktails, gracious entertaining, witty conversation, and intimate rendezvous (carried out with the utmost discretion, of course). Who wouldn't want to live in that world?

The rooms in this chapter take the civilized refinement of old Hollywood as their design cue and reinterpret it through a contemporary California lens that prevents them from feeling stuffy or dated. In all of these rooms there are elements that give off a formality, such as skirted tables with bullion fringe, Louis XVI armchairs upholstered in saddle brown leather, sofas trimmed in silk tape, parchment tables, and rich black lacquer. But the spaces themselves are still airy and open, with accents from leafy branches, potted orchids and sunlight from the outdoors woven in. There are lots of layers—but here, it's done within a tastefully limited color palette, and using materials like soft, buttery leathers, intricate embroideries, linen slipcovers, camel hair, fine

The simple ivory banquettes in the living room of this Pacific Palisades home are comfortable and elegant and, paired with the mirrored cigarette tables in front of them, the perfect place to linger over a cocktail. FOLLOWING: The room's multiple seating areas are held together by the neutral palette, whose sense of luxuriousness is enhanced by the use of materials such as velvet, cashmere, saddle brown leather, and silk trims.

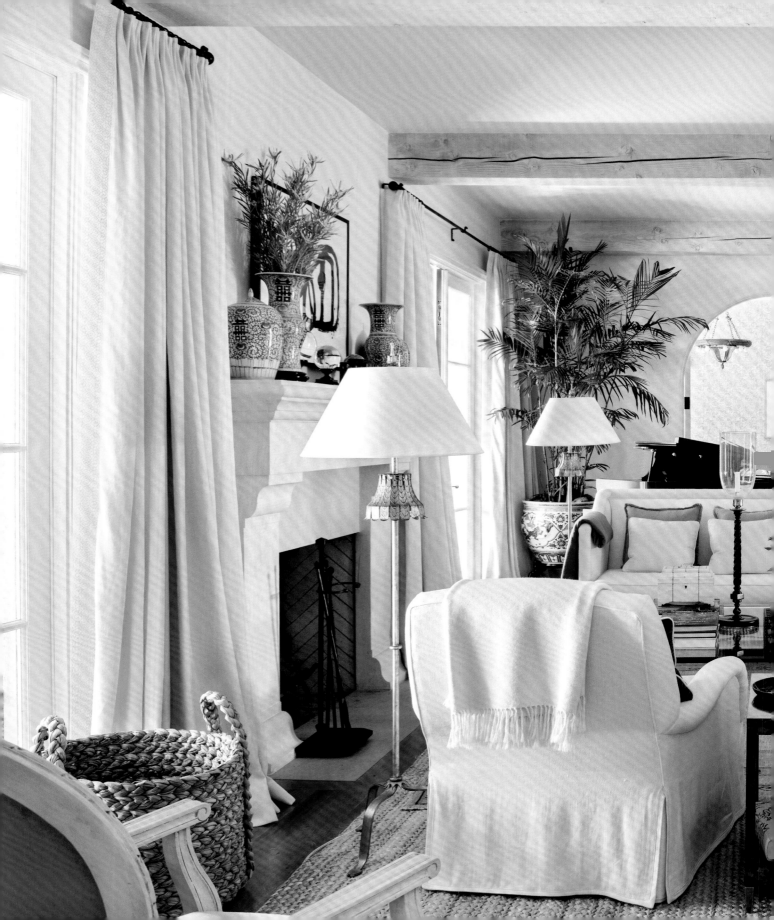

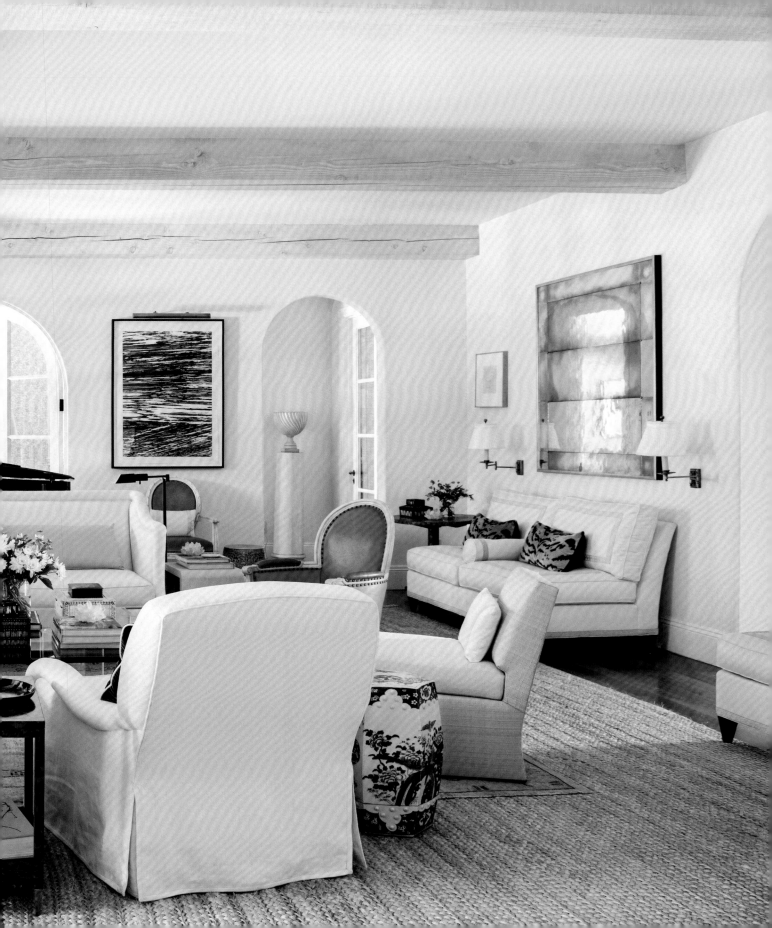

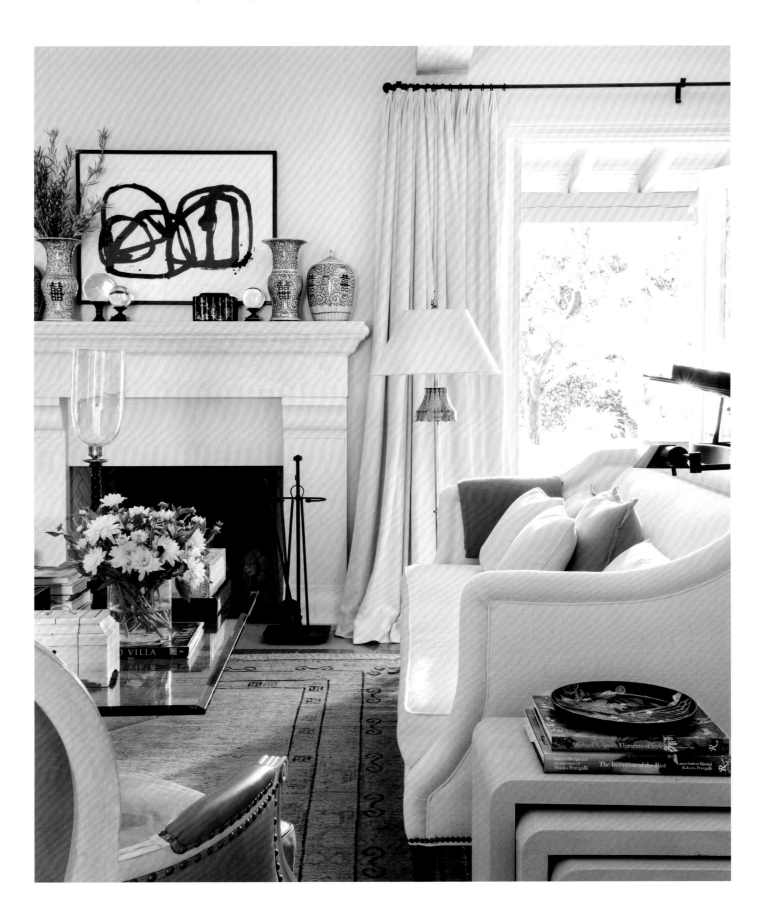

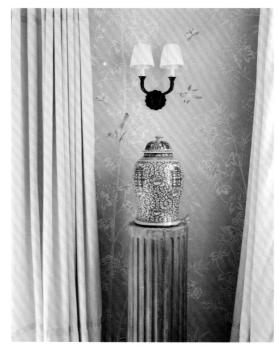

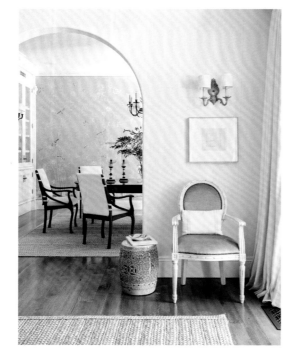

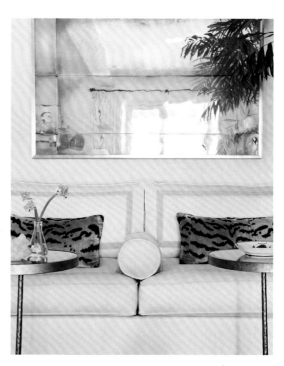

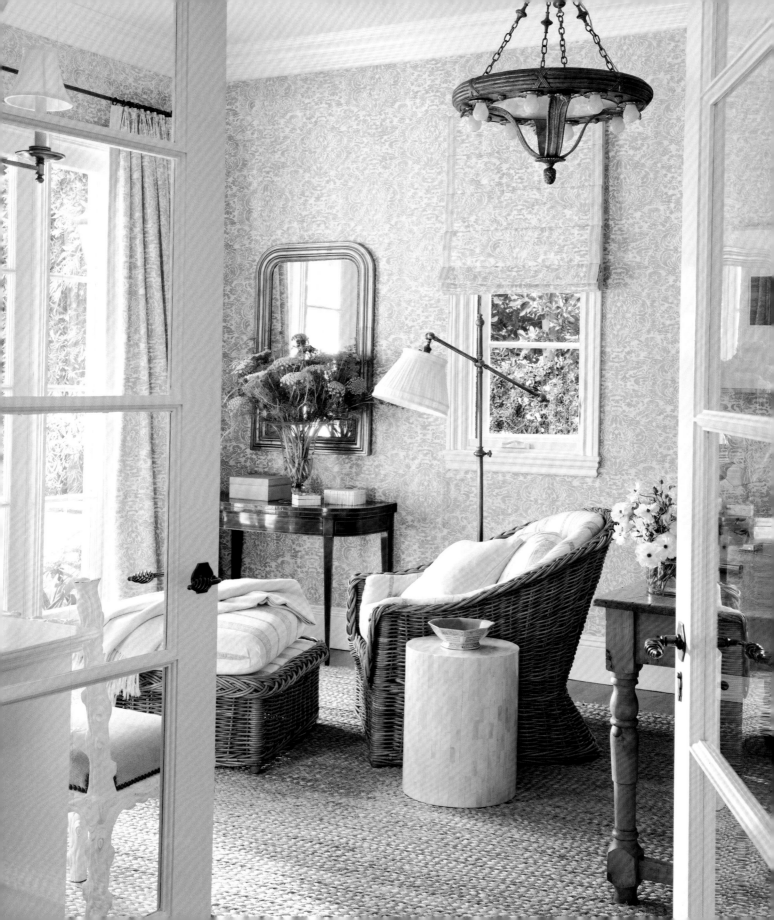

A formal dining room in custom Gracie wallpaper. PREVIOUS, LEFT: Animal print pillows and blue-and-white ceramics offer color and pattern without disrupting the palette. PREVIOUS, RIGHT: Matching damask wallcoverings and curtains add serenity to this study, as does the wicker lounge chair facing the garden. PAGES 60 AND 61: Layered rugs (left) and mixed ceramics on a mantel (right) demonstrate how subtle shifts in tone punctuate neutral rooms.

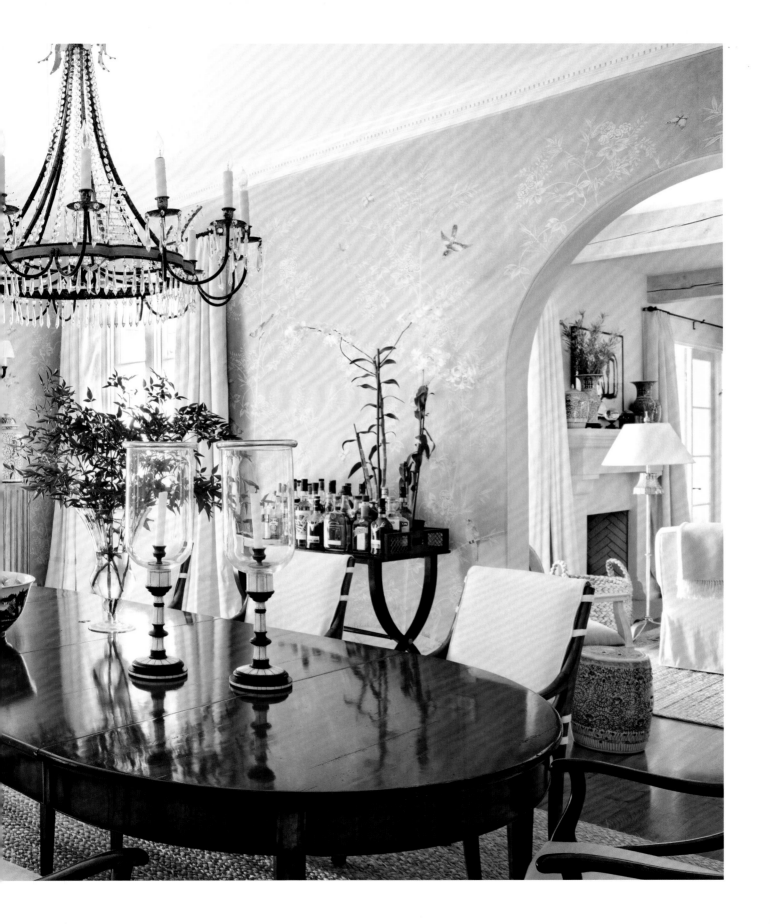

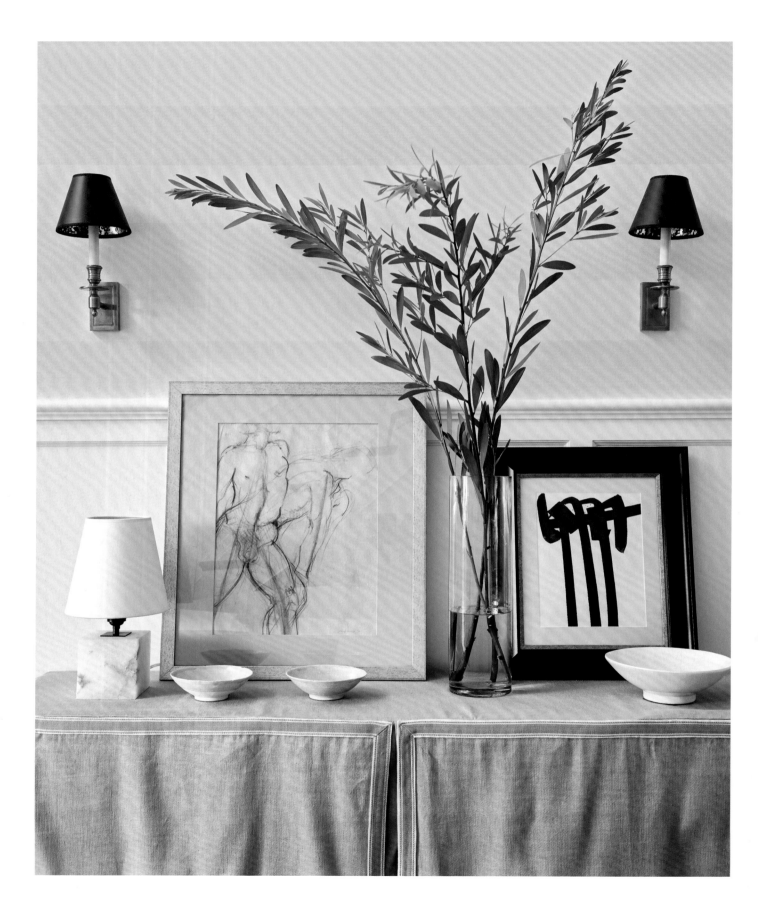

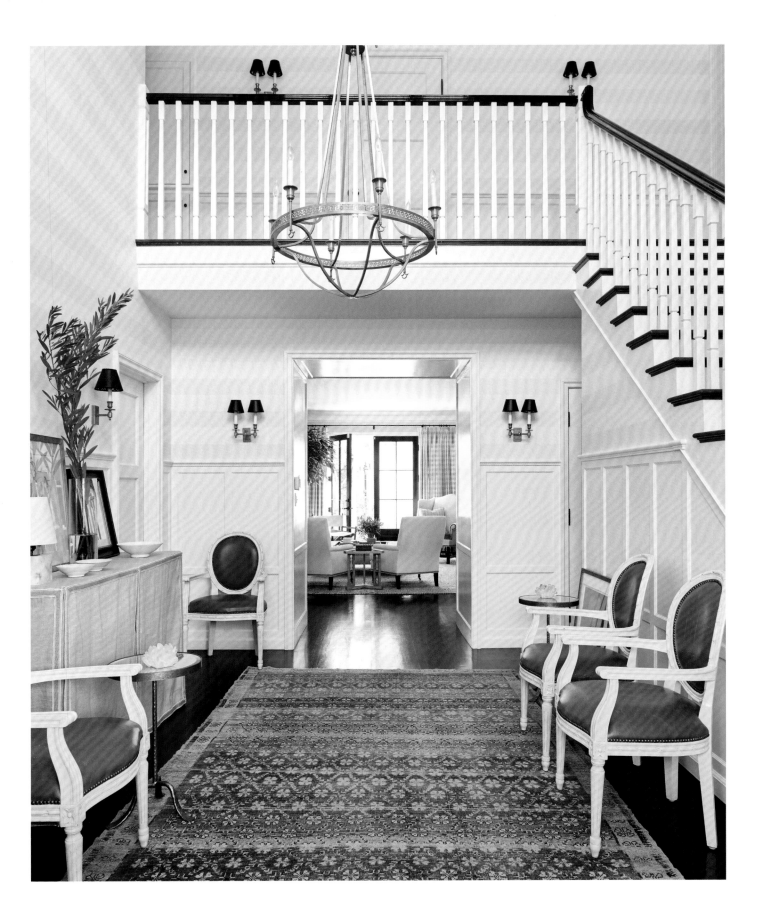

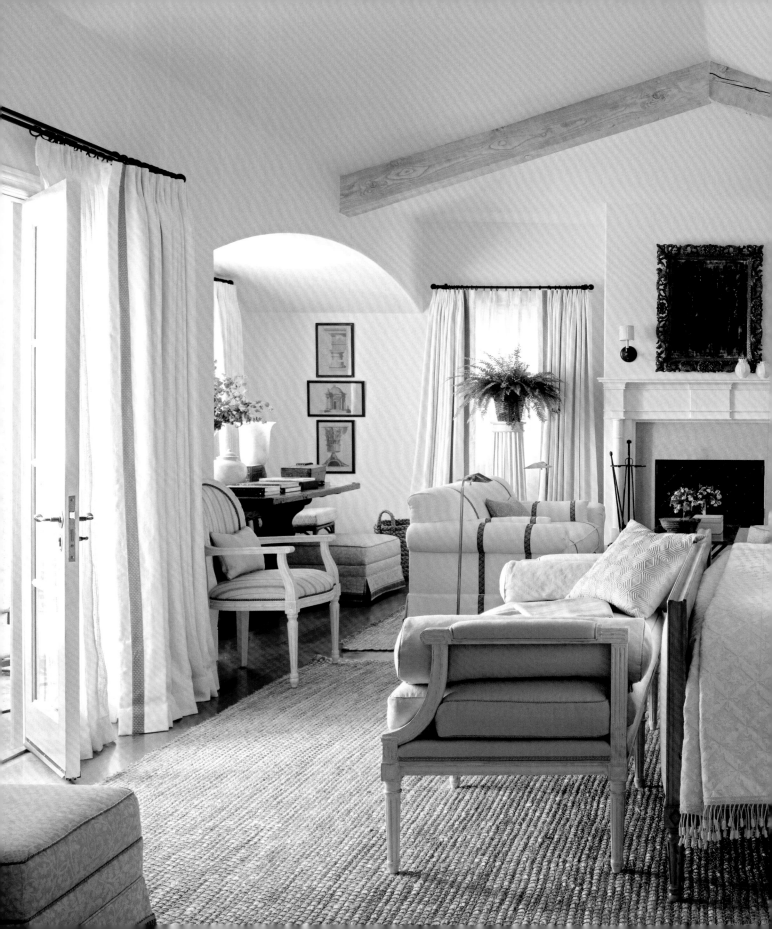

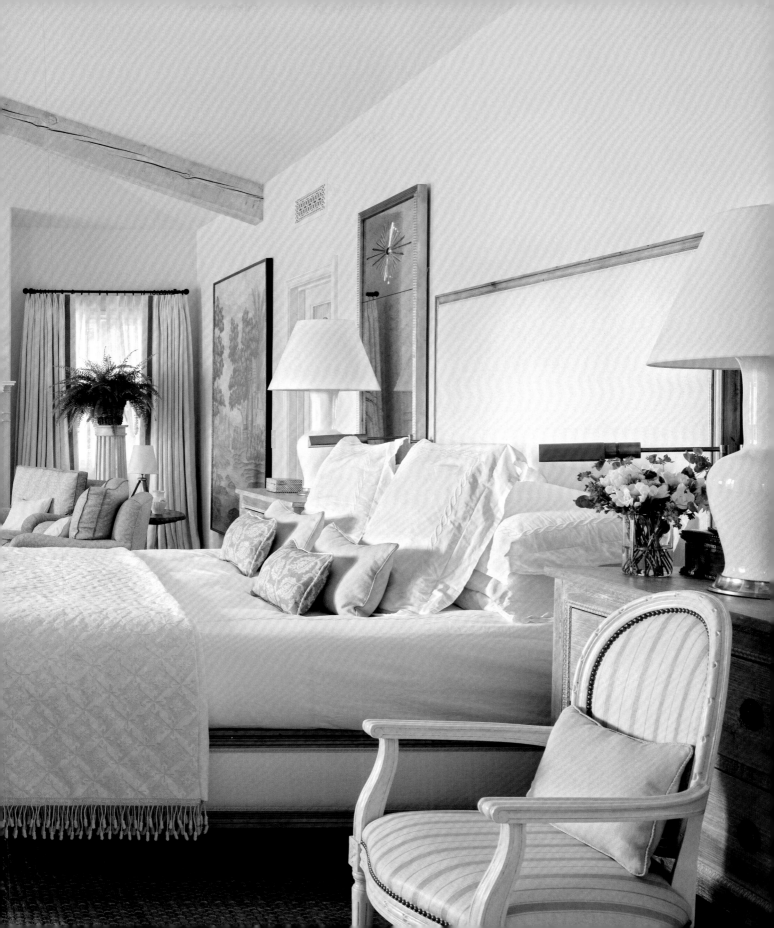

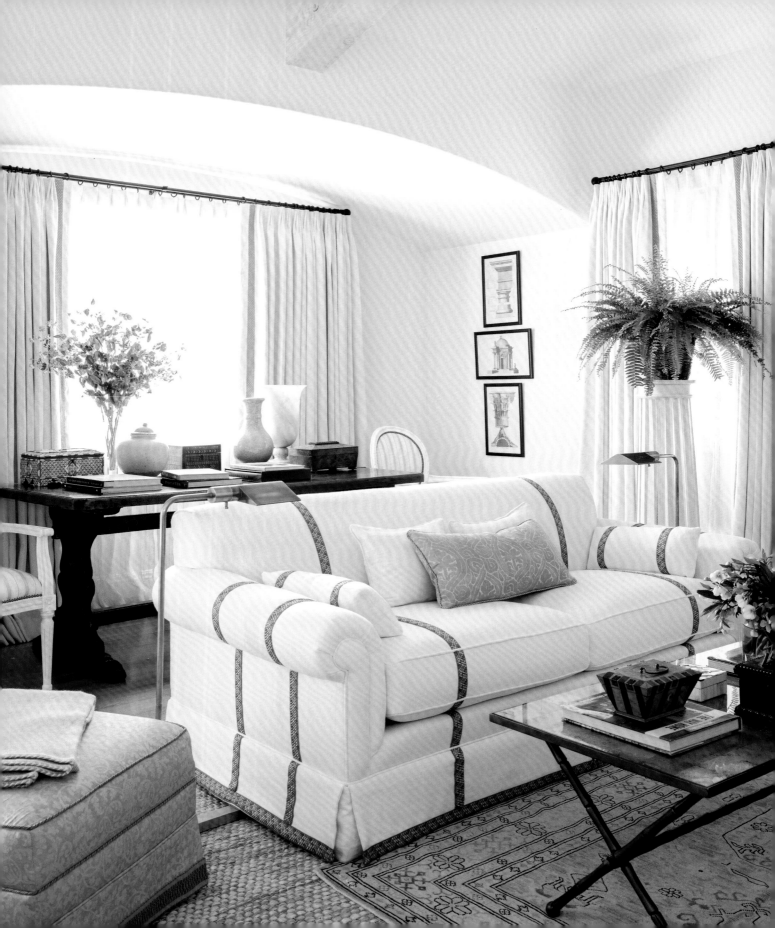

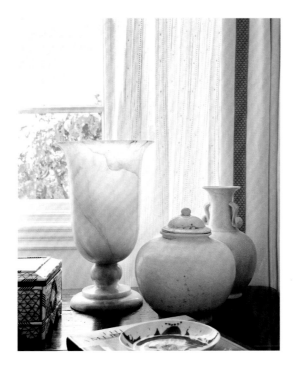

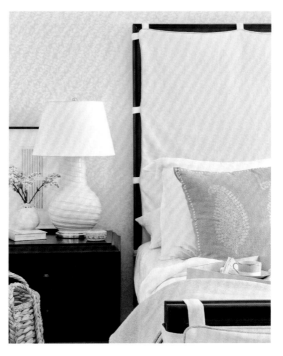

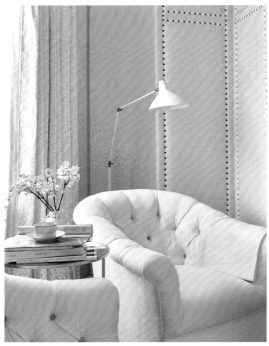

A wood bedframe is softened by a linen slipcover. PREVIOUS, LEFT: The sofa in the suite's seating area is trimmed in gold silk tape. PREVIOUS, RIGHT: Accessories in cream and white range from classic to modern. PAGES 68-69: Pale blue accents enhance the neutral master suite. PAGES 66 AND 67: Horizontal striped wallpaper, an abstract print, and French armchairs bring drama to a two-story entryway.

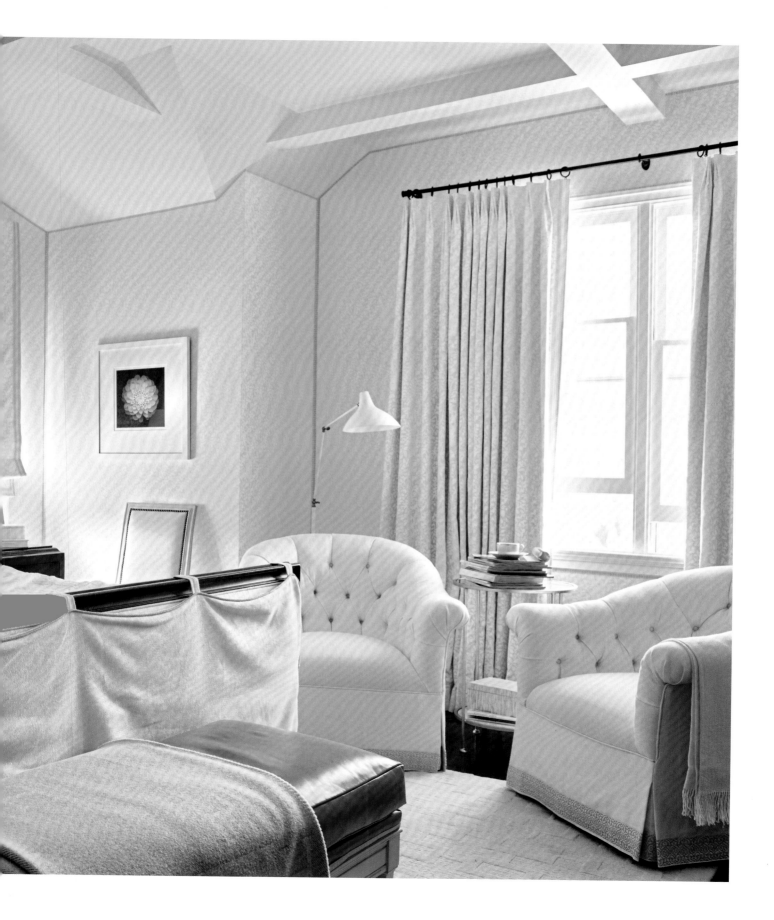

wools, delicate trims, and (of course) luxurious cashmere. These rooms contain some of my favorite contrasts, such as chocolate brown silk velvet against ivory linen, silk, or painted wood, which results in a sumptuous layering of neutrals, textures, and sheens.

The crisp, restrained color palette is also tempered by the retro elegance of slim cigarette tables, Billy Baldwin slipper chairs, crystal chandeliers, gilt-framed mirrors, Oushak and animal print rugs, and black lacquer chinoiserie armoires with tassels hanging from the handles. But these touches of nostalgic glamour don't have to feel old. Charcoal drawings, abstract prints, and contemporary black-and-white photographs in simple wooden frames (propped against the walls, rather than formally hung) keep the rooms from feeling dated without straying from the sophisticated message. Pedestals of different shapes and heights displaying hurricane lamps and blue-and-white ceramics are fun and eye-catching, while still adding refined, sleek lines to the rooms. Other individual touches keep spaces contemporary and inviting. In bedrooms and sitting rooms, pale blue adds softness to the tasteful elegance of more formal pieces.

Many of the rooms in this chapter are geared toward entertaining. In these, I've created different nooks, each filled with an interesting—but not ostentatious—mix of furniture and design elements. Bone-inlay boxes, miniature alabaster objets, vintage ashtrays, and shimmering rock crystals are intriguing additions that provide excellent fodder for cocktail-party conversation. The overall look here is one of livable sophistication, spaces that are comfortable and enjoyable to spend time in. These are rooms that invite you to look, laugh, and admire, to mingle with good company in great style.

A juxtaposition of objects on an Eero Saarinen tulip table becomes an intriguing focal point in a Hollywood Hills living room. FOLLOWING: Light tones amplify the view of natural greenery outside. PAGE 78: Unexpected details such as gold silk tassels hanging from the handles on the chinoiserie armoire (top left) and a fireplace filled with white coral (bottom right) make an elegant room more interesting. PAGE 79: Chaise longues were made for rooms like these.

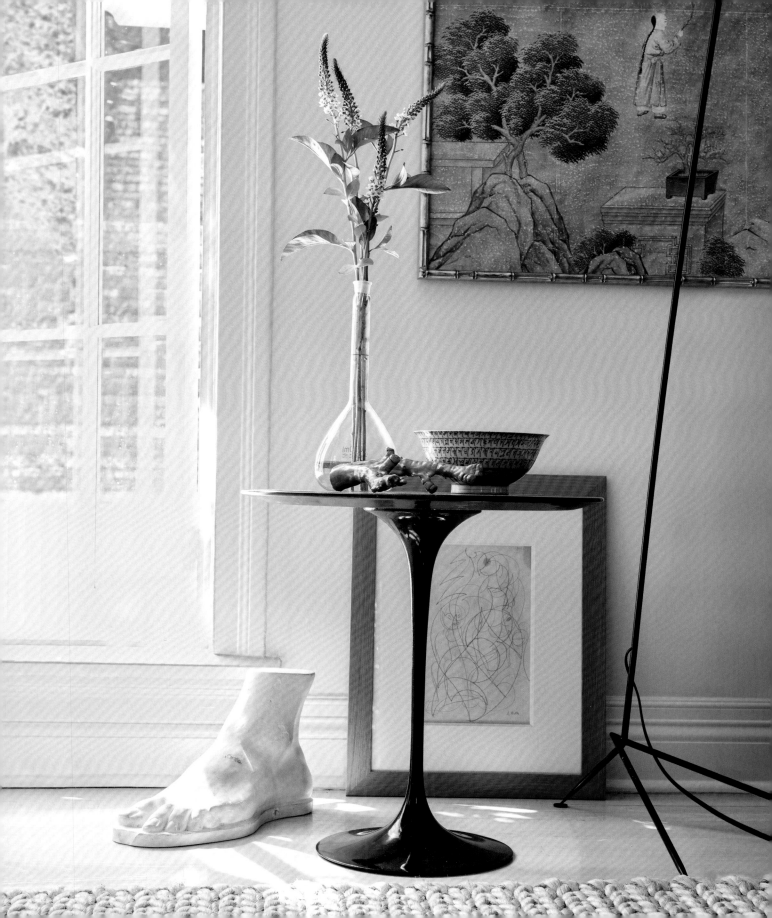

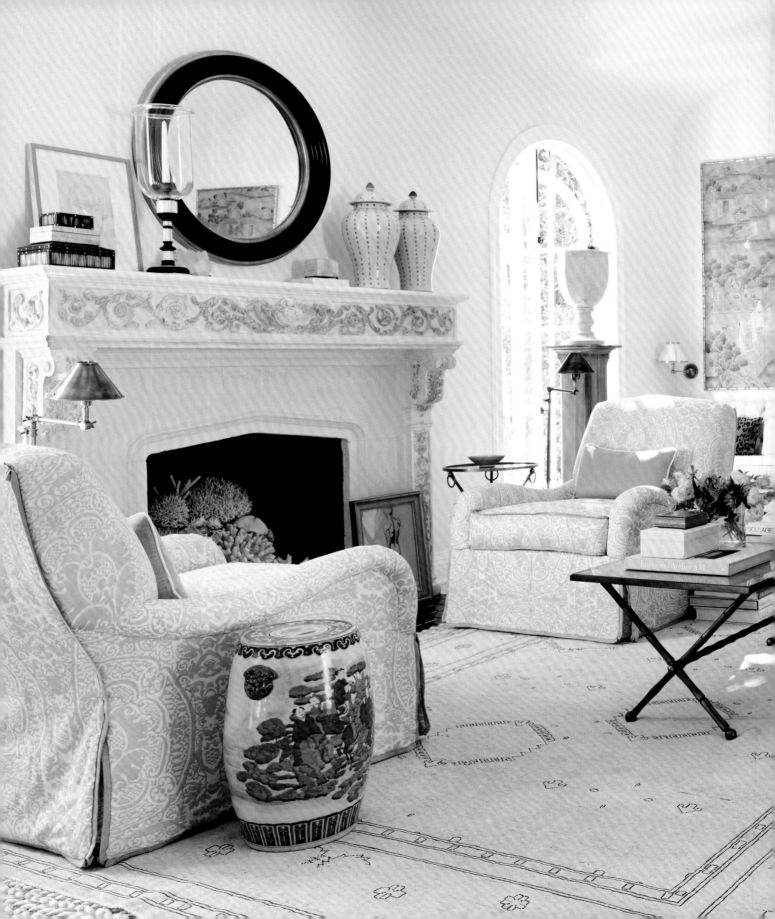

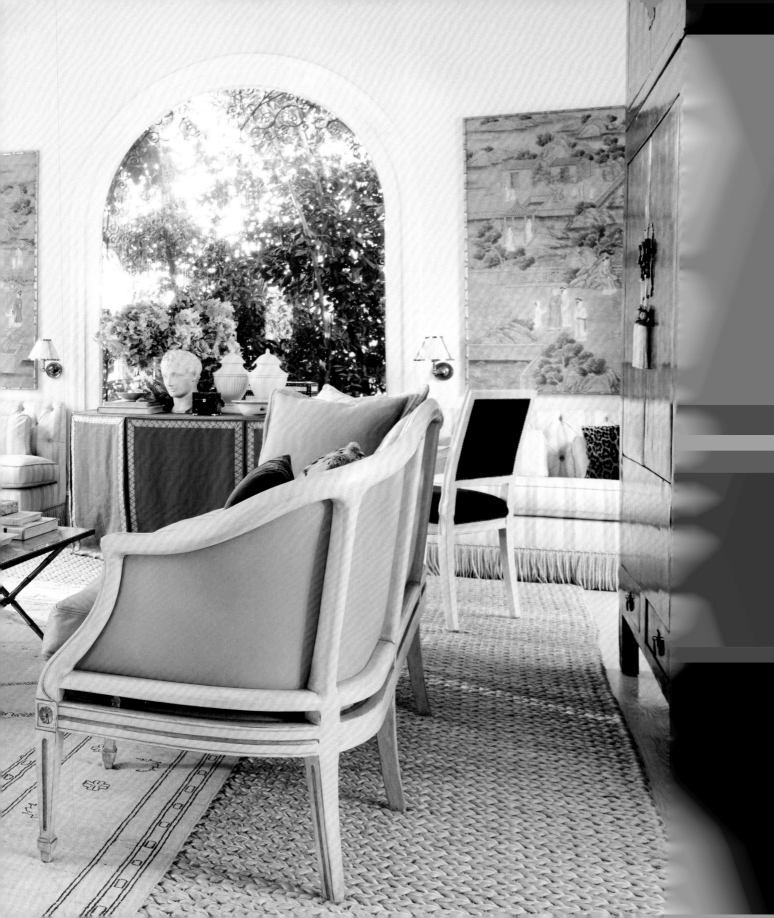

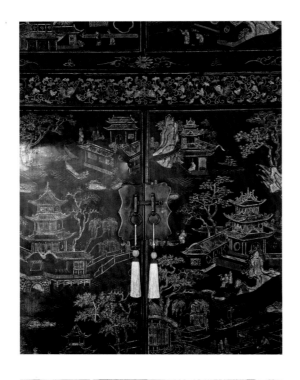

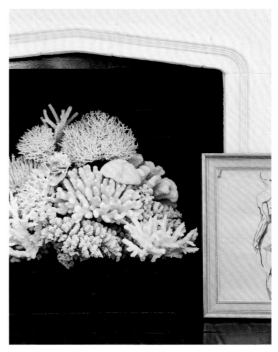

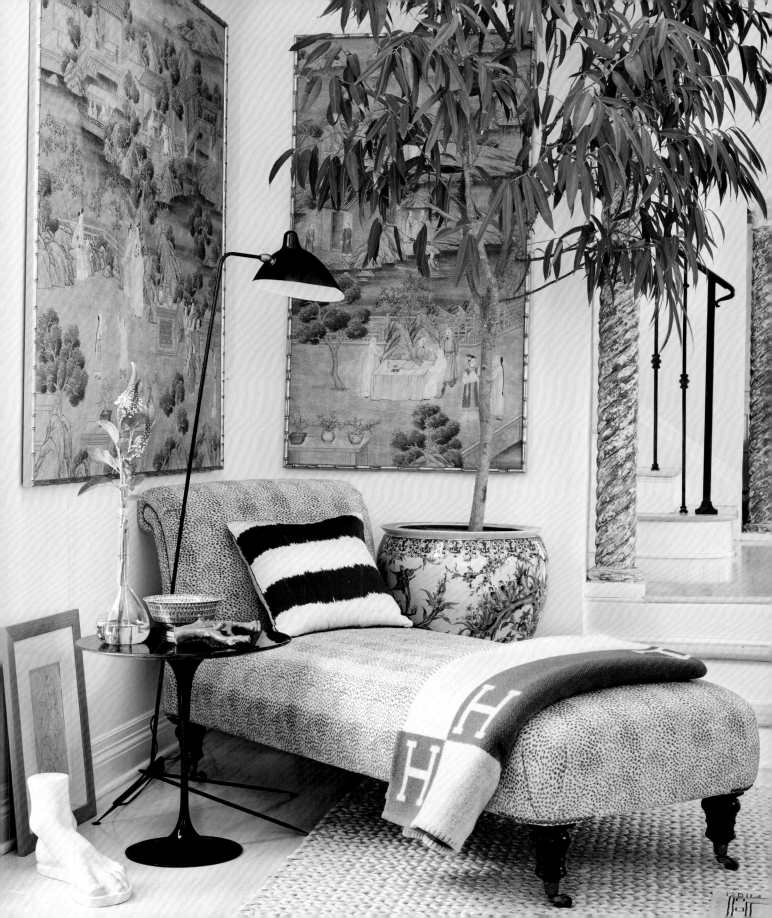

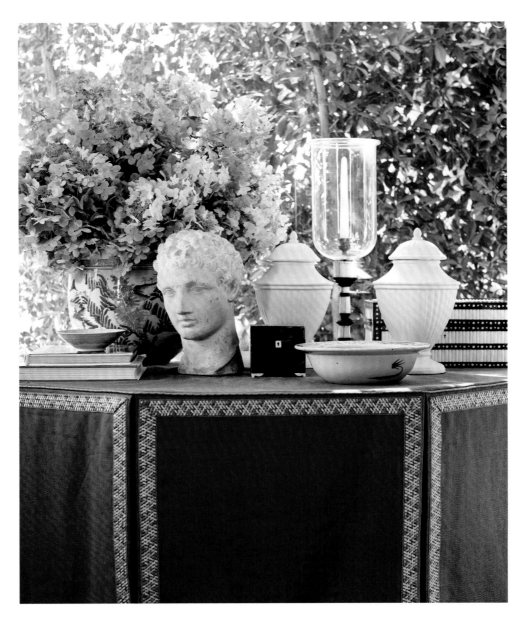

A skirted table makes any room

feel glamorous, especially when topped with luxurious fabric like this camel-colored linen edged with braided silk tape. OPPOSITE: The tufted banquette in the corner is flanked by Galerie des Lampes reading lights and sits beneath a chinoiserie panel. The pedestal on which the ivory plaster urn rests is made of weathered wood.

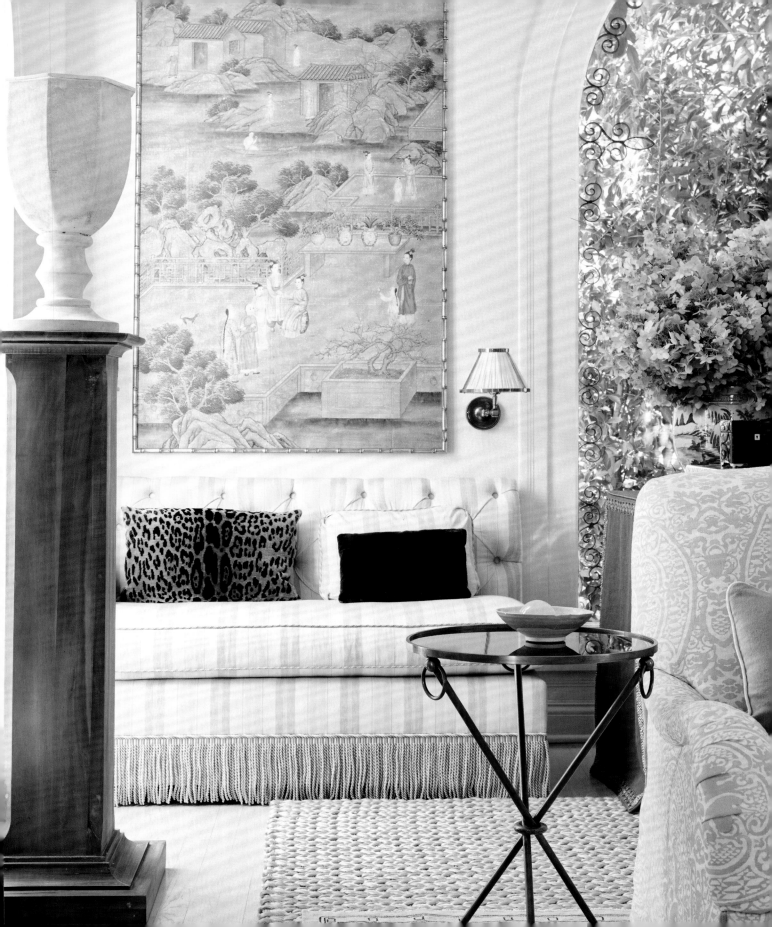

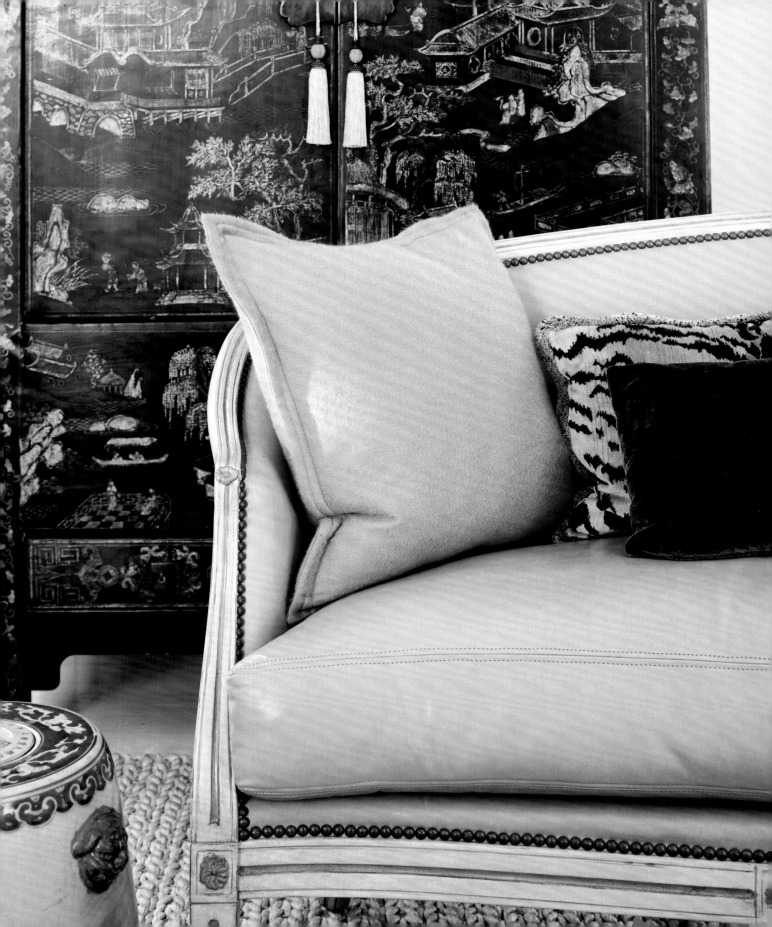

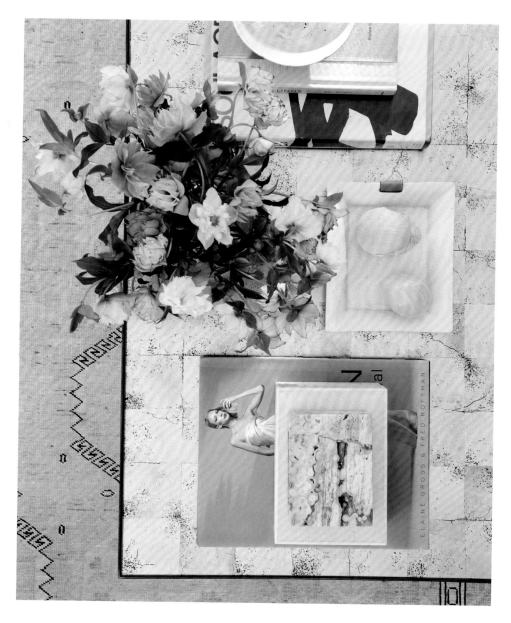

Nail-head detail, as seen on

the frame of this Italian settee, is an elegant way to include texture in a neutral room.
The roughness contrasts beautifully with refined fabrics like camel hair,
silk, velvet, and leather. ABOVE: A French gilt table showcases books, boxes,
an antique French ashtray, an ivory skull, and an alabaster egg.

A feast of art books, hurricane lamps, and tortoise and chinoiserie boxes adorns the black lacquer table in a dining room that doubles as a library. FOLLOWING, LEFT: A daring mix of ivory painted wood, chocolate silk velvet, animal print, and a blue-and-white ceramic garden stool. FOLLOWING, RIGHT: Saddle brown dining chairs trimmed with nail heads and ivory tape are a strong focal point against an animal print rug and the ornate gilt bar.

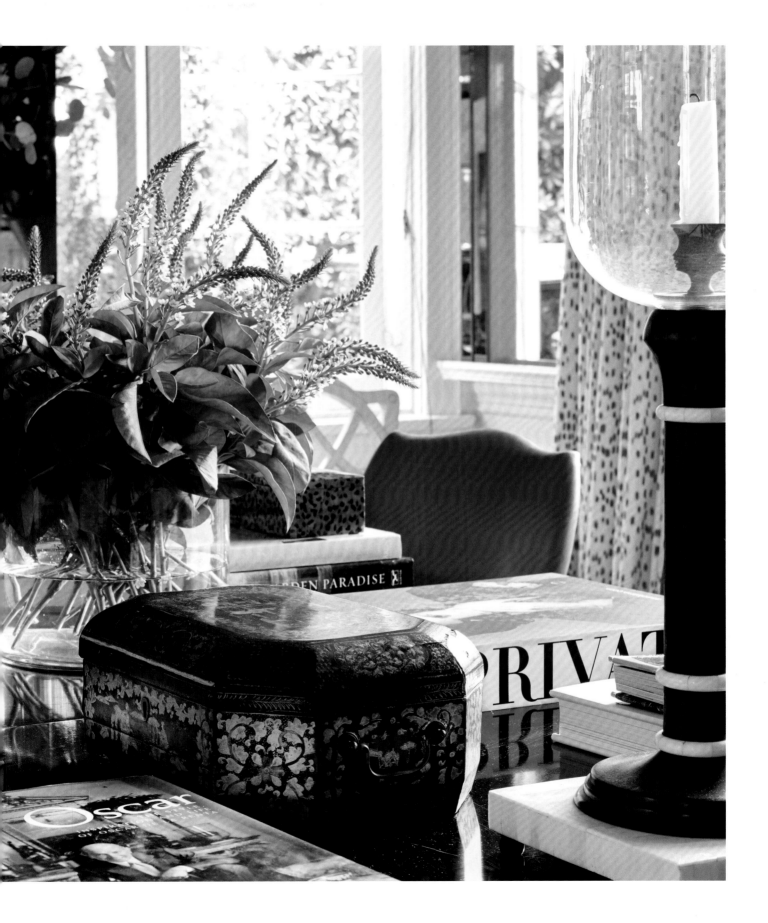

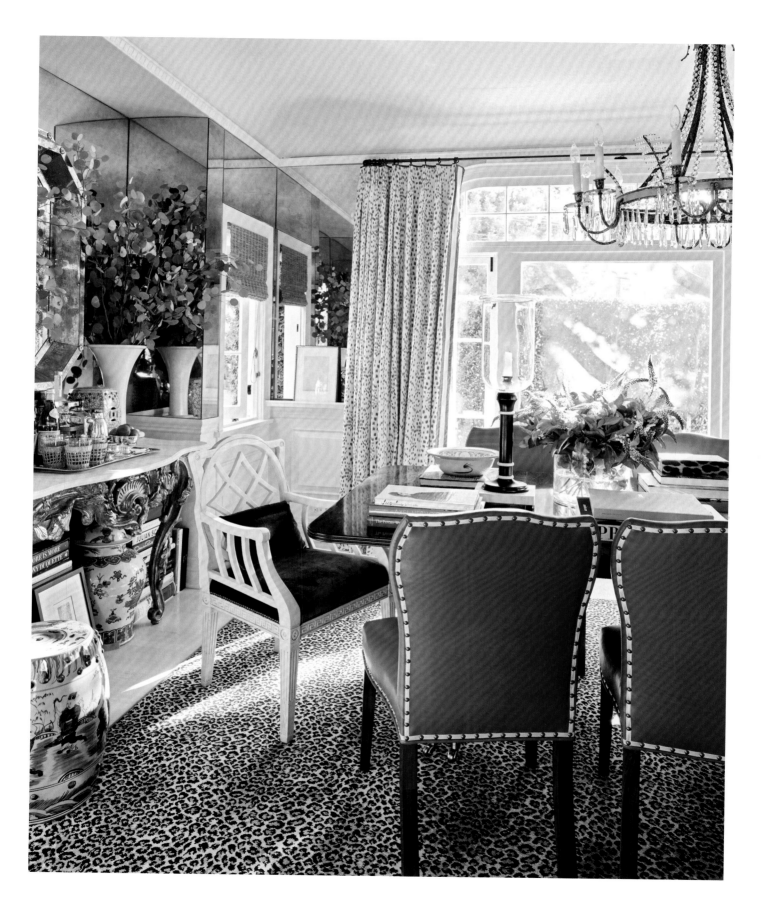

GARDEN GREEN
BRINGING THE OUTSIDE IN

Mauve

P.J.Redouté

DESIGNED BY VEERE GRENNEY ASSOCIATES PHOTOGRAPHY BY DAVID OLIVER
PRODUCED BY CAROLYN ENGLEFIELD WRITTEN BY CAROLINE DONALD

Gardens are a passion of mine—I love the endless colors, textures, and tones of plants and flowers. Two of my favorite gardens are those of Bunny Mellon (a self-taught botanist and horticulturist) and my dear friend Bunny Williams; I'm drawn to the way Oak Spring Farm, Mellon's famed Virginia estate, and Williams's beautiful home in Falls Village, Connecticut, incorporate natural elements into their decor. Garden stools, straw baskets, iron furnishings, stone benches, and treillage playfully mingle in their houses, creating a seamless passage between indoors and out. My own garden is a lush, leafy escape whose natural elements and design also inspire the decor in my home. When the glass doors from my kitchen and living room are open—as they often are—the garden becomes another room and its peaceful energy, beautiful color palette, and the soothing sounds of the stone fountain flow into the rest of the house. Thick ficus "walls" make the space feel cozy and protected, while climbing fig ivy creates a lattice-like pattern that echoes the effect of a scenic wallcovering. Both contrast beautifully with the brick stairs, blue and white ceramic accessories, and the robin's egg blue cushions of the garden furniture. The pairing of deep green with a lighter blue mirrors the naturally occurring contrast between plants and sky—a look I love to recreate indoors.

Vibrant greens and blues, a potted topiary, and natural textures like wicker and rattan bring a garden inside. FOLLOWING: The kitchen doubles as a family room, thanks to the garden-inspired English rolled-arm sofa and wicker armchairs. PAGE 94: Books, potted myrtle topiaries, and a cascade of printed pillows (top left and right, bottom right) provide plenty of lush color. A curtain in Carolina Irving vine fabric (bottom left) has a touch of contrasting blue on the leading edge. PAGE 95: Breakfast alfresco—almost.

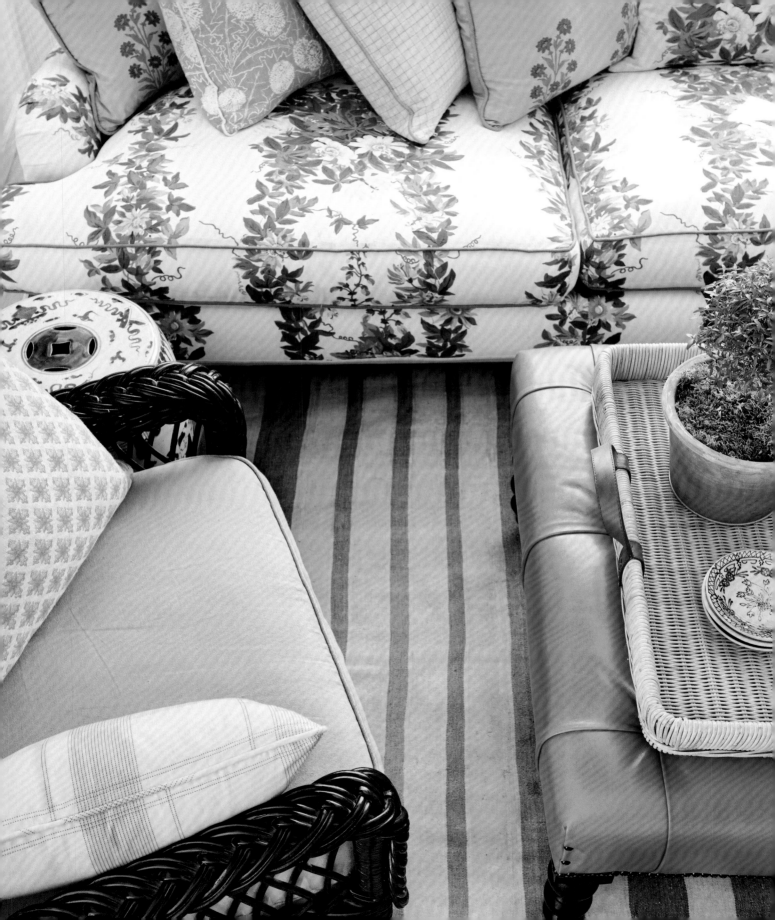

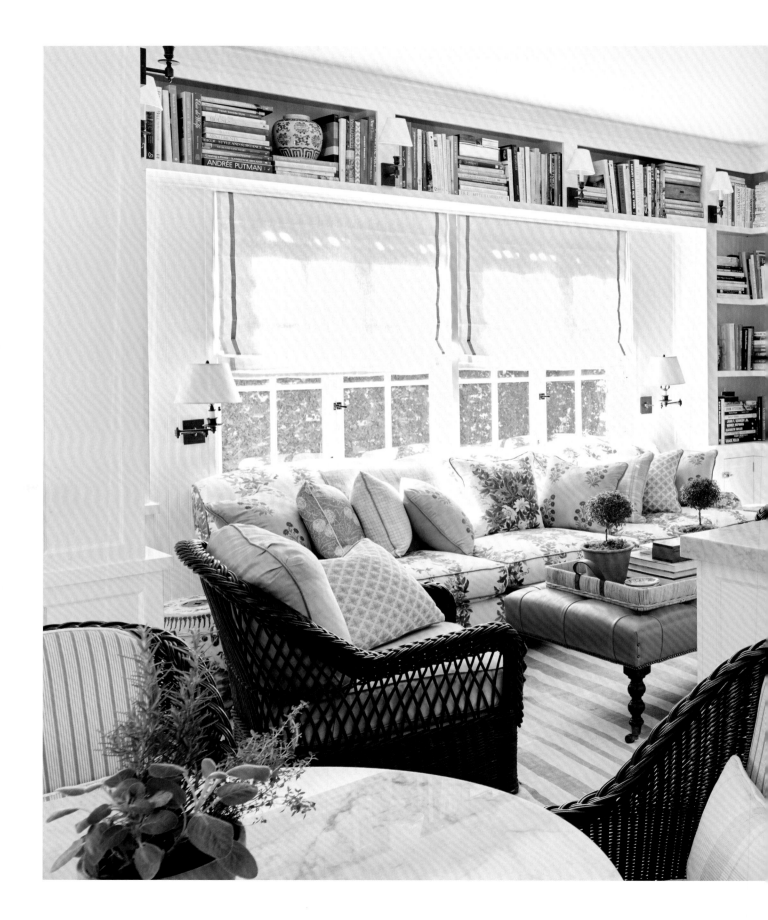

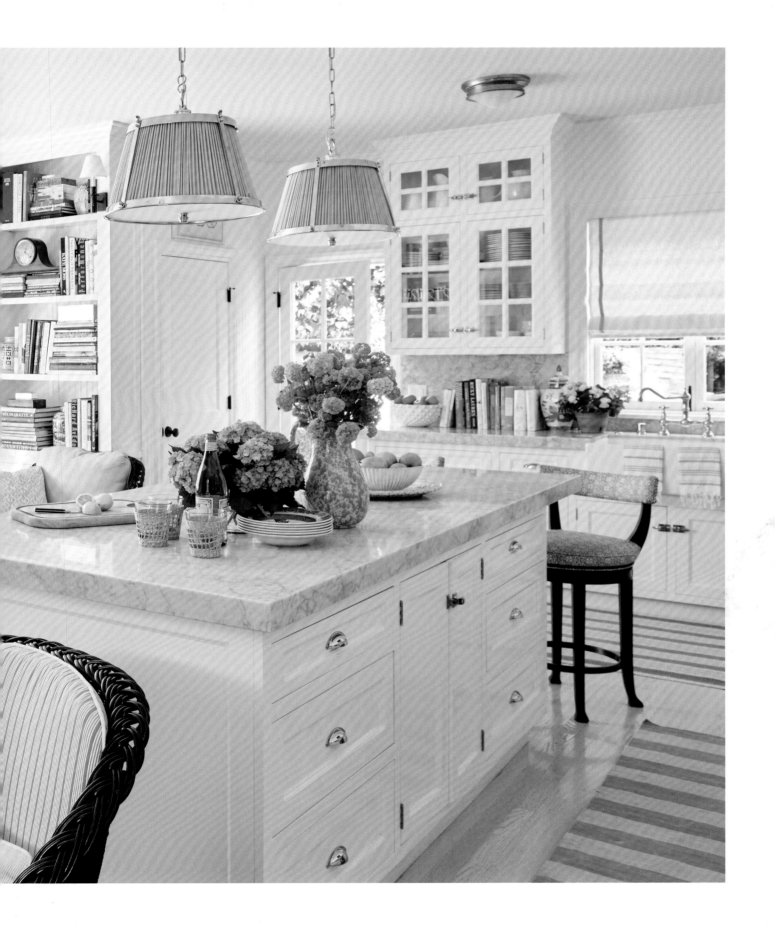

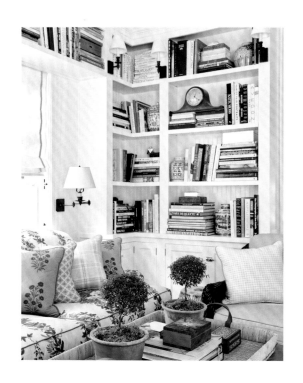

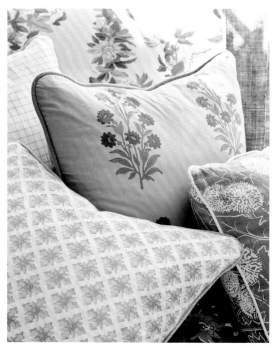

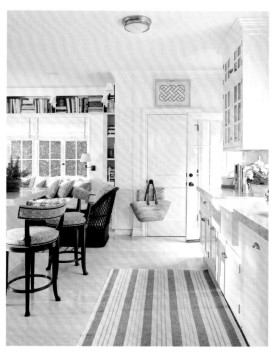

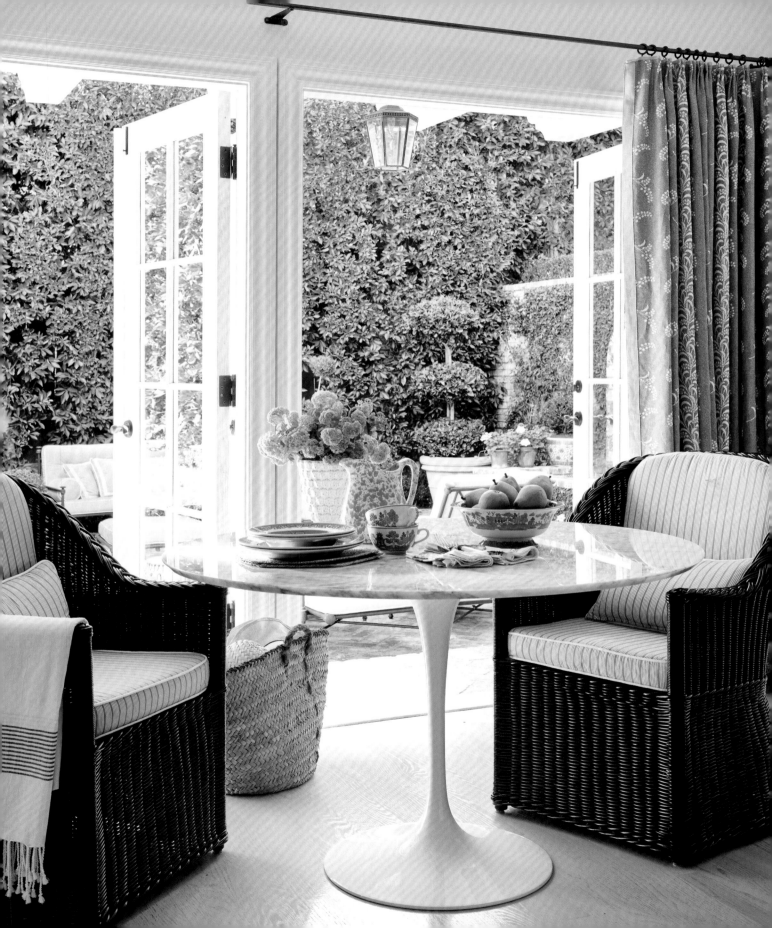

In the Hollywood Hills, a ficus-covered wall provides a lush backdrop for blue and white. FOLLOWING, LEFT, CLOCKWISE FROM TOP LEFT: Robin's egg blue cushions are trimmed in white, and the eighteenth-century table where the antique urns sit is stone. Brick stairs lead to the garden's back gate, while potted boxwoods and topiaries are scattered around a garden fountain. FOLLOWING, RIGHT: An army of potted boxwoods leads the way to the rose garden.

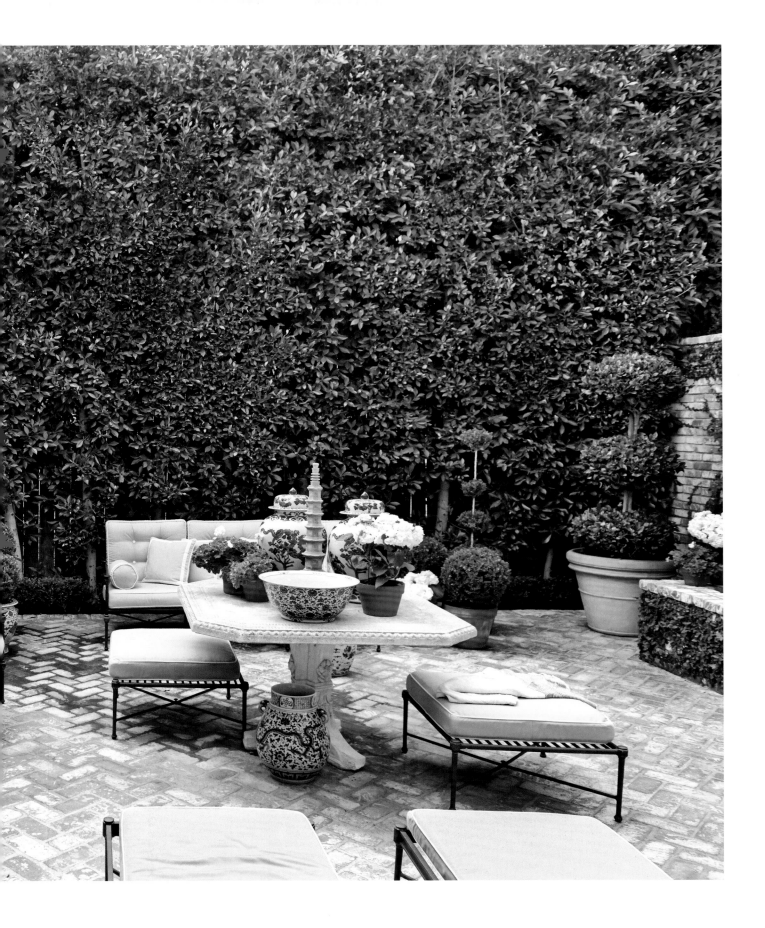

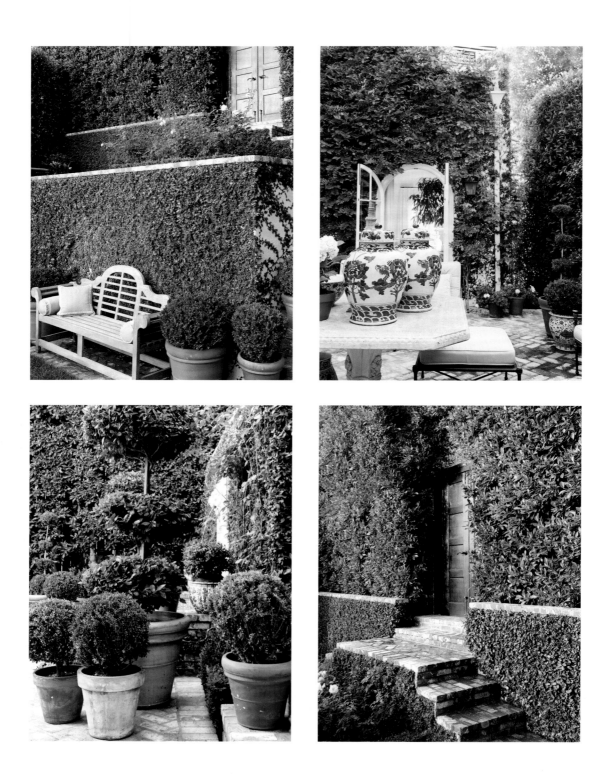

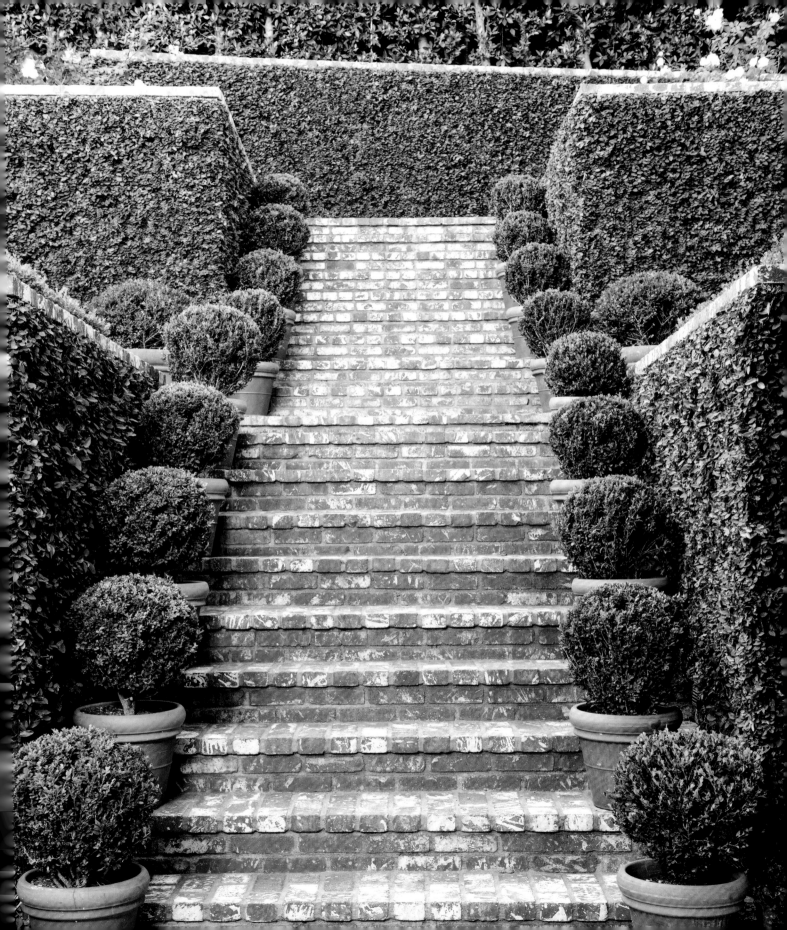

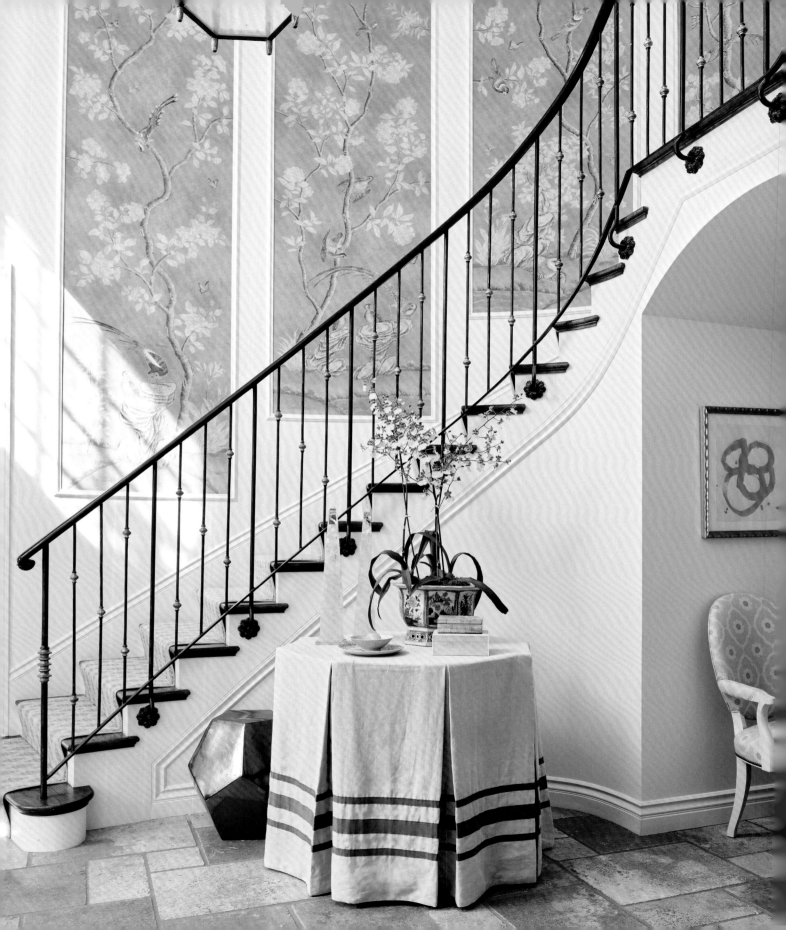

Indeed, any verdant hue—from the palest summery aqua to the most intense garden green—can bring the joyous carefree spirit of nature into a room. I adore simple greenery—ferns, boxwoods, potted herbs, ficus alii, green hydrangea, and myrtle topiaries are the plants I use most often. (I especially love how these plants look when displayed in one of my signature blue-and-white ceramic vases.) Like Mellon and Williams, I often work elements typically found outdoors, such as moss-covered terracotta pots, iron tables, wicker furniture, and lattice-backed chairs, into indoor rooms as a way to evoke the casual elegance of a well-tended garden. Hand-painted wallpaper depicting birds or botanical scenes is another wonderful, whimsical way to bring the outdoors inside, as are textiles printed with branches, blossoms, and other floral motifs.

Another thing I love about garden-inspired decor is how versatile it is—these motifs can be brought into homes of any size or style, and the rooms in this chapter range from a casual family home to a grand Beverly Hills estate from the 1920s. The cheerful, comfortable qualities of gardens enhance the atmosphere of any room, and are one of the very few references that is universally appealing. From pillows in a mix of bright green prints and a sofa covered in garden-inspired chintz in a cozy breakfast nook to framed hand-painted botanical scenes hanging on trellis-inspired wallpaper in a formal entryway, bringing nature indoors has a magical feeling that pairs beautifully with all styles of living.

Because of its strong association with life, renewal, and springtime, green is a happy color that is perfect for any home where you want to welcome the outdoors in.

Garden-inspired chinoiserie panels greet guests in the entryway of a Pacific Palisades home. The table skirted in pale blue with olive trim brings together the colors of the outdoors. FOLLOWING: Sky and garden meet again in the dining room, where a gentle blue geometric fabric on the walls contrasts with pale blue-green paint on the woodwork. PAGE 104: Blue-and-white ceramics and a bright patterned cushion brings just-bold-enough accents to an heirloom neoclassical Federal console. PAGE 105: Bamboo shades, lively textiles, and a dramatic chandelier by John Roselli Antiques add playfulness to formal dining.

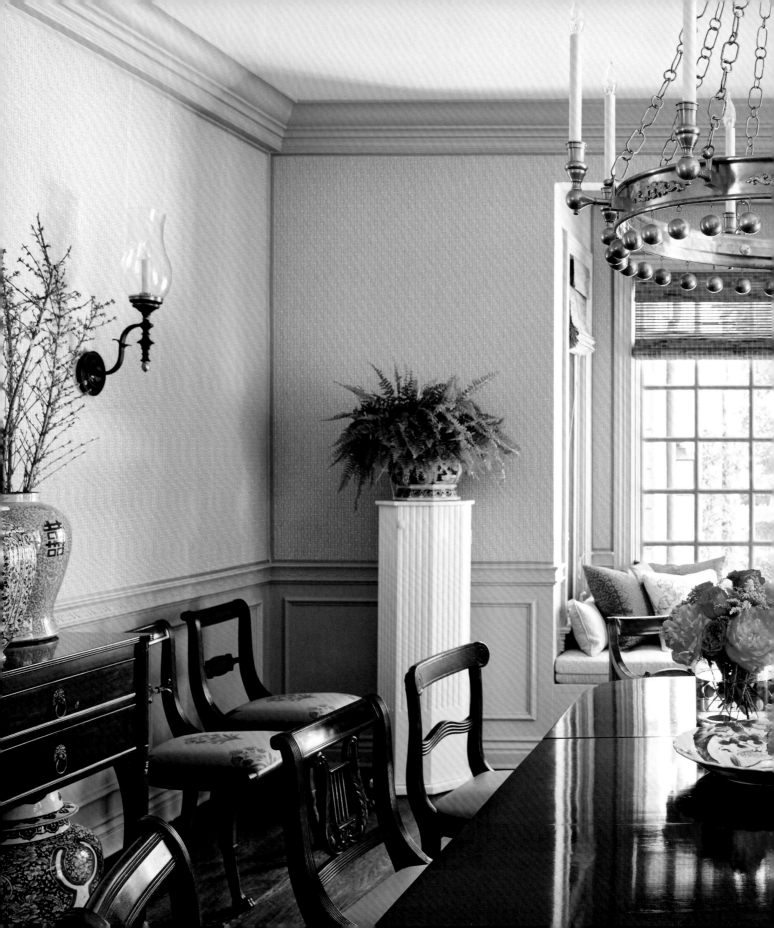

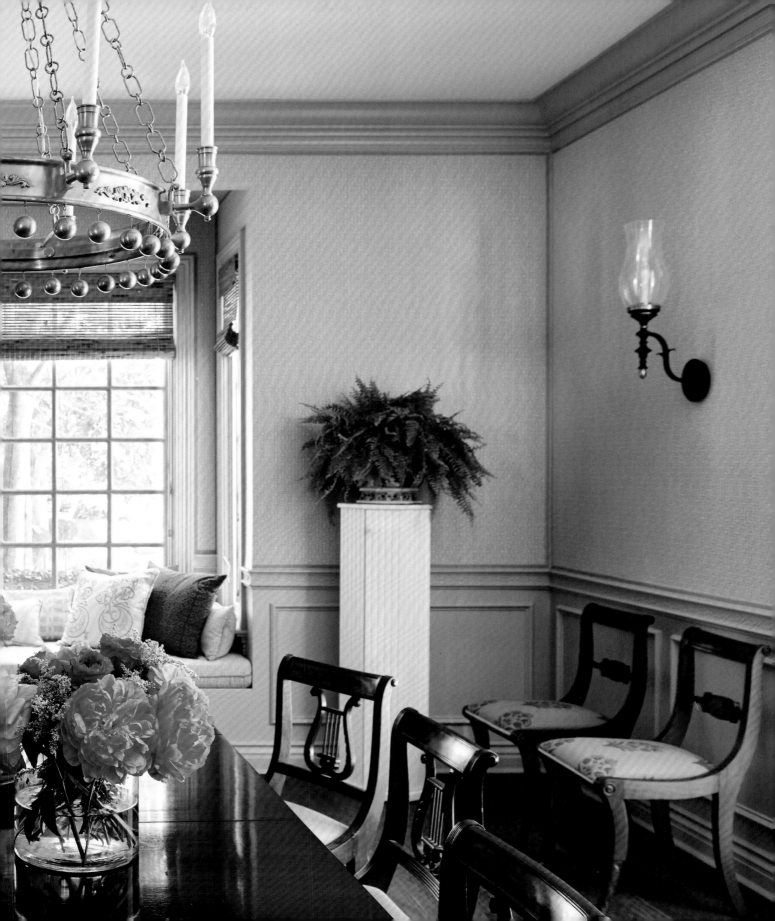

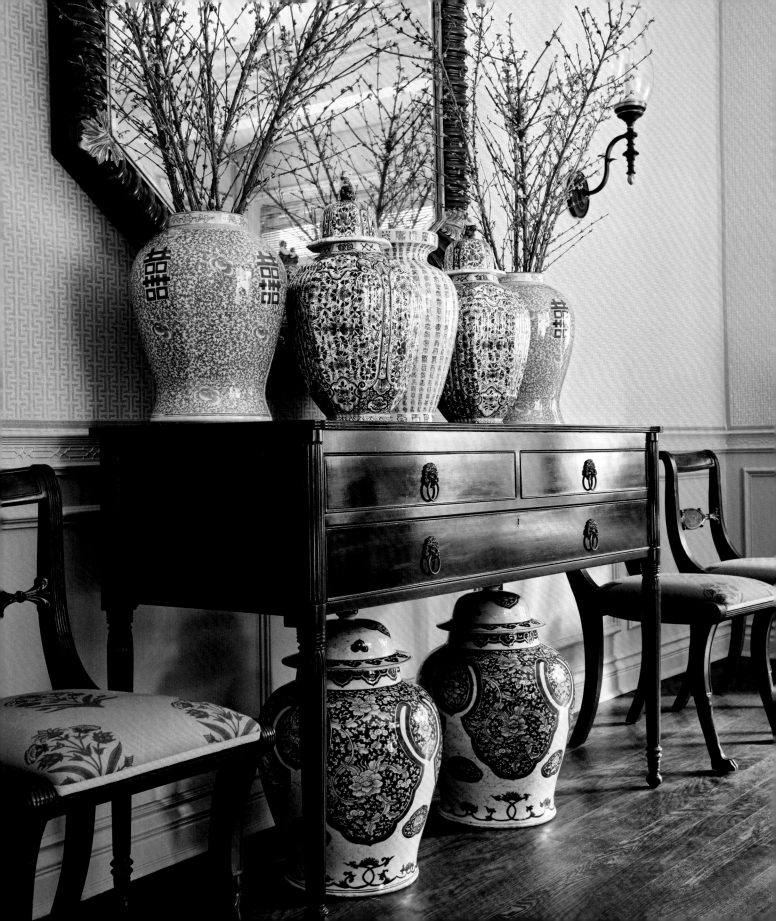

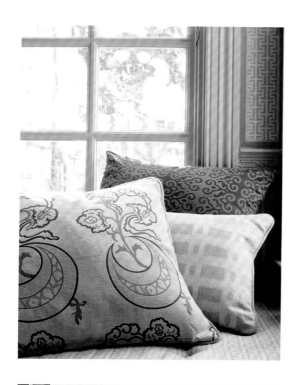

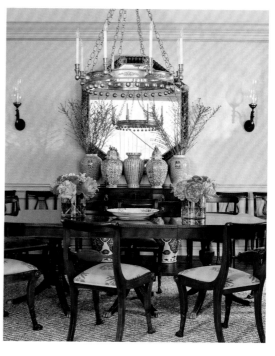

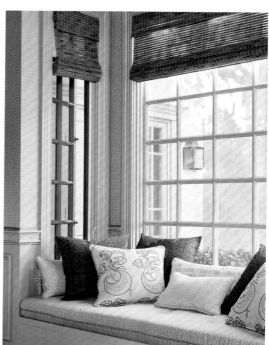

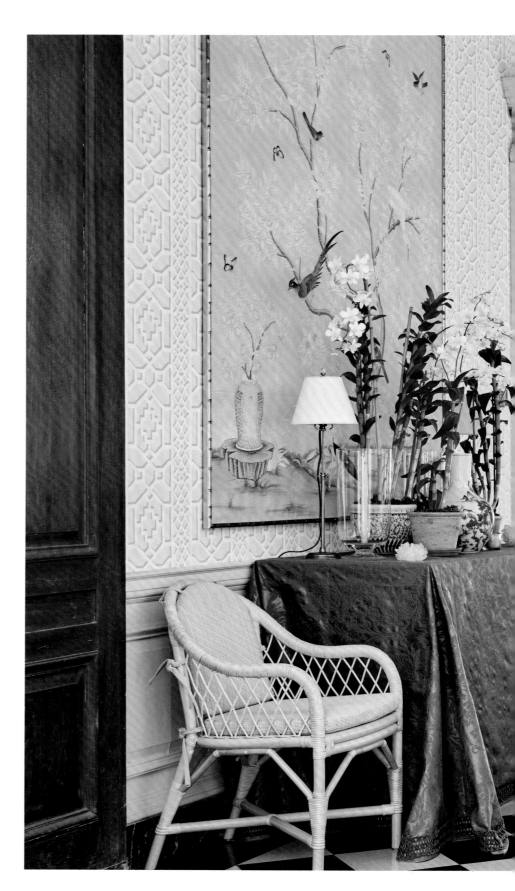

The grand hall in a Beverly
Hills estate feels less
intimidating with the
additions of wicker,
chinoiserie panels, and
green wool damask.
The chinoiserie panels are
framed in gold bamboo.
Potted plants, garden stools,
lattice wallpaper that
recalls ivy-covered garden
walls, and blue-and-green
chintz upholstery bring
in the world of the garden.

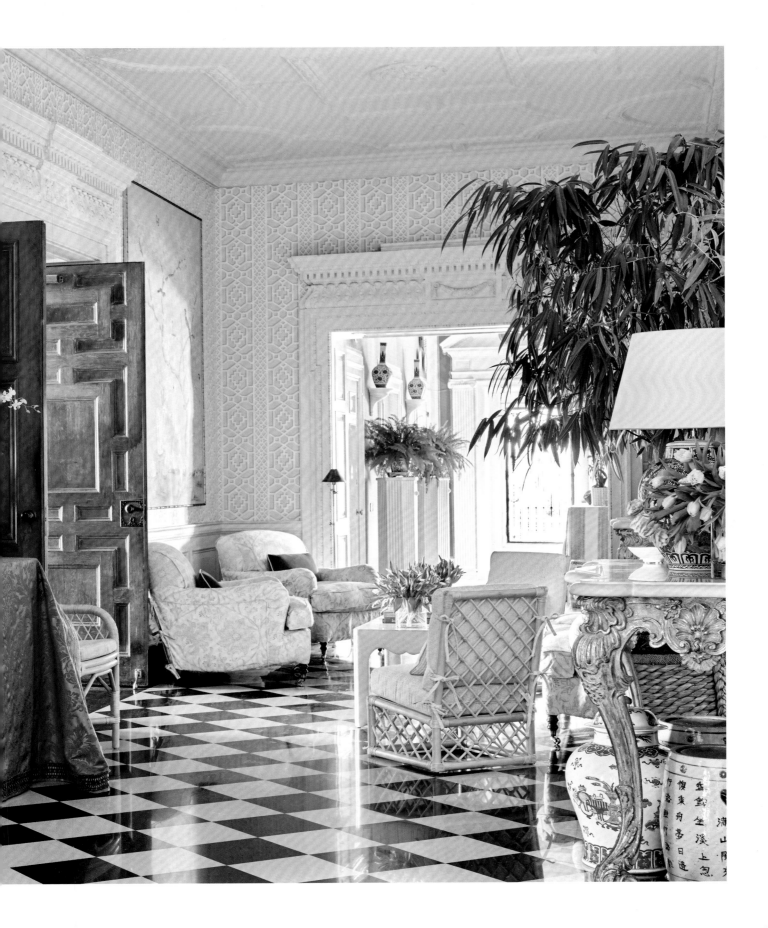

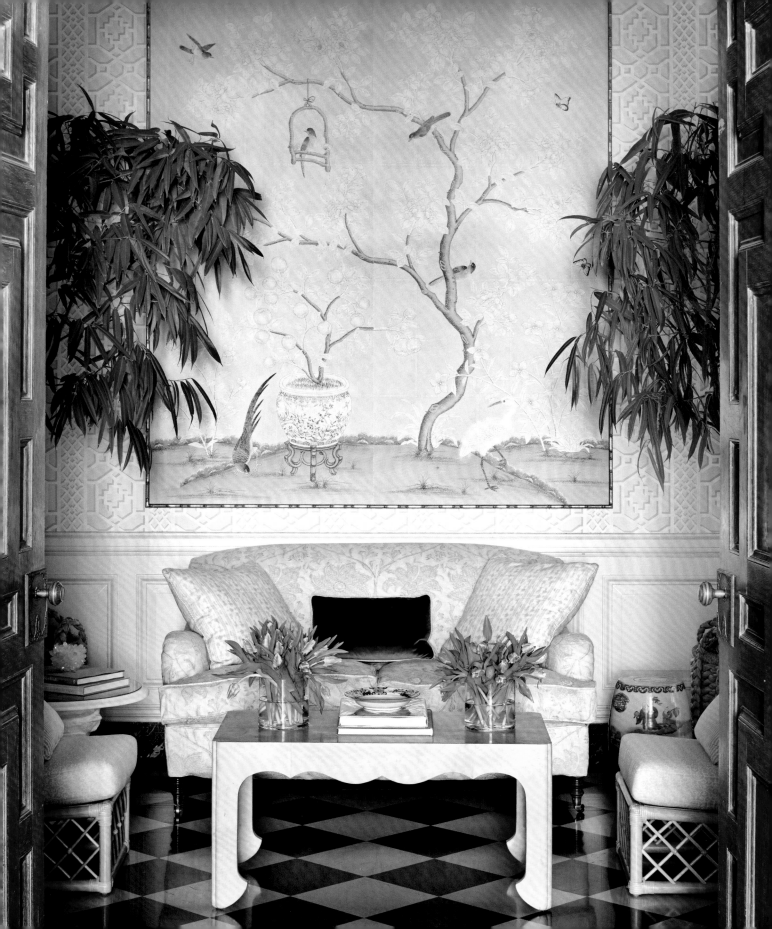

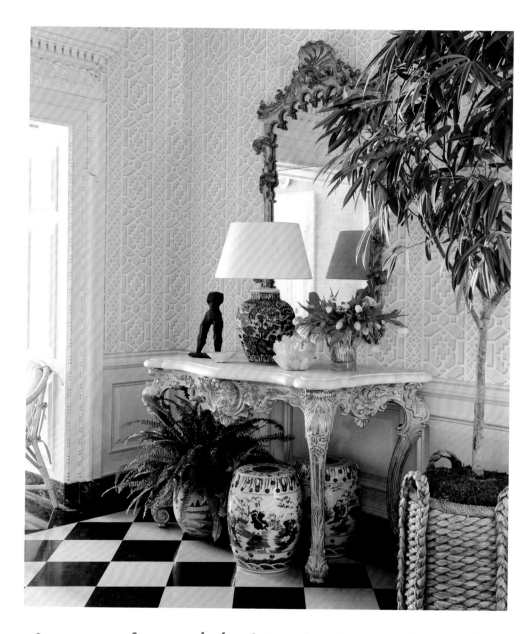

A parchment table by Jean-Michel

Frank (left). ABOVE: Lattice wallpaper creates a garden-like backdrop for the ornate console and mirror. FOLLOWING, LEFT: Blue and white stand out in a sea of green. FOLLOWING, RIGHT: Kelly green fabric wallcovering contrasts with white molding and pedestals. An ironwork door recalls a garden gate. PAGES 112-113: A verdant palette and potted trees blur the boundary between outdoors and in.

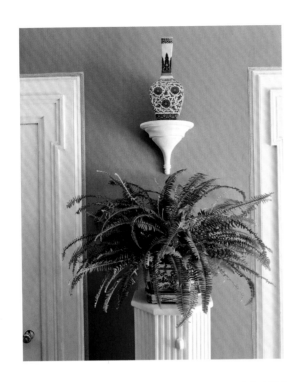

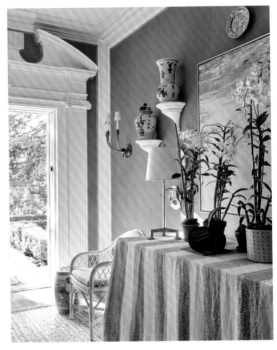

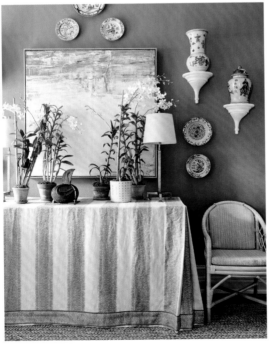

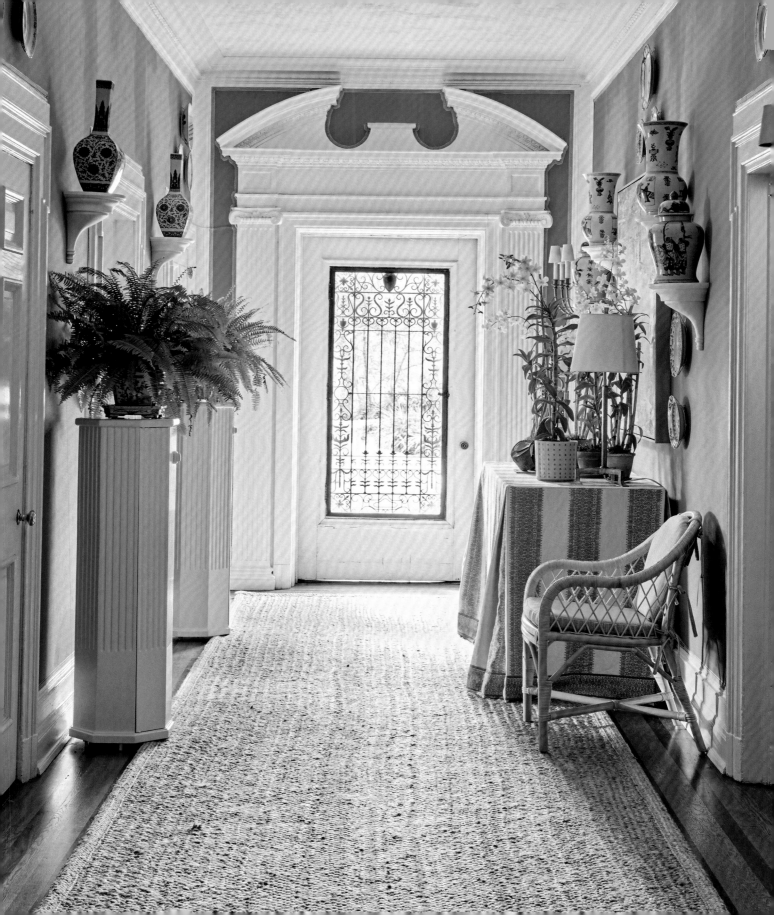

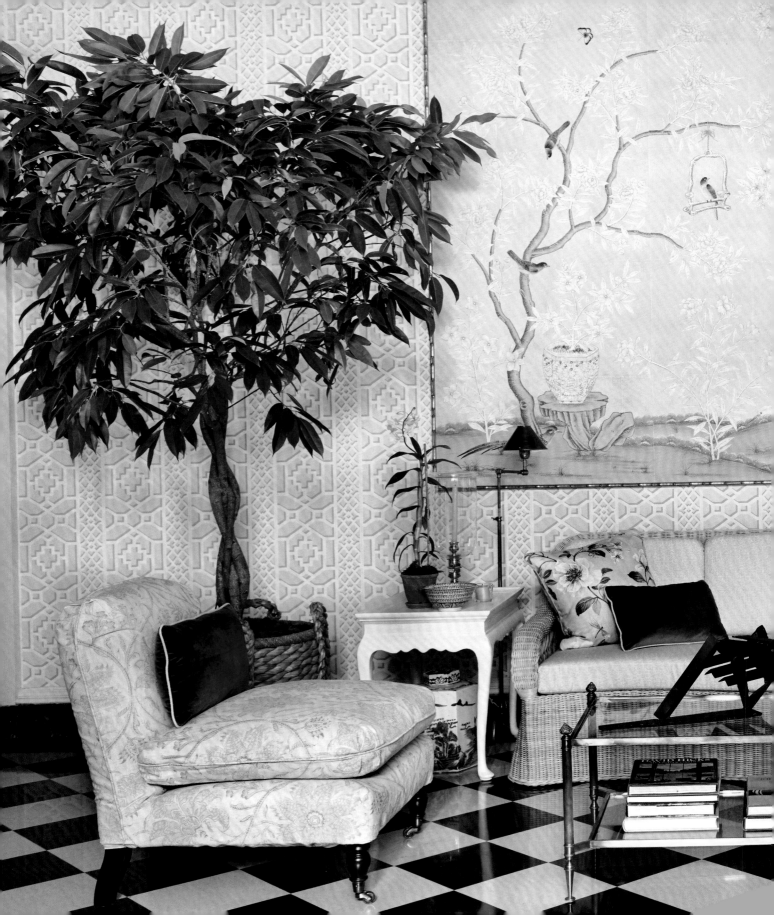

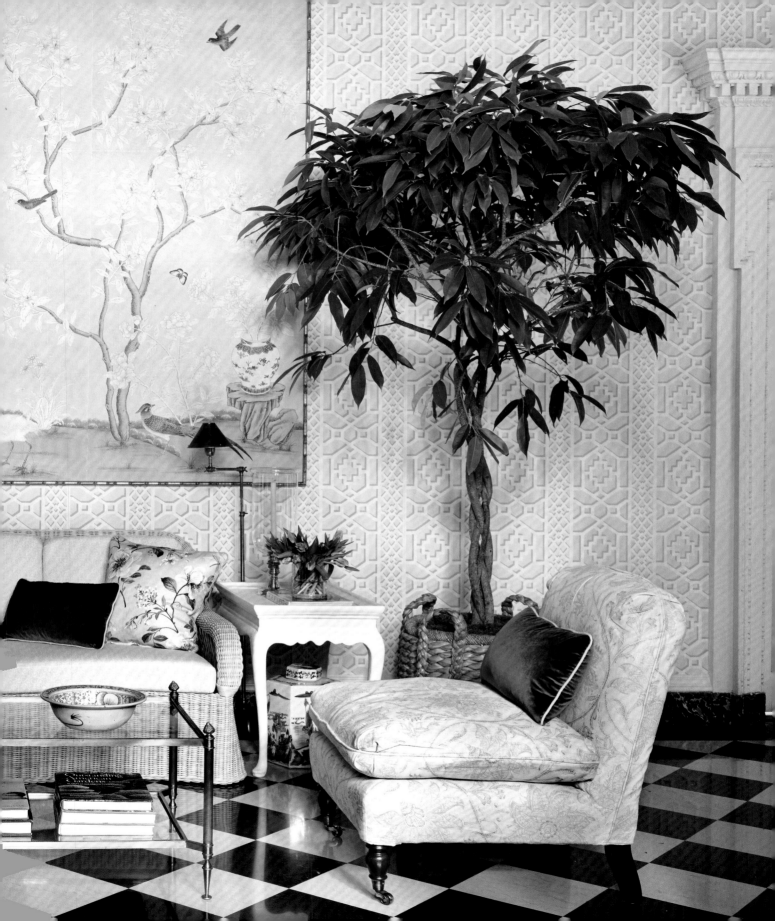

ALWAYS BLUE
ROOMS FOR THE GOOD LIFE

At the end of his career, Cary Grant was once asked who his favorite on-screen costar had been. He named Grace Kelly because, as he put it, "She had serenity." Personally, I think Grace Kelly is the most beautiful woman who ever lived; her porcelain skin, delicate features, and ladylike elegance will forever be admired and remembered. I like to imagine an alternative universe where Grace ended up in a beautiful Paul Williams estate in Bel Air, living a serene and genteel life surrounded by gentle color and elegant decor. I envision her in a wood-paneled sitting room with lots of bookshelves, lounging on an ivory tufted chaise with matching silk bullion fringe, answering correspondence on monogrammed stationary, dressed in a custom-made blue button-down shirt and, of course, pearls. Later she would receive guests in a bright, high-ceilinged living room with grand columns and lots of lacquered moldings. Clad in ivory wide-legged trousers and crocodile loafers, Grace would serve tea from a china-blue French settee, the afternoon sunlight filtering gently through gathered silk curtains dripping with tassels and trims.

The spirit of Grace is the main inspiration for the rooms in this chapter. I can easily imagine her in any of these spaces, living elegantly and peacefully within their soft, simple beauty. All have a feminine quality and are even a bit regal, full of Deco influences and unapologetically pretty touches. I love to fill these creamy and airy spaces with lots of glass and even more gilt. There's little color beyond soft blue and ivory, with the exceptions of pale pink flowers and cherry blossom branches, leafy green

A regal skirted table is the focal point of this elegant Pacific Palisades living room. The black lacquer of the door and Chinese armoire add depth. FOLLOWING, LEFT: A beautiful console with a plaster branch-and-flowers base holds an antique urn, a delicate bone box, and an ivory-colored Chinese bowl. FOLLOWING, RIGHT: The range of beautiful blues in this room connects it to the sky, as do the undressed windows that open to a sunny terrace.

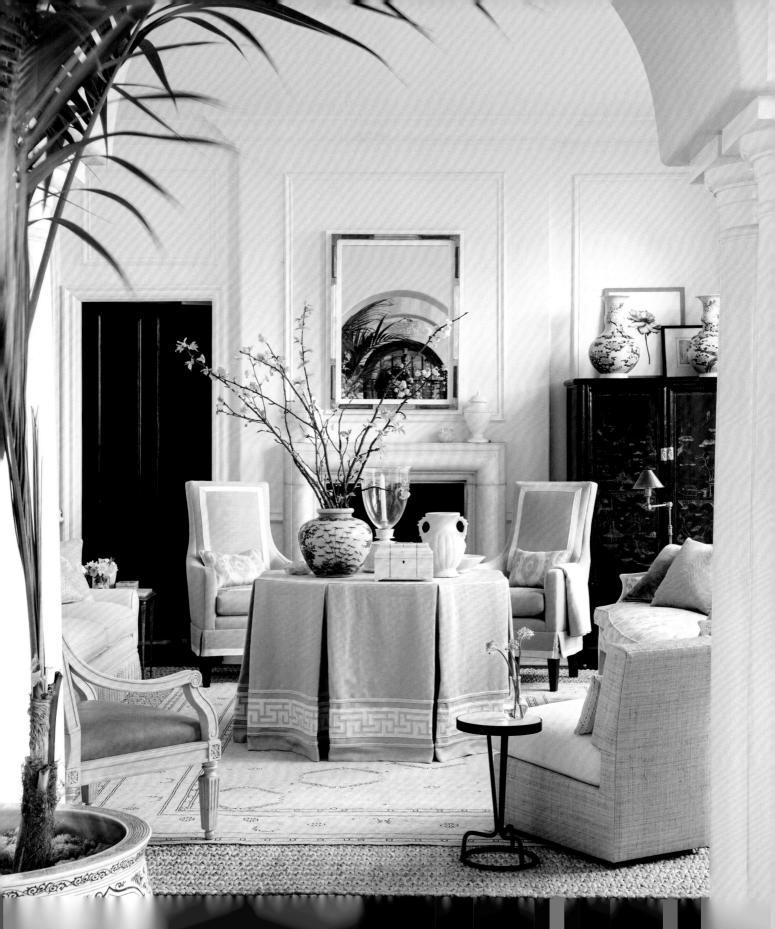

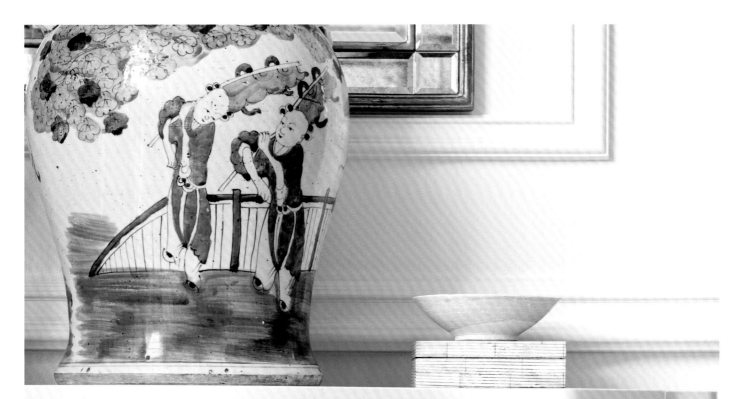

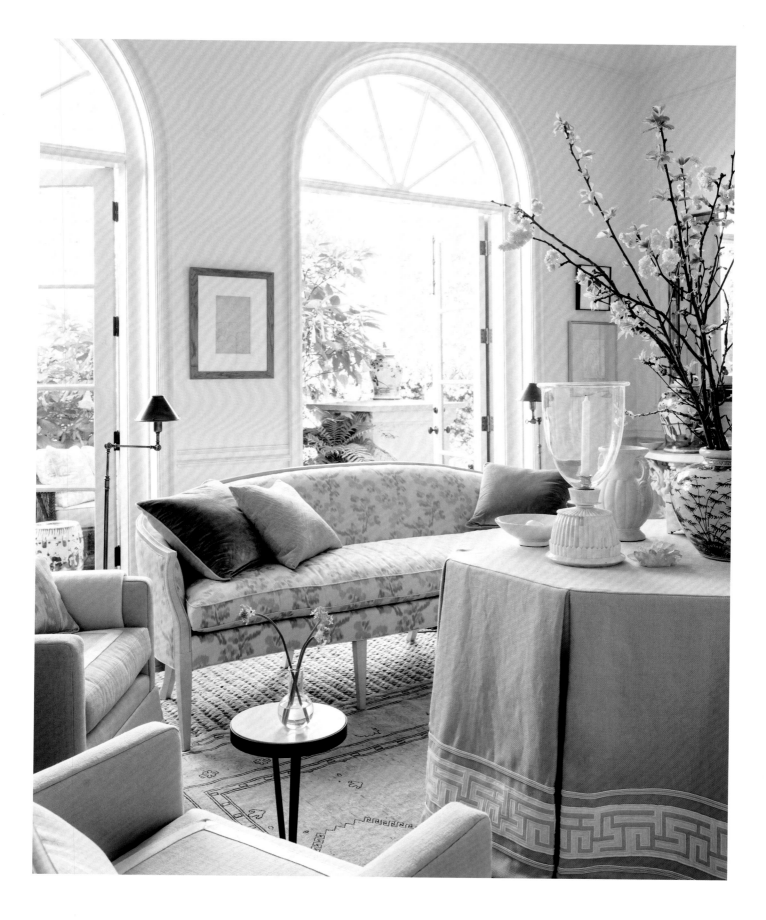

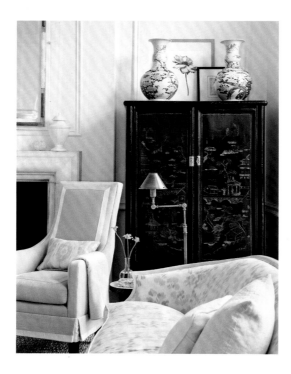

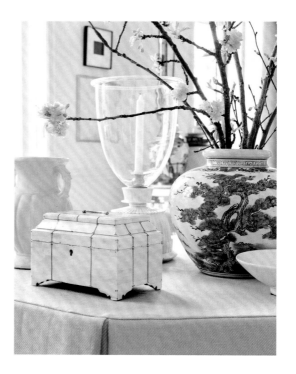

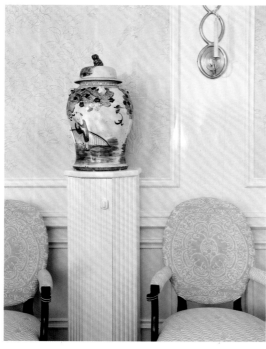

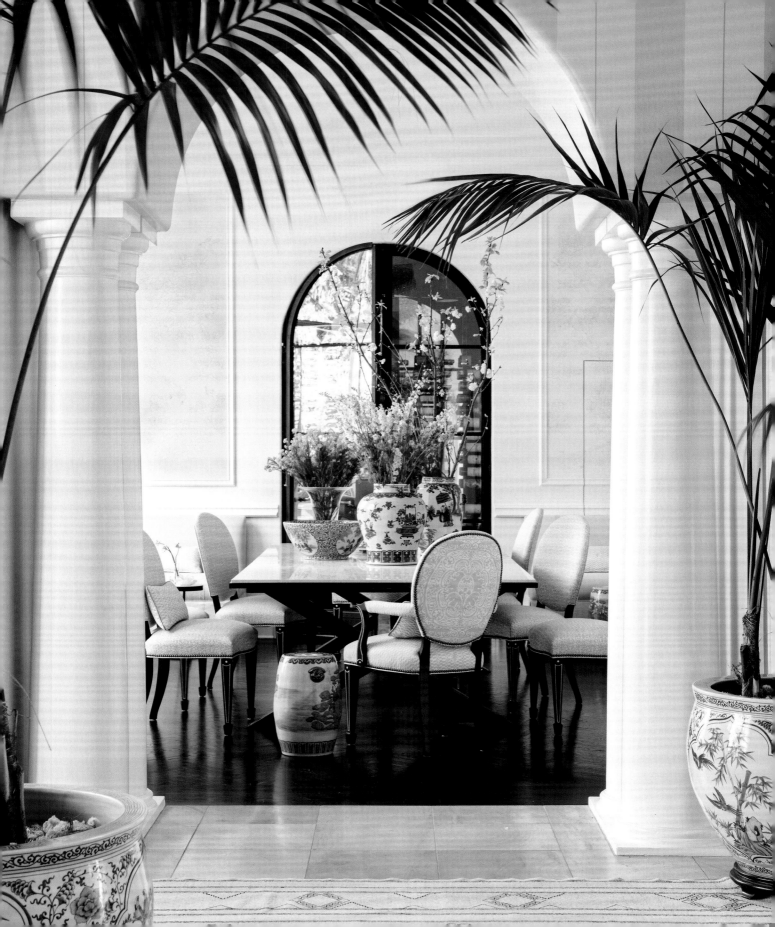

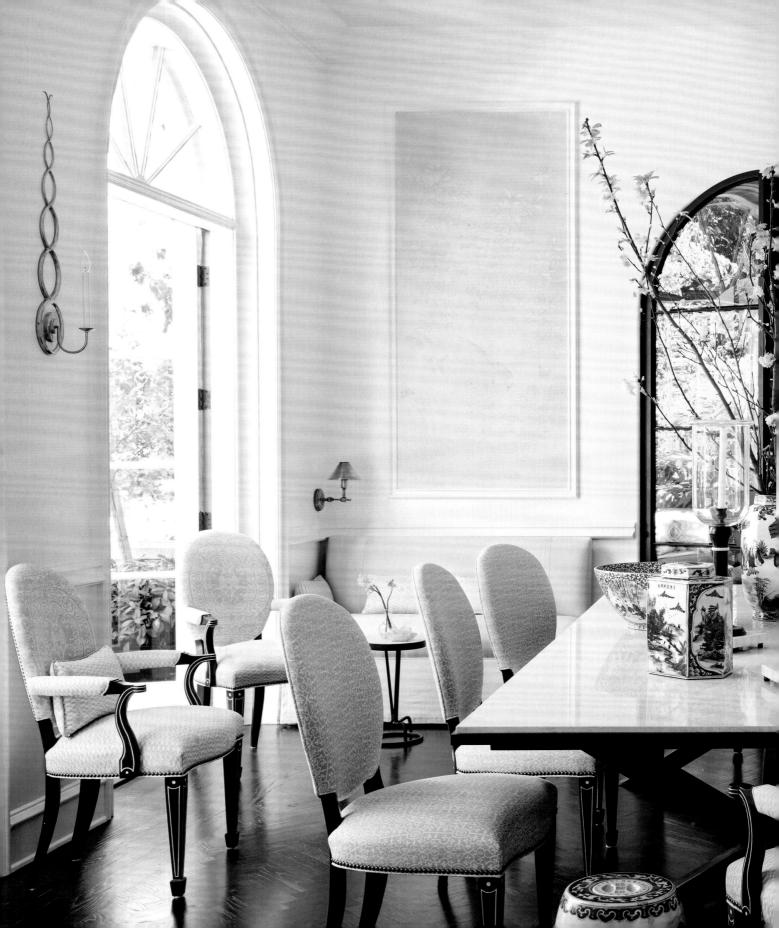

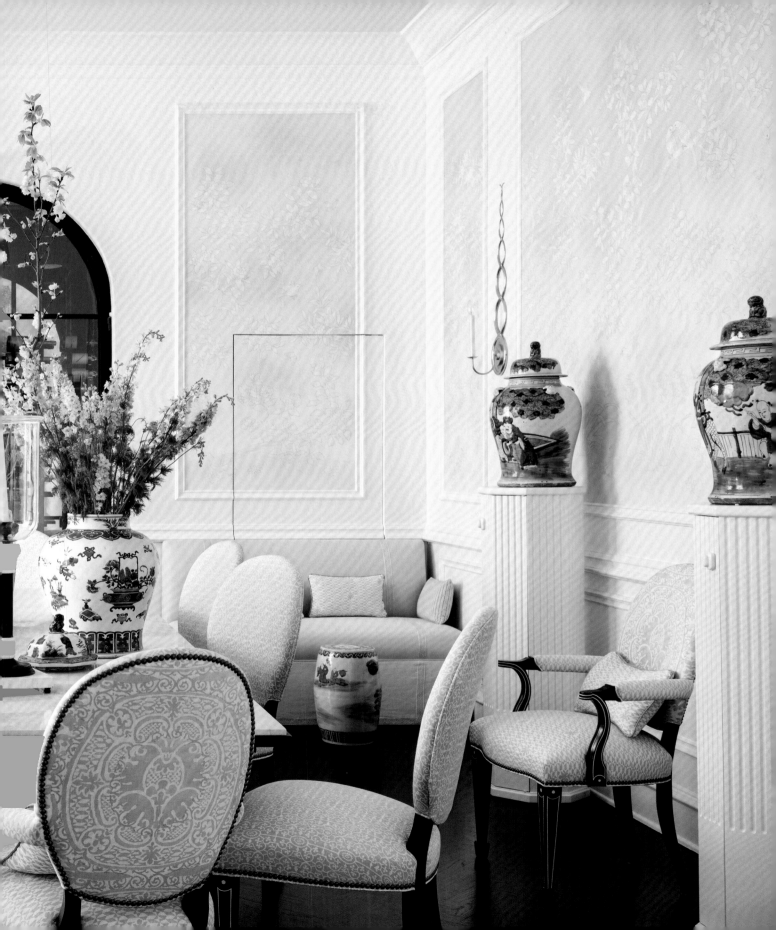

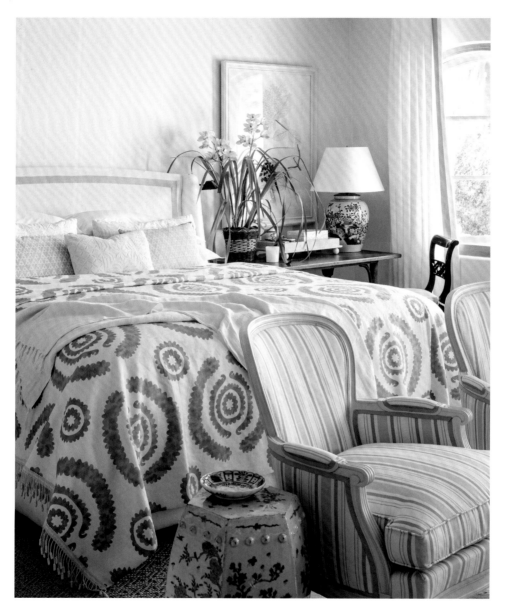

The master bedroom of a beach

house reflects the blues of the ocean (above). OPPOSITE: Soft blue and ivory on the seating contrast with the slightly bolder dhurrie rug. PREVIOUS: Pale blue and white give the formal rooms of the house a breath of fresh air. PAGES 122-123: An army of dining chairs and blue silk-trimmed banquettes are ready for an influx of guests.

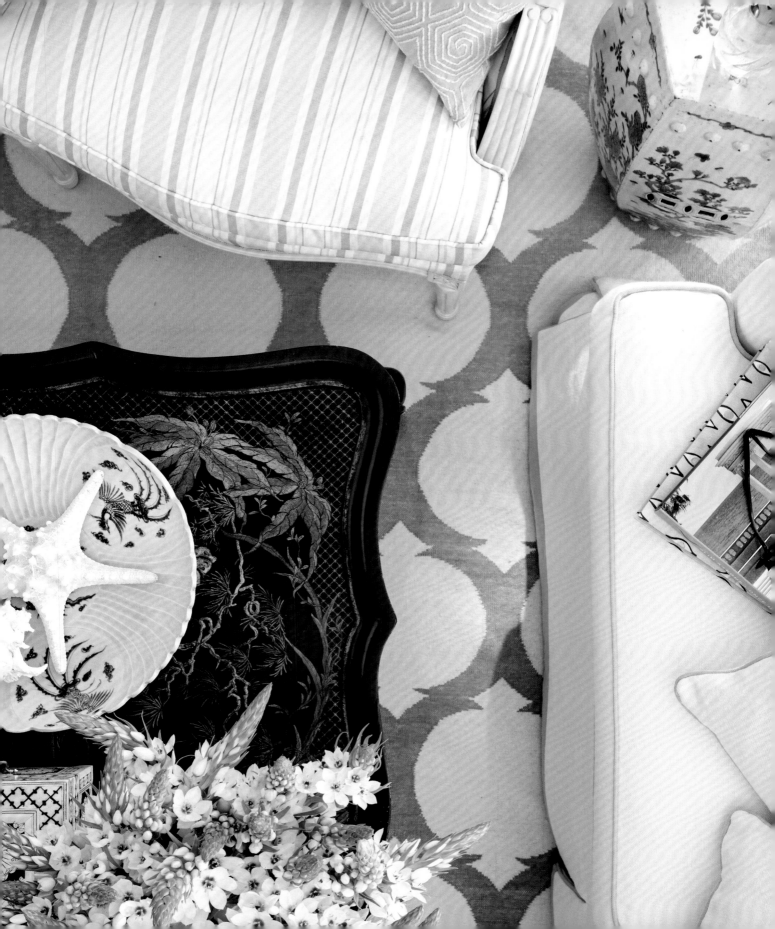

An en-suite sitting area is the perfect place to read, relax, and take in the ocean view. The loveseat and curtains are solid ivory with a simple blue inset, which provides a break from the stripes and patterns elsewhere in the room. Pieces of white coral on the bookshelves allude to the seaside, while black accents from the lampshades, mirror frame, chinoiserie coffee table, and window bench anchor the light, beachy look.

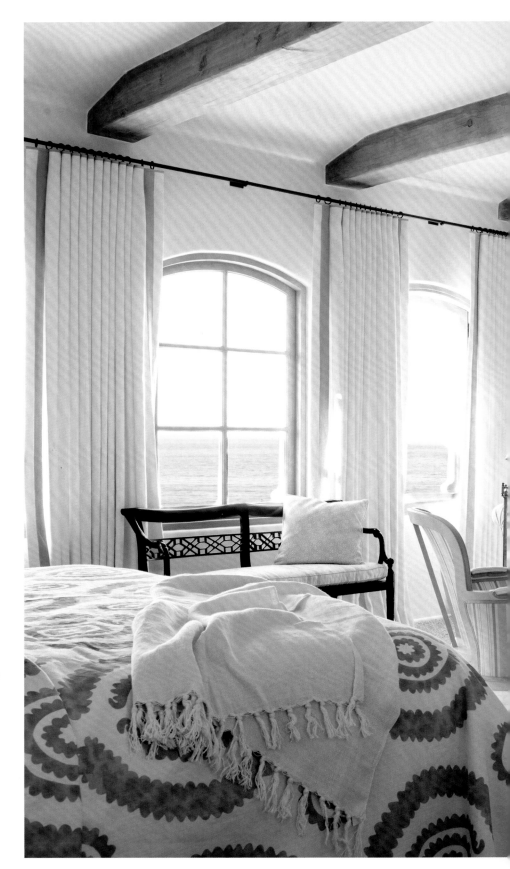

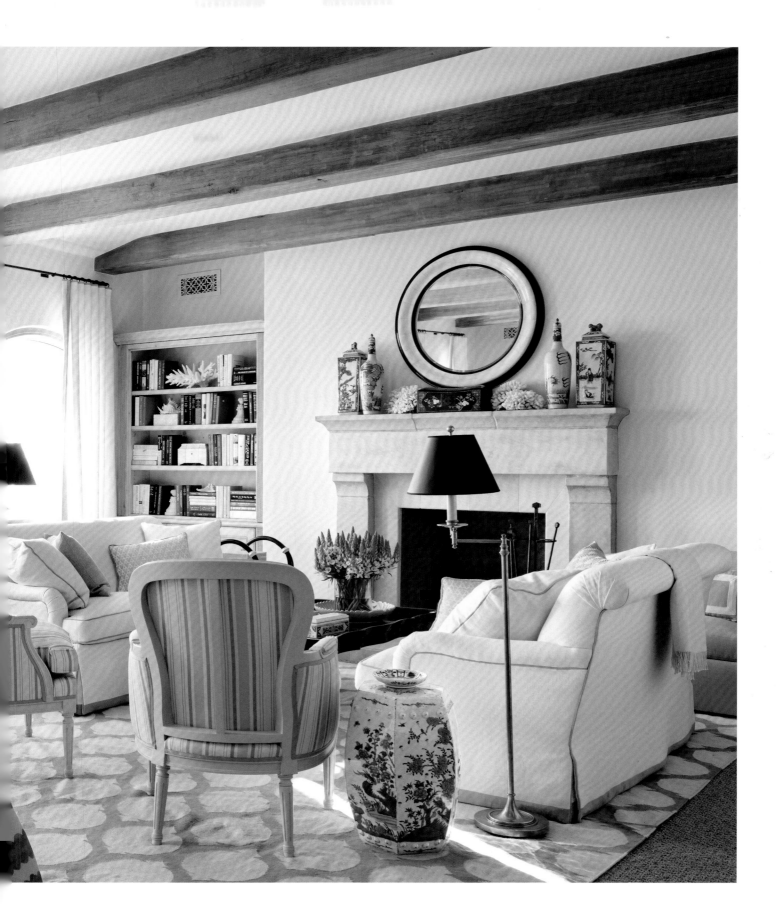

palms, and black accents here and there. There's also Gracie chinoiserie wallpaper, hand-painted with scenes of blue skies with birds perched on gentle flowering branches, shagreen boxes and trays, plaster tables, Venetian mirrors, antique Samarkand rugs layered on marble floors, crystal chandeliers, and plenty of white accessories, including ivory vases in all shapes and sizes, bone boxes, and stone busts.

The furniture in these rooms upholds the mandate of elegant comfort. To convey a sense of luxe in living spaces, I often use banquettes, swing-arm reading lights with pleated silk shades, tufted ottomans, and skirted tables. Bullion and tassel trims give just the right amount of shimmer and movement, adding intrigue without overwhelming the serene mood. In the master bedrooms and guest suites, adjacent to luxurious canopy beds, I add loveseats, Galerie des Lampes floor lights, cashmere throws, and comfortable chairs upholstered in subtle blue prints, so that the bedrooms feel like spots to linger in, and can be used all day long. I think of many of these rooms as "afternoon places," perfect for receiving phone calls or getting caught up on books and magazines. They are spaces that invite leisure and use luxurious materials to make people feel welcome, rather than to appear ostentatious.

High Society, Grace Kelly's final film appearance before becoming princess of Monaco, is set in the summertime domiciles of the well-heeled East Coast Establishment, and its well-heeled but welcoming lifestyle is the spirit that I try to bring into these rooms. Whether it's a Newport mansion or a Bel Air estate, the sun is always shining, the doors are always open, there's always a pool in back, and no one is ever far from a cool drink or a banquette to relax upon—that is what I call "the good life." It's a formula that never goes out of style, especially when it includes endless blue.

Bedroom sitting areas are some of my favorite spaces to create—they add everyday comfort and luxury. Here, an intricately patterned antique rug is the focal point in a room with an otherwise clean look. The coffee table of glass and parchment feels lighter than most, giving the room a modern elegance.

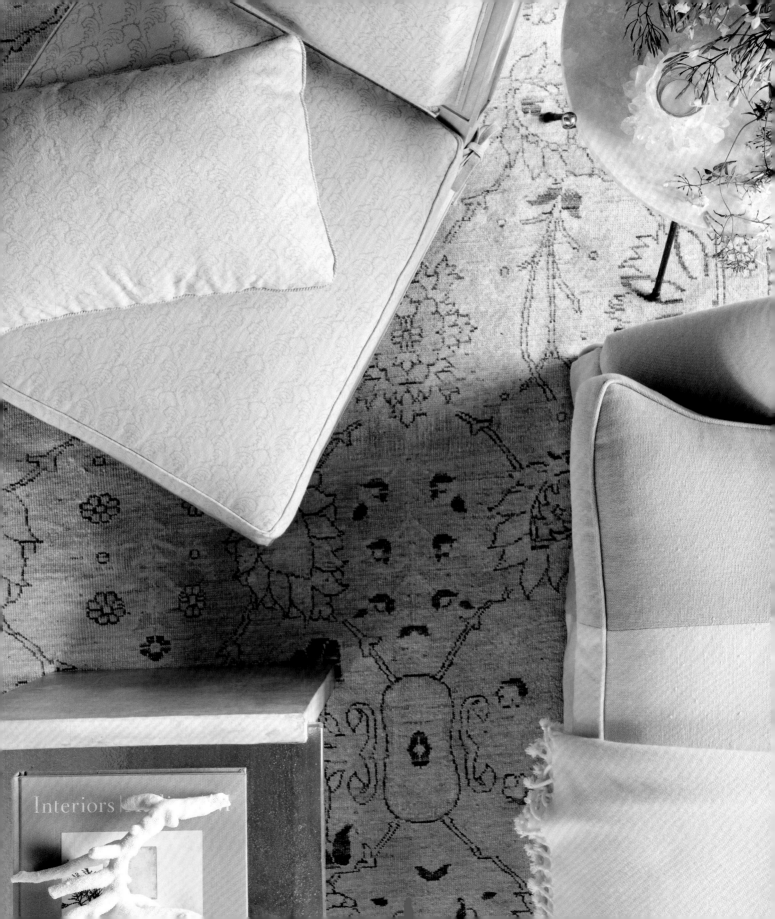

Interiors

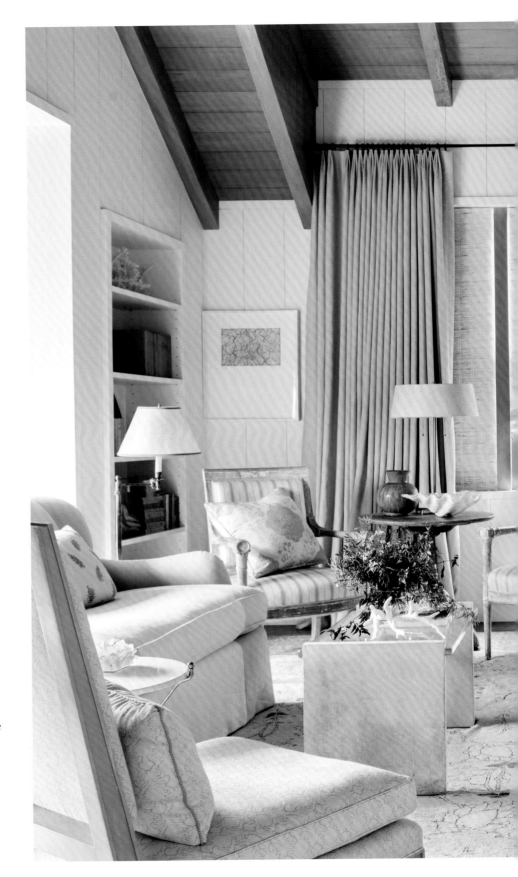

In this master bedroom, soft blue dominates subtly, with cream playing a supporting role. Blue even pops up in some unexpected places, like the frames of the painted-wood slipper chair in the foreground and the pale blue ceramic base of a bedside lamp. Bamboo shades and a wood ceiling provide beautiful counterpoints.

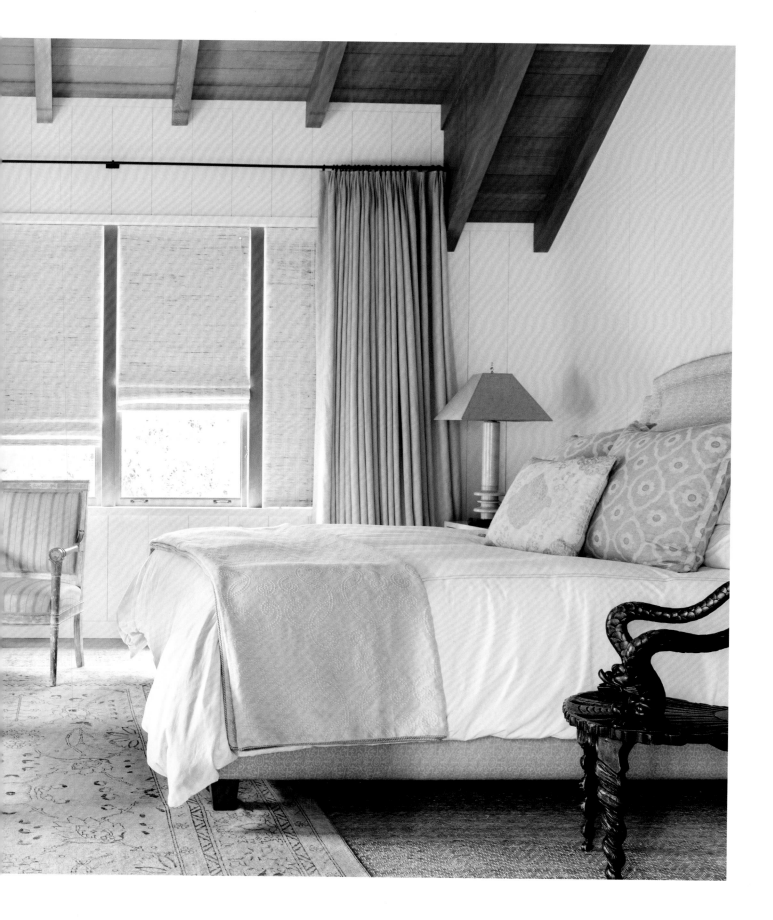

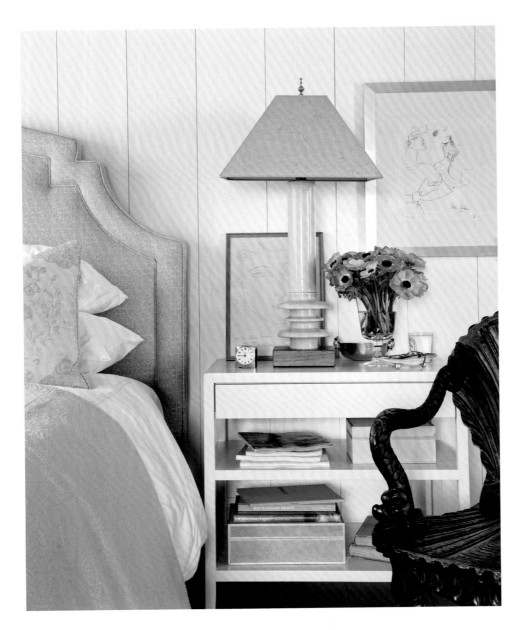

The antique chair carved like a
shell adds boldness to the soft palette (above). OPPOSITE: A glamorous eighteenth-century Italian gilt console dazzles against a bedroom's pale blue walls. FOLLOWING, LEFT: The walls, curtains, and sofa in the sitting room of a Pacific Palisades master bedroom are all upholstered in the same pale-blue-and-ivory print, with a coordinating skirted table and upholstered wicker chair.

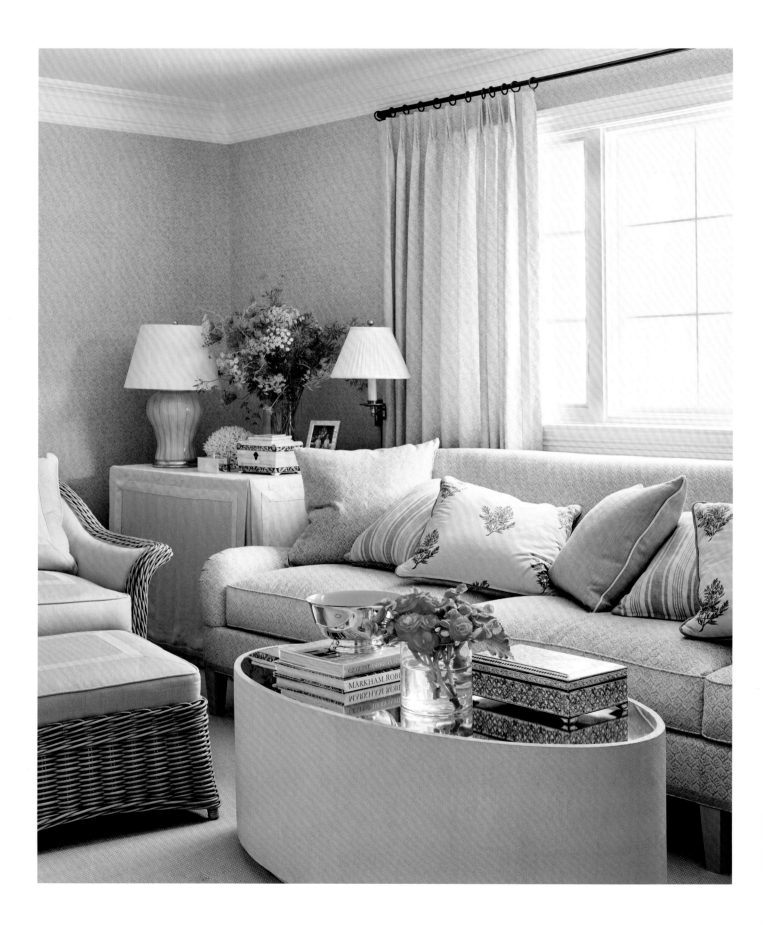

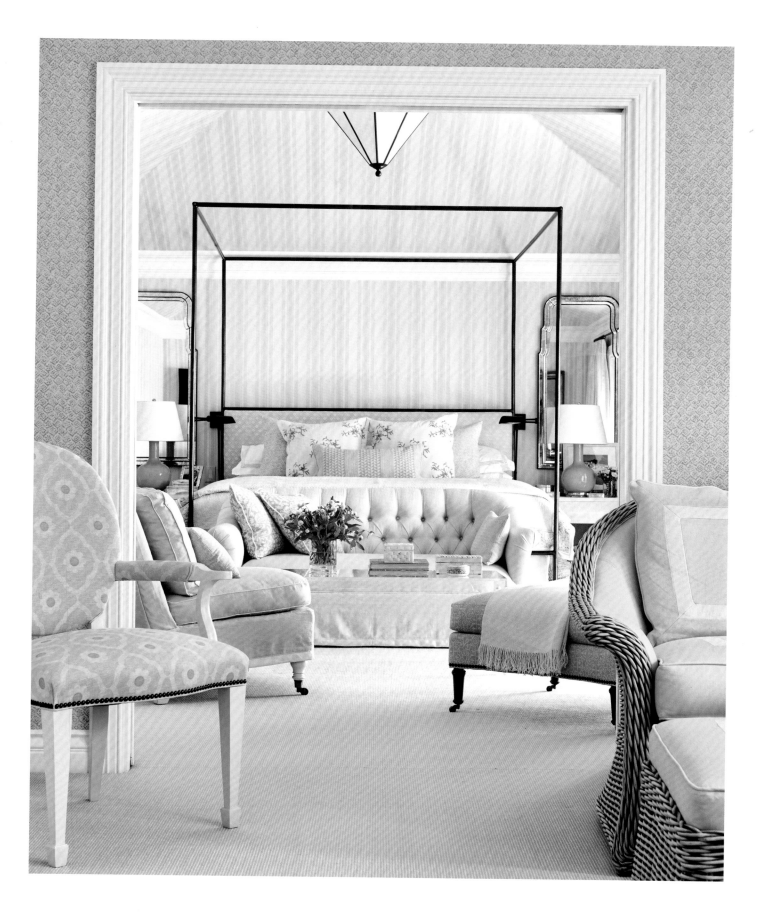

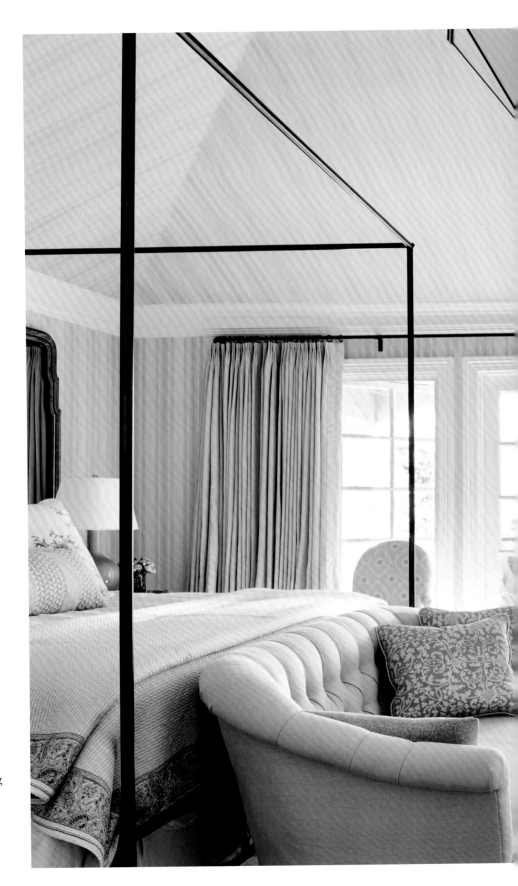

A tufted loveseat, a canopy bed, and a few touches of pink from the textiles, flowers, and artwork add femininity to the bedroom. The discreet Lucite coffee table seems to float amid the pieces of pale blue furniture. PREVIOUS, RIGHT: The master bedroom as seen from the sitting room. The blue-and-ivory striped wallpaper that runs along the walls and vaulted ceiling makes the room feel tented.

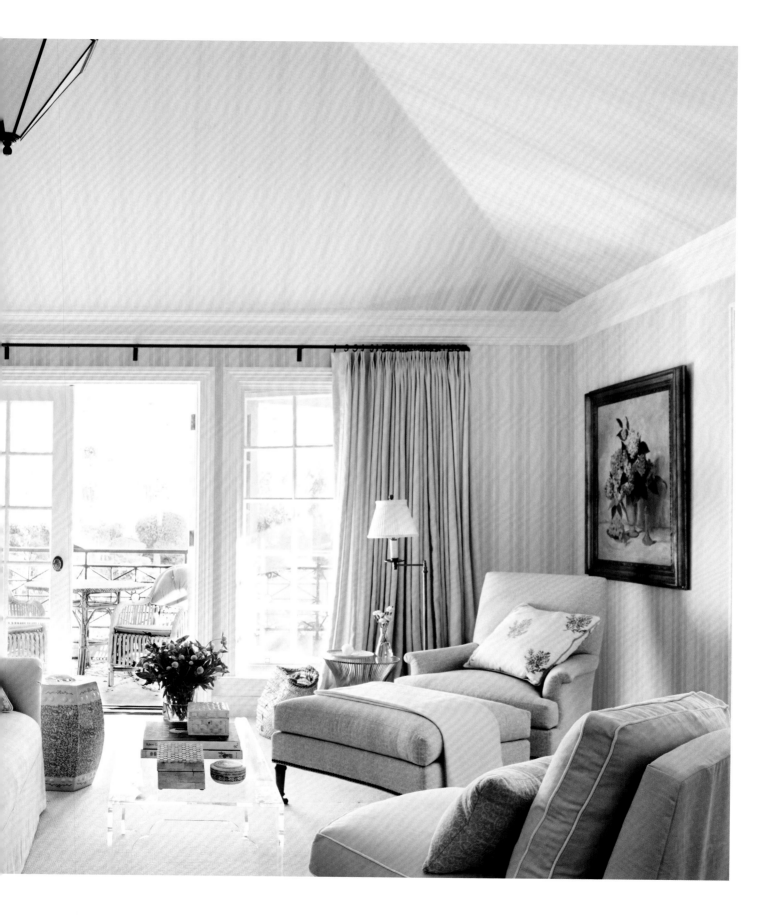

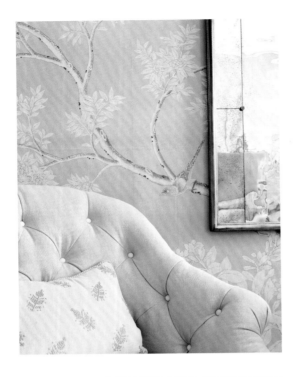 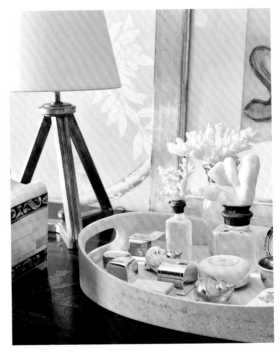

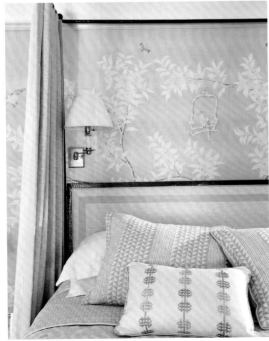 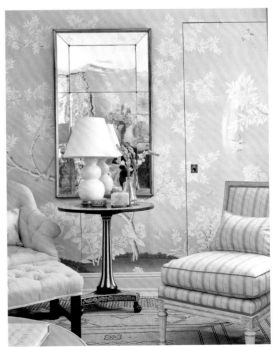

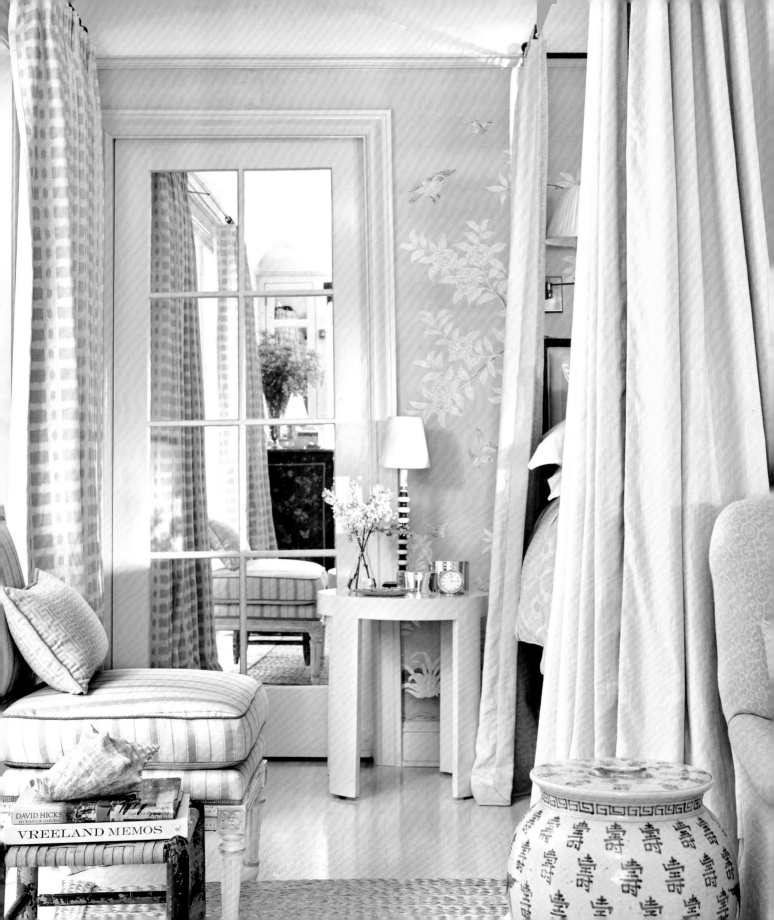

The ivory-painted
Chippendale side chair and
leather ottoman with silk
bullion fringe enhance the
elegance of this Hollywood
Hills bedroom. PREVIOUS,
LEFT, CLOCKWISE FROM TOP
LEFT: The boudoir pillow on
the lounge chair is
embroidered with blue
leaves. A shagreen tray
holds a collection of silver
pillboxes. The closet door is
concealed by Gracie
chinoiserie wallpaper. Blue
and ivory surround a
canopy bed. PREVIOUS,
RIGHT: A mirror-paneled
pocket door reflects blue
and ivory fabrics. The
antique parchment side
table is French Deco.

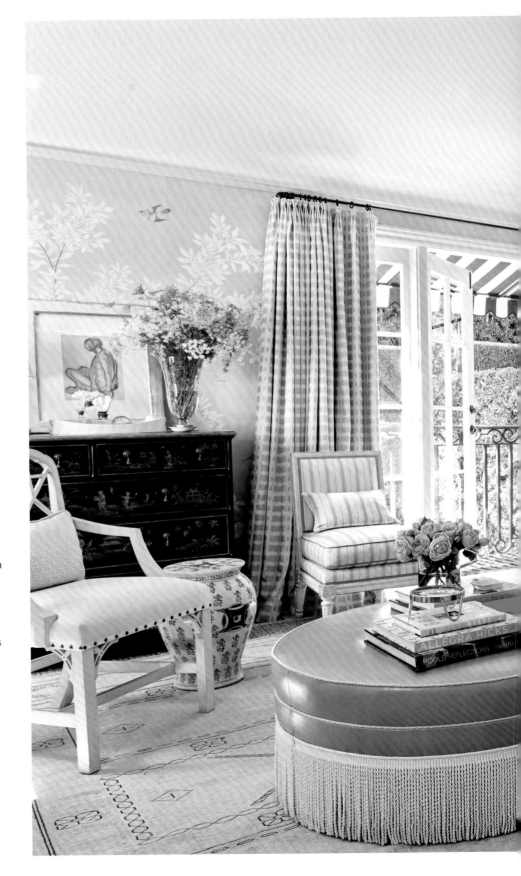

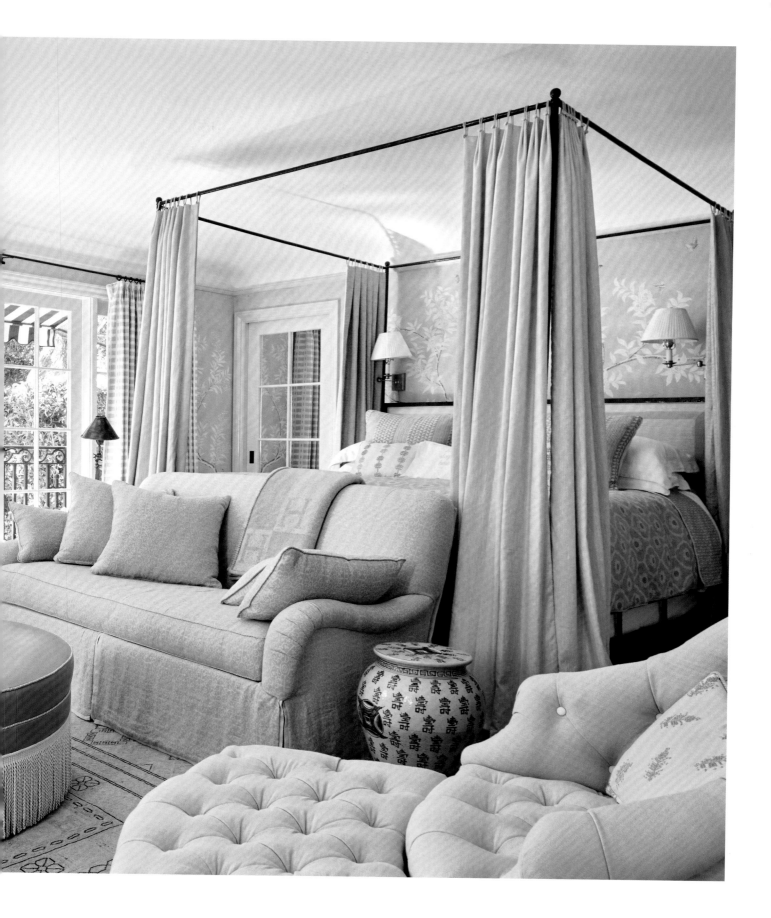

NATURAL TERRITORY
THE STYLE OF ADVENTURE

*O*ut of Africa is my favorite movie of all time, and its setting—the rugged landscape, airy lodges, and the layered interiors—as well as the chic but utilitarian clothes the characters wear (safari shirts, straw hats, and loose jodhpurs held up with saddle-brown leather belts) have been an inspiration since I first saw the film. The colors, textures, and natural wonders of Africa—also portrayed beautifully in the work of Peter Beard, one of my favorite photographers—have given me some of my most beloved design signatures, like nubby natural-fiber rugs, straw baskets, neutral batik prints, boxes made of tortoiseshell, quill, and wood, and palms and other plants that bring nature inside. Drawn together and set against a simple palette of tan, ivory, cream, and chocolate brown, these elements create rooms with a sexy breeziness and a sense of escape, rooted in natural beauty.

The lifestyle of the film is also an inspiration. It is exotic and adventurous, but also romantic, and its mix of adventure and serenity drives the decor in this chapter. These rooms are casual, airy, and peaceful, spaces that invite you to relax and recharge with the windows open to welcome the breeze. Instead of silks and French chairs, they are outfitted in linen and rattan; in place of black lacquer and patterned fabric wallcoverings and draperies, there are white walls and bamboo

A straw hat on a striped banquette
suggests adventure and exploration. FOLLOWING: In a Pacific Palisades library, deep chocolate-brown walls provide a dramatic backdrop for a room filled with adventure-inspired decor. PAGE 148: Paisley medallion, rattan, and tortoise come together beautifully over a striped dhurrie rug. The fabric on the spool chair is a Carolina Irving batik. PAGE 149: Simple abstract prints stand out on rich brown walls.

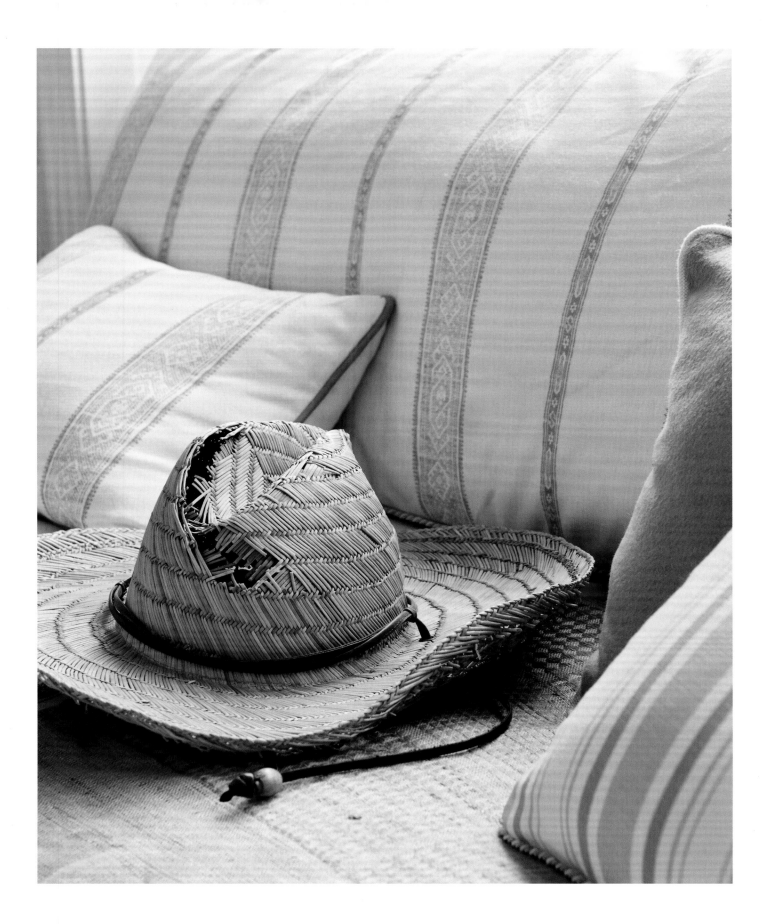

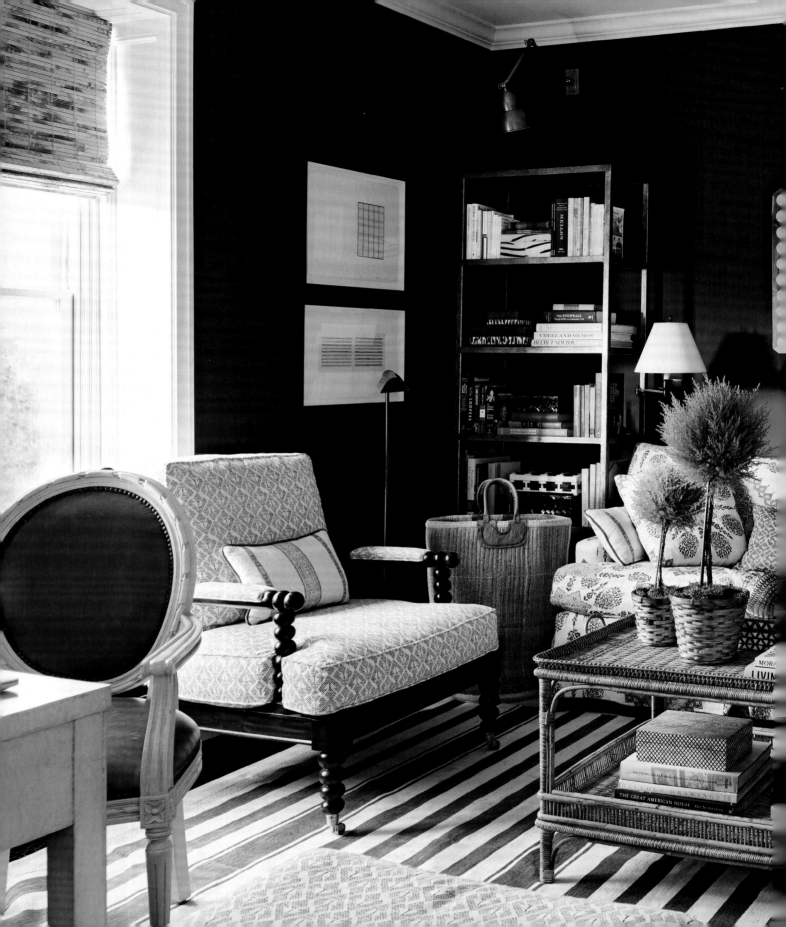

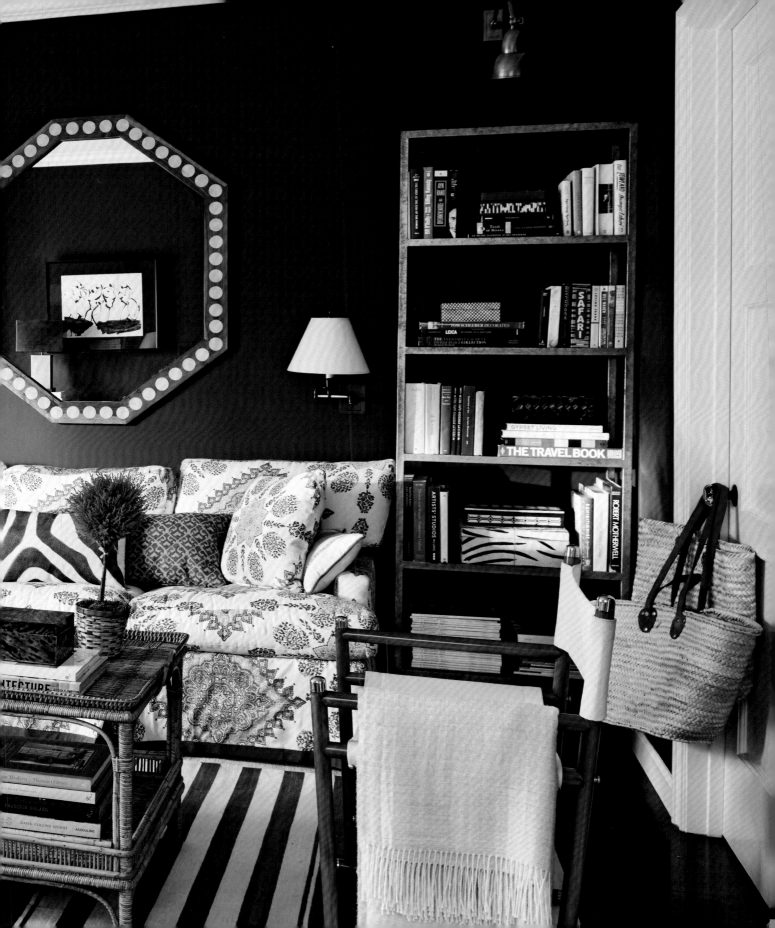

MORANDI

MORANDI

LIVING ARCHITECTUR

THE GREAT AMERICAN HOUSE Gil Schafer III

THE STEINS COLLECT

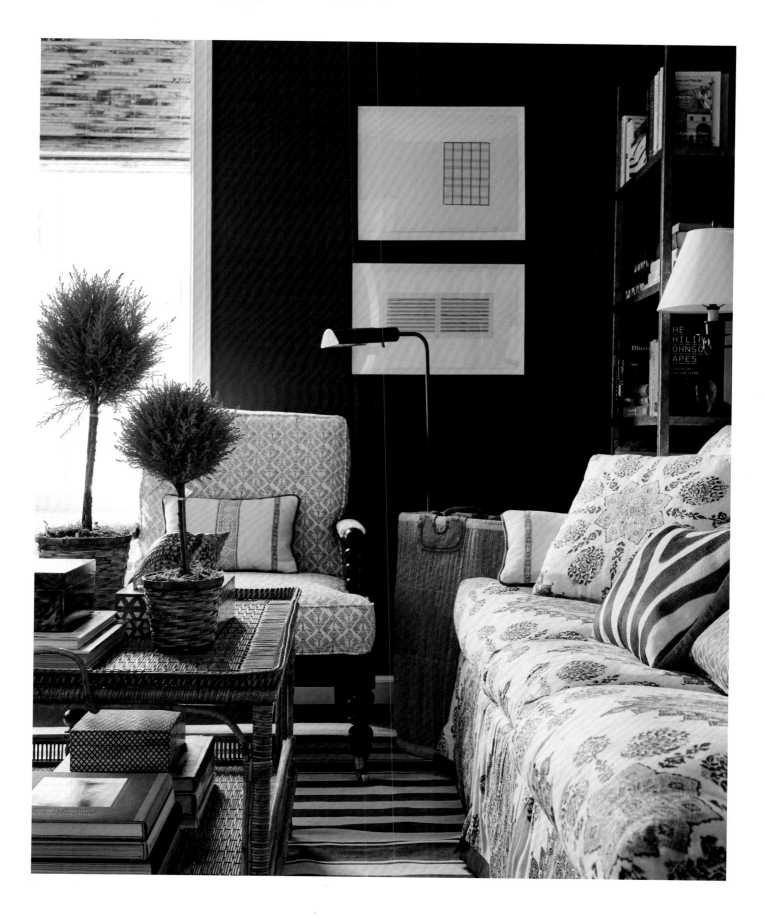

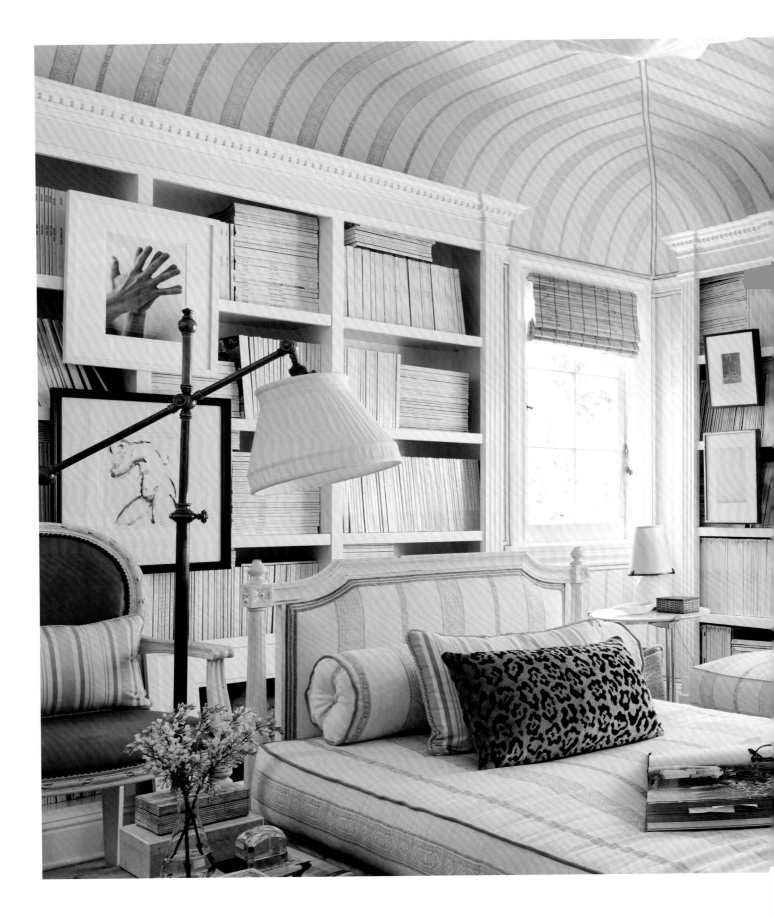

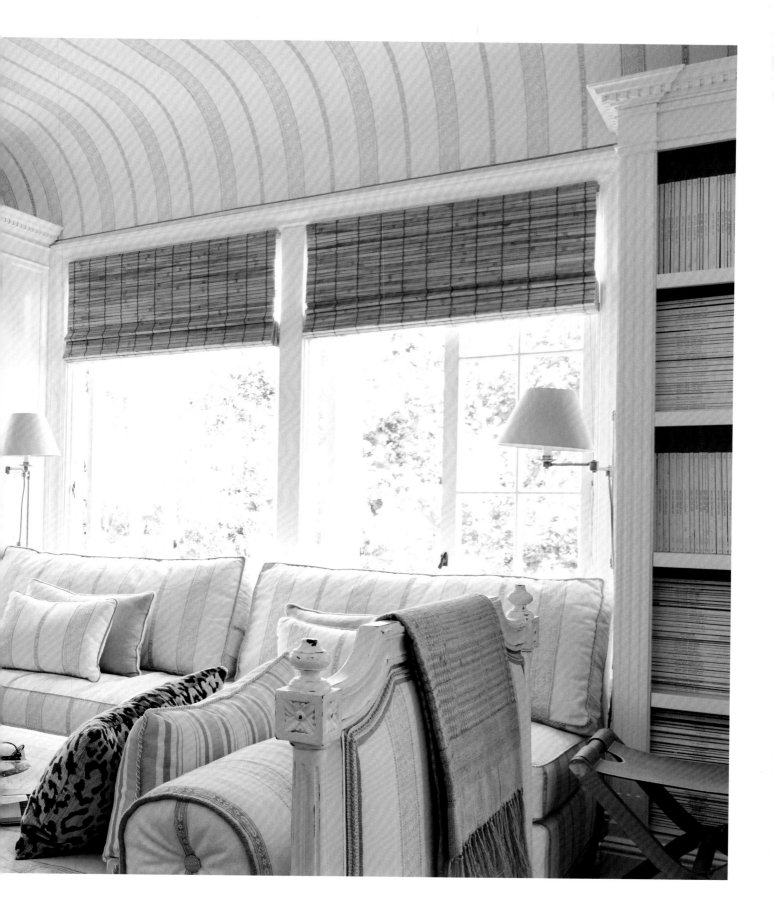

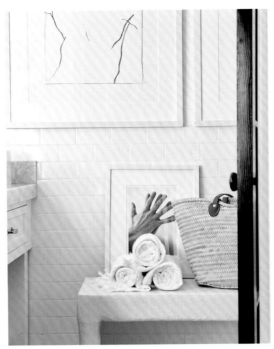

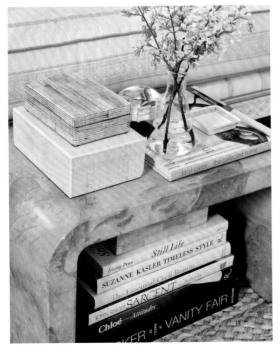

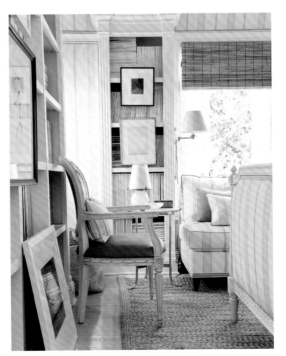

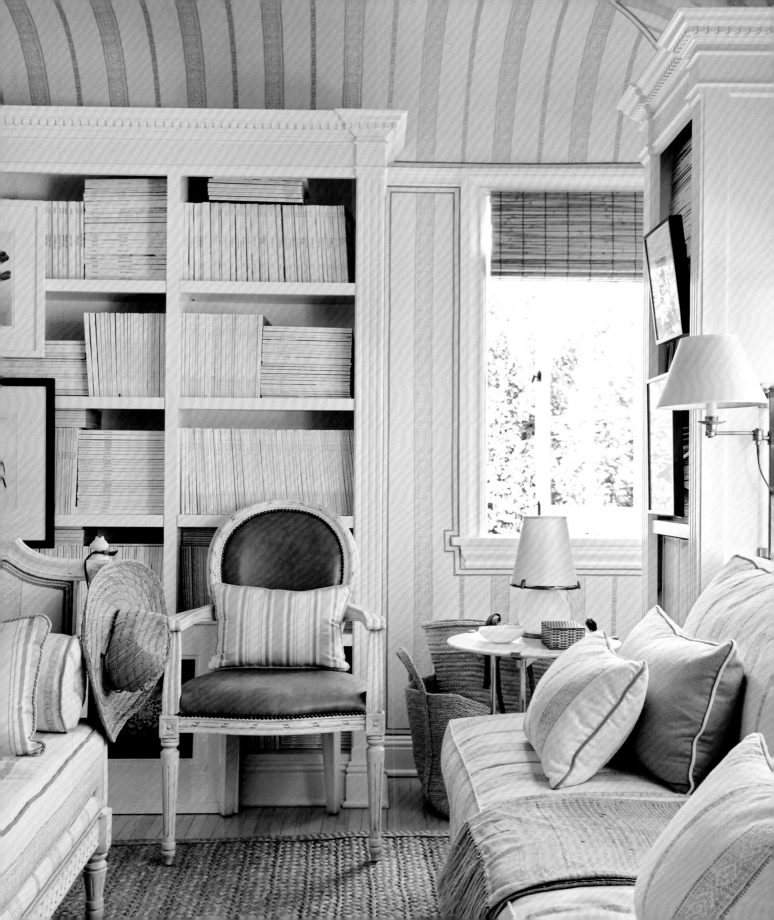

shades. Many of the rooms have effects that make them feel "tented," as if only draped fabric separated you from the outdoors. There's always a daybed near, should you want to read a book, write in a journal, or take an afternoon nap. Yet though these spaces feature neutral tones, they still have powerful personalities. Animal prints, ethnic accessories (like African ceramic bowls and large sculptural coins that were once used as currency), deep chocolate undertones, and accents of leather and lush greenery add depth and intrigue to the simple color story. The juxtaposition of clean lines, bright white walls, graphic art, and Parsons-style furniture makes these some of my most modern rooms.

Though the color scheme runs along a narrow spectrum, these rooms display a surprising versatility. Some spaces are dominated by darker browns, giving them a strong, masculine, sporting vibe. But others—such as the library in my home, where I display my extensive magazine collection, white spines out—feel clean, light, and airy. Still others (like the wood-walled sleeping porch) have a languid, otherworldly feel, thanks to comfortable furniture pieces like leather Moroccan poufs, woven rope day beds, and billowy cotton curtains that sway with the breeze. The common themes are the simple, neutral color palette, the incorporation of natural elements, and accents that suggest exotic locations. Like the characters in *Out of Africa*, these rooms have a beautiful, adventurous spirit, and invite you to dream of faraway lands, real and imagined.

A custom shelter sofa rests under a fiddle-leaf fig tree. The plaster table is by Stephen Antonson and the rattan armchairs are by the Bielecky Brothers. PAGES 150-151: In this Hollywood Hills library, a tented ceiling, neutral-striped daybed, and a treetop view invite repose. PREVIOUS, CLOCKWISE FROM TOP LEFT: A wing chair is lightened by white lacquer and tan accents. An all-white bathroom feels fresh. Framed prints and a Karl Springer parchment table and framed prints enliven the library. PREVIOUS, RIGHT: Fashion and interior magazines collected over twenty years line the bookcases.

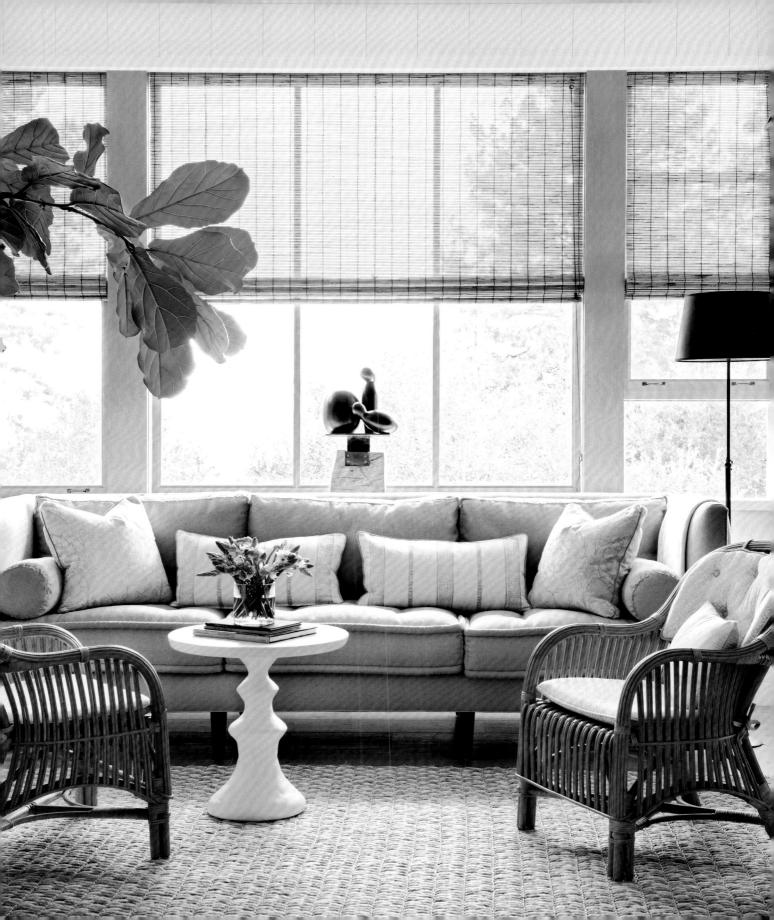

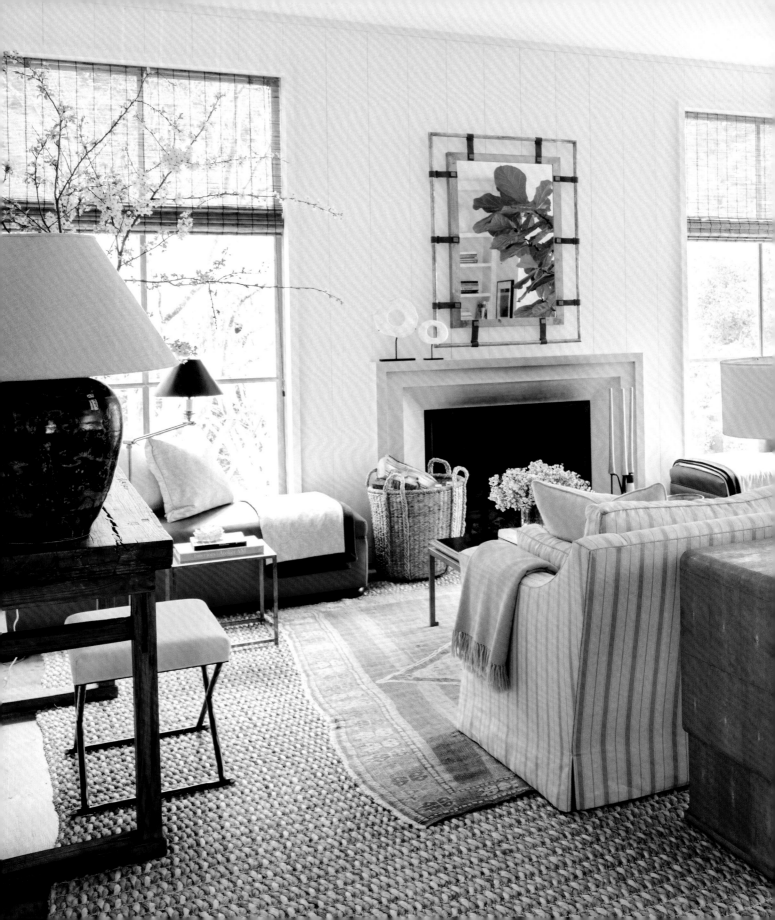

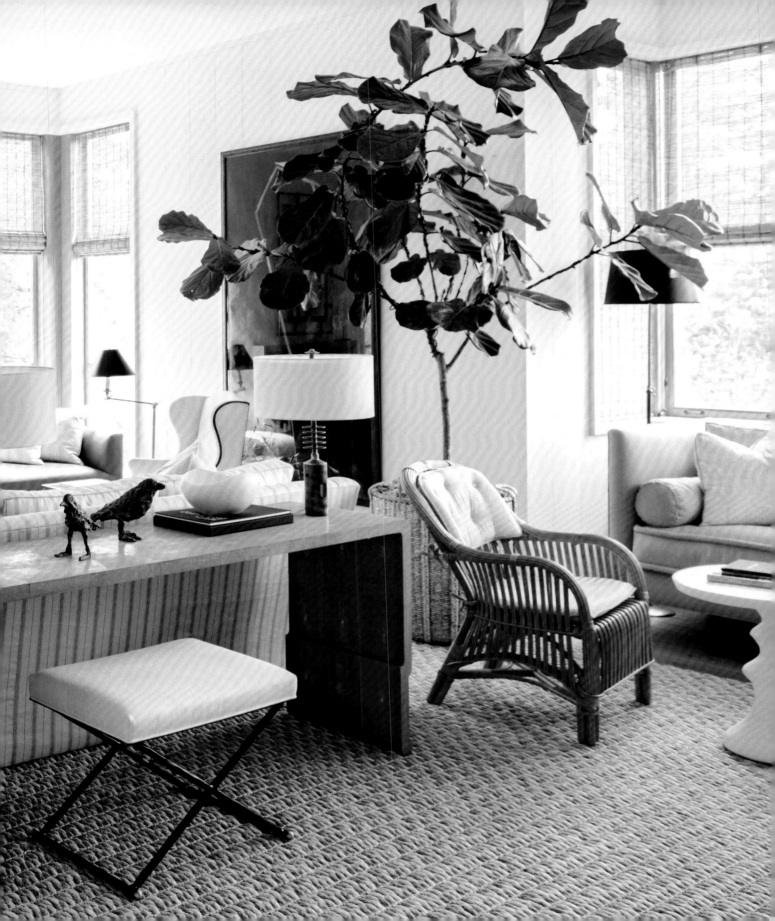

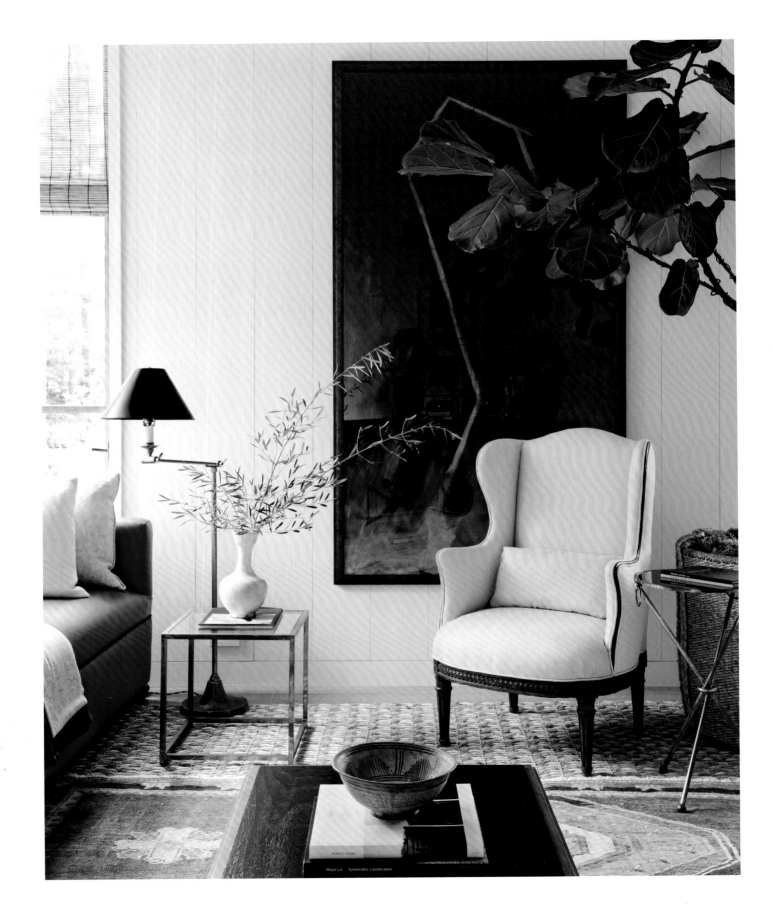

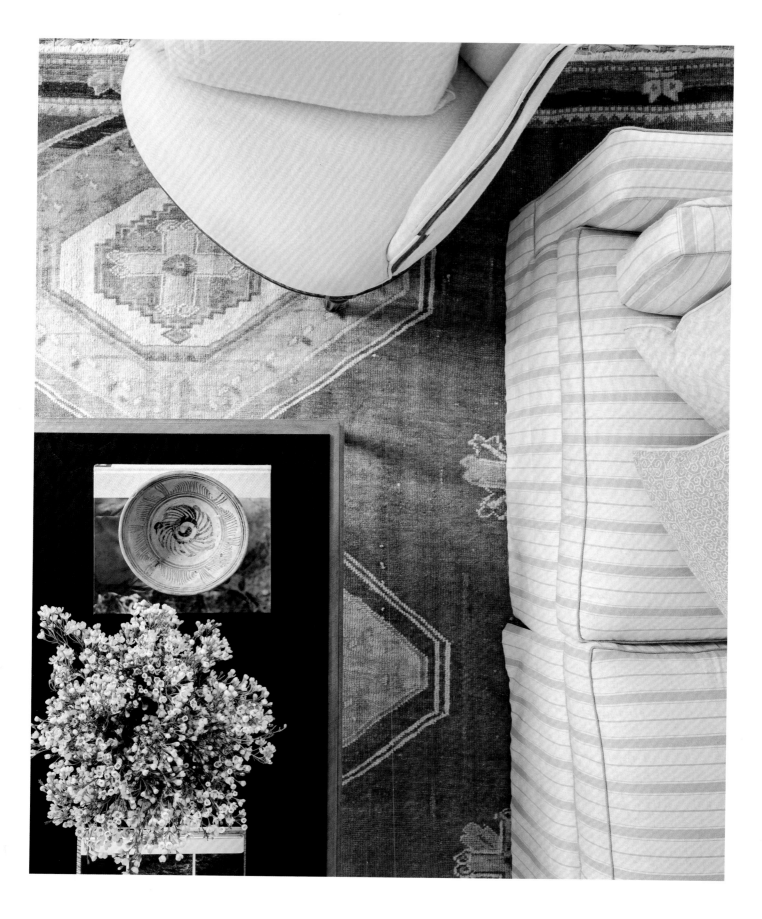

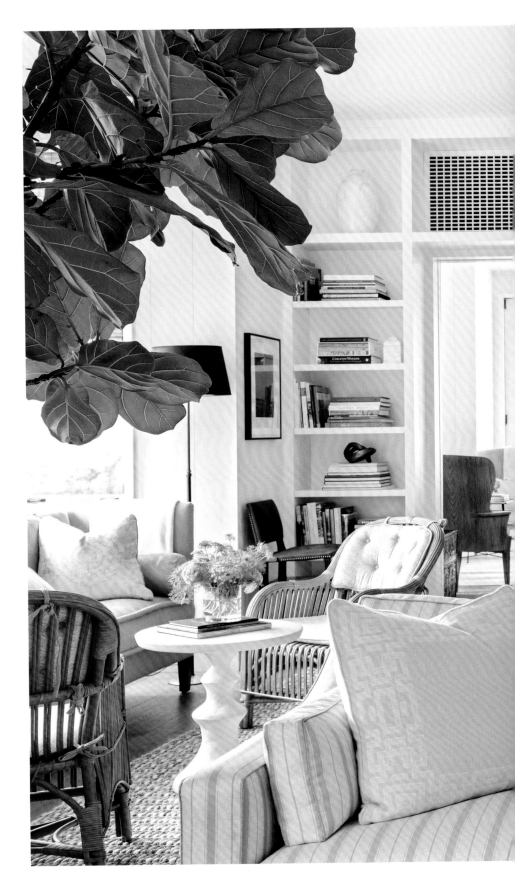

In this Northern California living room, a game table sits in front of shelves filled with books, antique English boxes, and ivory-colored Chinese vases. PREVIOUS, LEFT: A petite French wing chair silhouetted by a dark, graphic print. PREVIOUS, RIGHT: Neutral stripes, a patterned rug, and an African bowl come together around a Richard Shapiro coffee table. PAGES 156-157: This room illustrates the importance of mixing textures in monochromatic rooms.

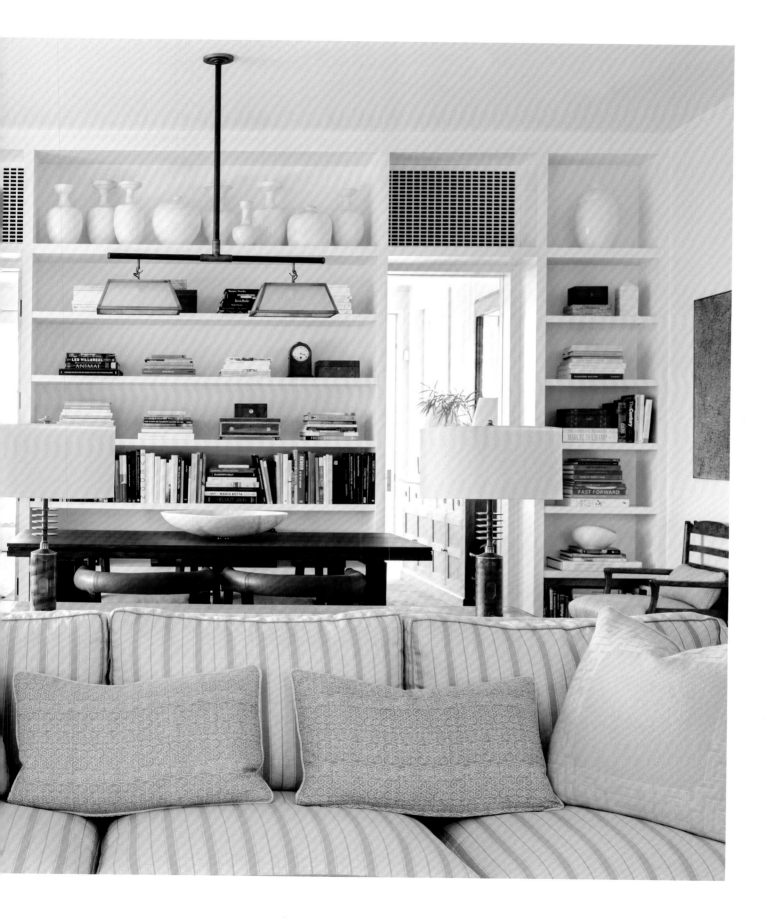

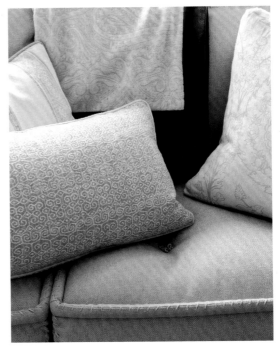

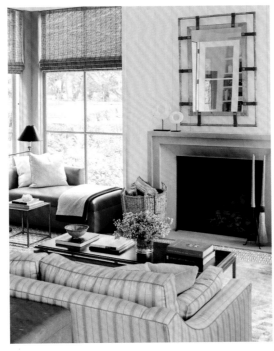

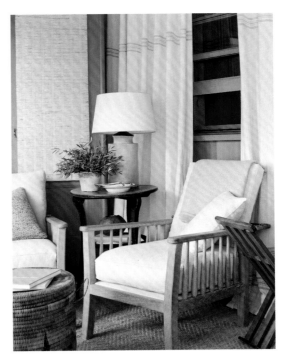

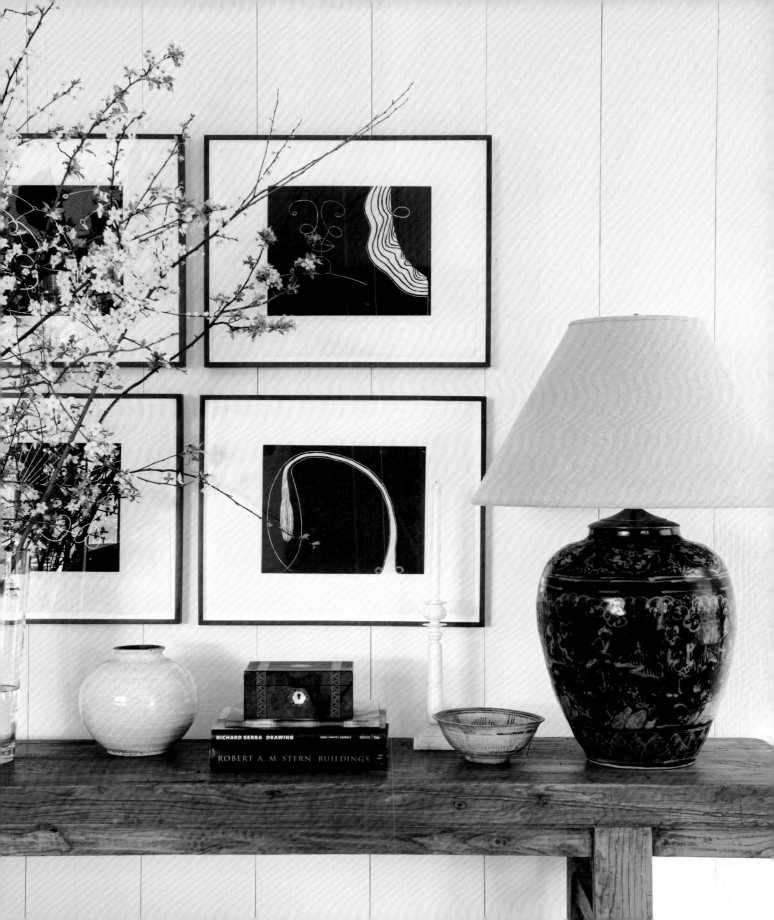

RICHARD SERRA DRAWING

ROBERT A. M. STERN BUILDINGS

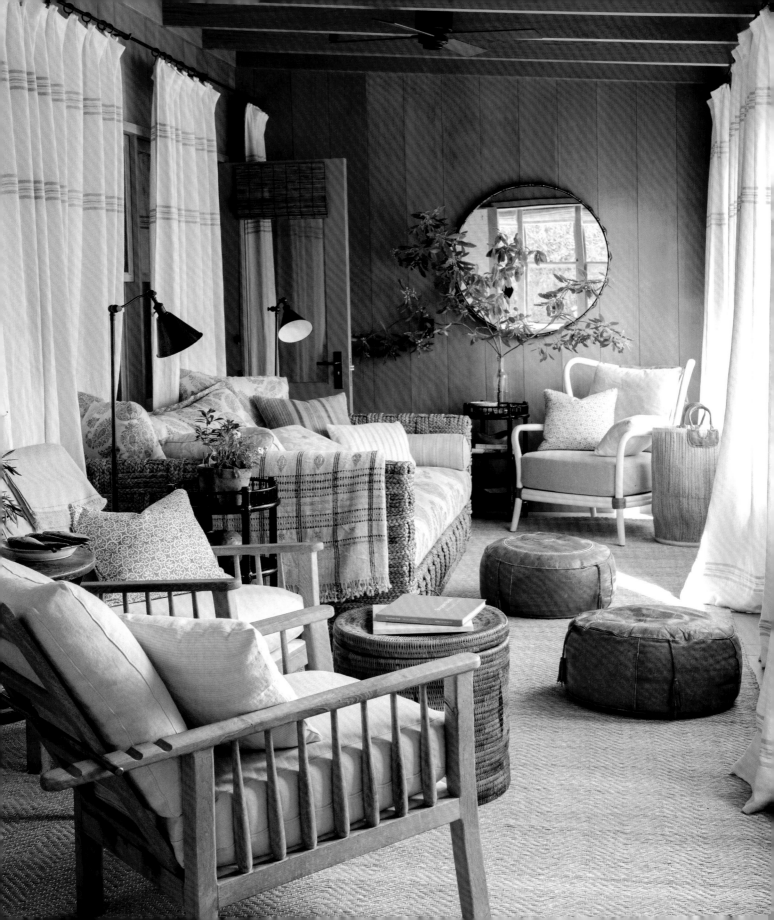

An octagonal study
showcases masculine
elements, including a
Chinese partner's desk.
PREVIOUS, LEFT: On the
sleeping porch, the John
Himmel rope daybed
beckons. PREVIOUS, RIGHT:
The Belgian commode
and Spanish gilt mirror
communicate a life of
exotic travel. PAGE 162,
CLOCKWISE FROM TOP LEFT:
Tribal currency and a brass
and leather mirror from
Lucca Studio; pillows on
a sofa cushion with
whipstitch detail; lounge
chairs in the a sleeping
porch; a leather chaise in
the living room is made
for reading. PAGE 163:
Abstract art hangs over
an eighteenth-century
Chinese console.

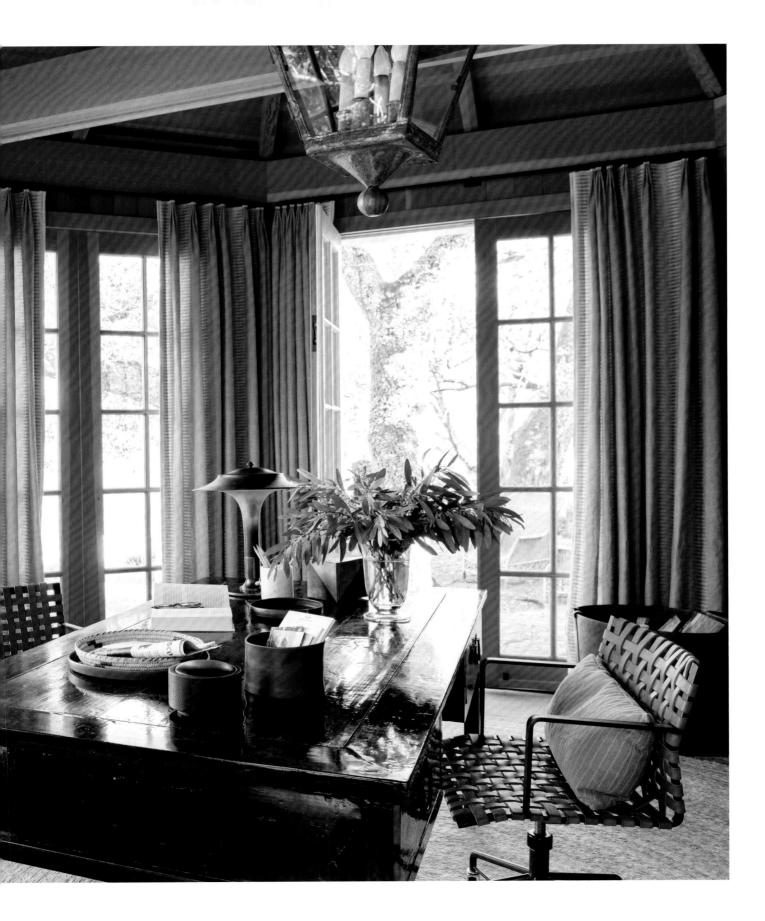

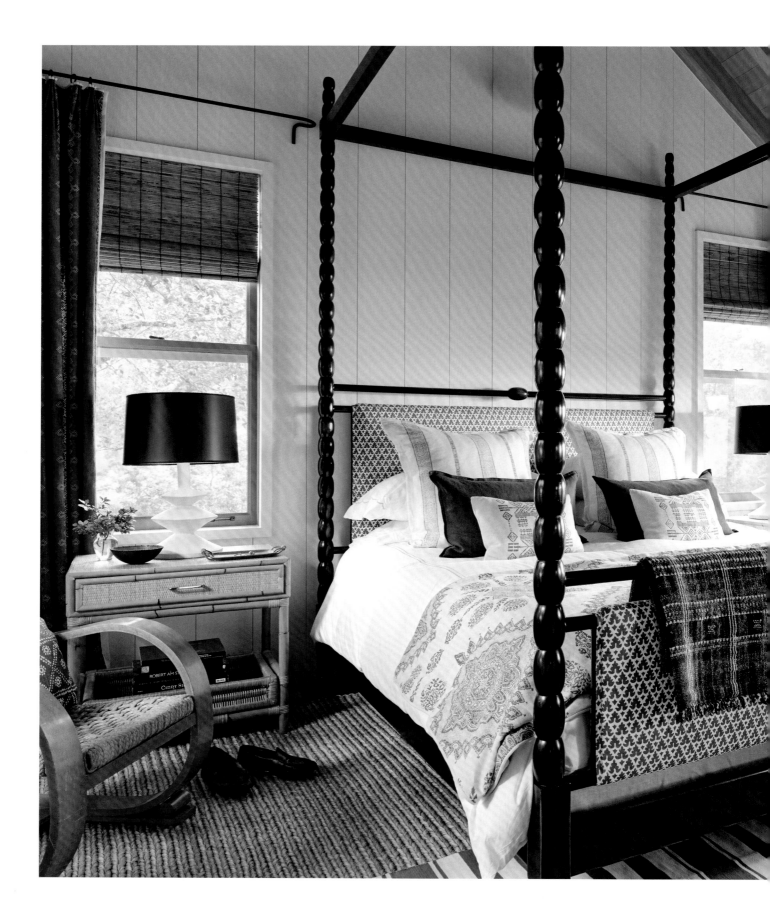

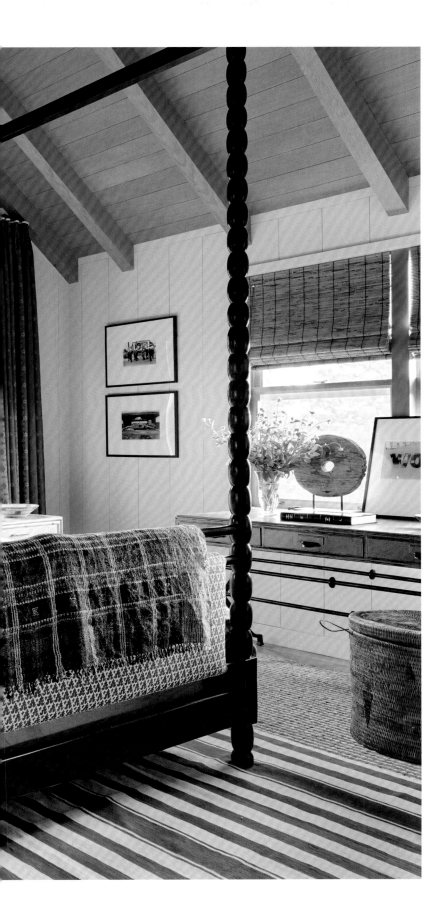

A guest bedroom is a fitting place to create a sense of escape. Here, bamboo bedside tables, a mid-century woven rope armchair, tortoise blinds, a striped dhurrie rug, and vintage textiles create a neutral but dynamic foundation for travel-inspired art, like the historic black-and-white photographs and wooden sculpture on the desk.

BEAUTIFUL BRIGHTS
COLORFUL ROOMS FOR HAPPY TIMES

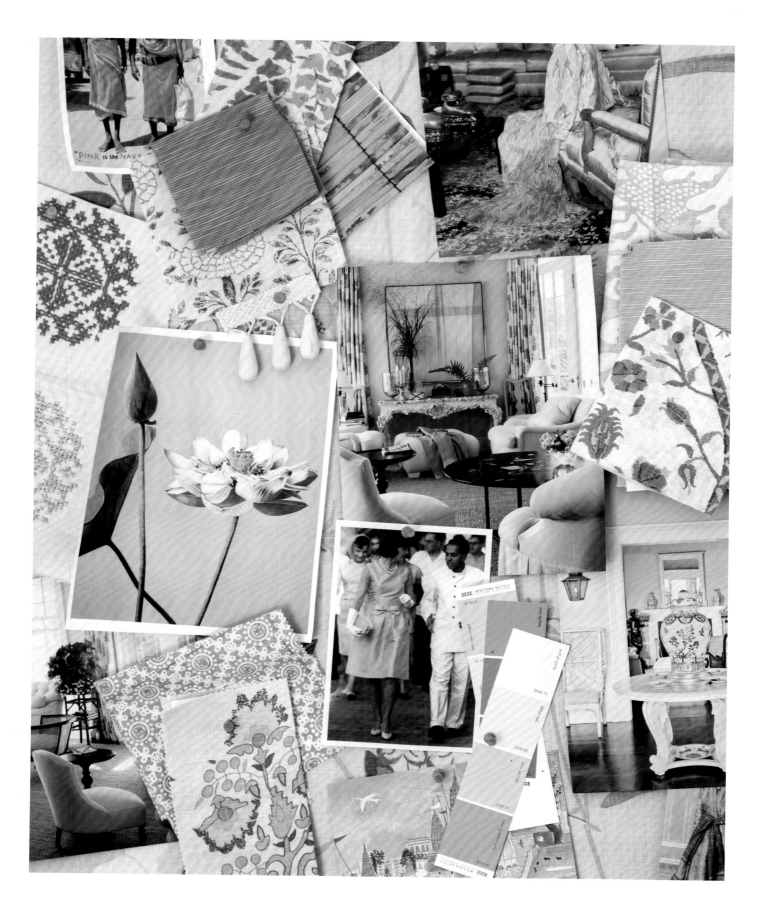

Brightly colored prints have been a mainstay of American fashion at least since 1962. That year, Jackie Kennedy made a goodwill trip to India with her sister Lee Radziwill that was documented with images of the duo in colorful shift dresses amid that country's lush flowers and bright patterns. The photos and footage instantly brought vibrant colors into vogue. President John F. Kennedy did his part to cement the connection between brights and style by sporting chinos in cheerful shades of red and yellow when on holiday on Cape Cod. Then there is the influence of modern art, from pieces like Ellsworth Kelly's bright Color Field paintings and Mark Rothko's beautiful abstract expressionism, as well as the photography of Slim Aarons, whose sumptuous depictions of glamorous leisure made color seem like the life of the party. From preppy to Pucci, bright colors are exciting, cheerful, and mesmerizing.

This relationship between beautiful brights and picturesque living translates easily into home design. One of the most enjoyable parts of this color theme for me is how many influences can be layered in a single room. And there are so many ways of doing "bright" that it's wonderful not to have to limit myself to one or two! I adore the whimsy of paisley upholstery and floral-printed curtains; the intrigue of vintage textiles from Morocco, India, and Turkey; and the happiness of a single saturated color from a bouquet of flowers, a painted wall, an upholstered piece of furniture, or a piece of modern art. The inherent playfulness of a bright palette invites mixing and matching (or mixing and intentionally clashing!). These are rooms to have fun with—and in.

I often say that books make the best accessories; they add personality to the decor of any room. This leather ottoman is a great foundation for colorful book jackets, flowers, shagreen boxes, and colored glass bowls.
FOLLOWING: Pairing bright colors and floral patterns with neutrally toned elements like bamboo shades and the natural-fiber rug provides a nice interplay between whimsy and weight.

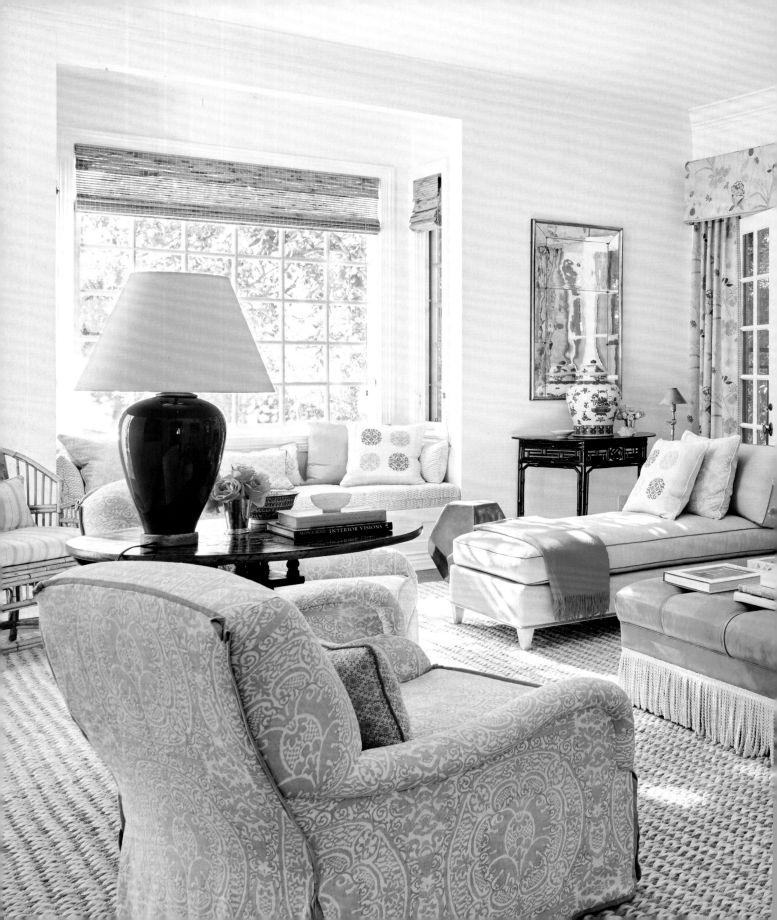

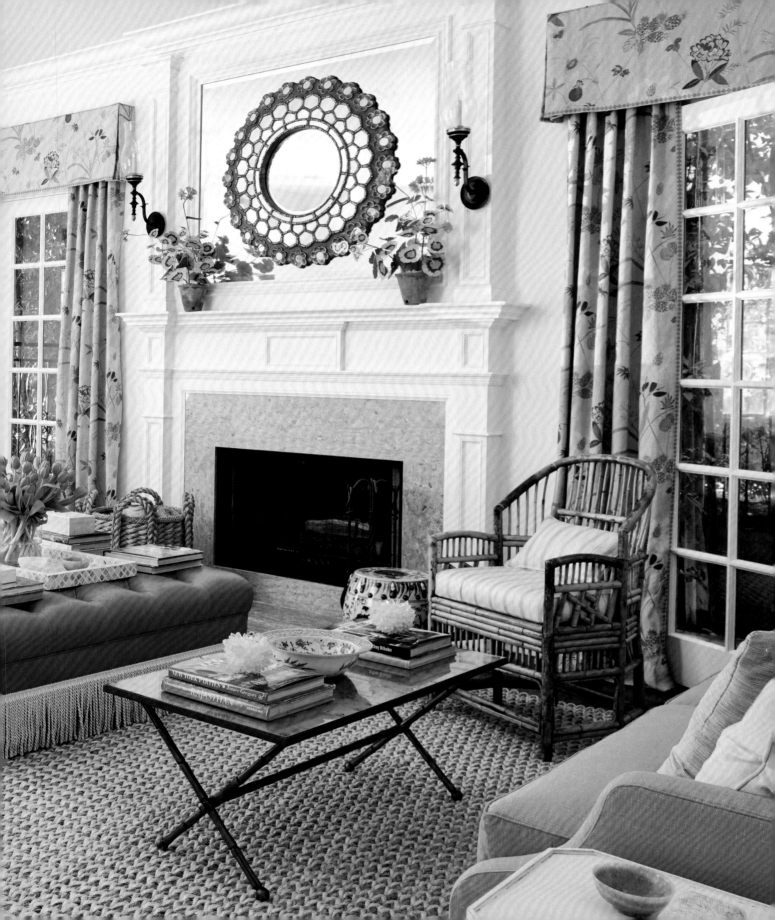

The sofa's coral hue becomes the focal point of the room, drawing the eye toward an intricate Indian painting with a botanical border. FOLLOWING, LEFT: Detail of colorful chinoiserie wallpaper. FOLLOWING, RIGHT: An English chinoiserie table presents a bright vignette that pops against a rug of handwoven abaca, a close relative of the banana plant. PAGES 180-181: In the family room, Indian influences and a Moroccan mirror mingle with solids, paisley, and stripes. PAGE 182, CLOCKWISE FROM TOP LEFT: Orange ball trim adds dimension to a curtain with Indian motifs, while a blue-and-white striped banquette is brightened by a mix of pillows. The chartreuse chaise and bamboo armchair with orange cushions are both comfortable and colorful. PAGE 183: Paisley and ikat sit happily in front of a pair of bright Indian panels.

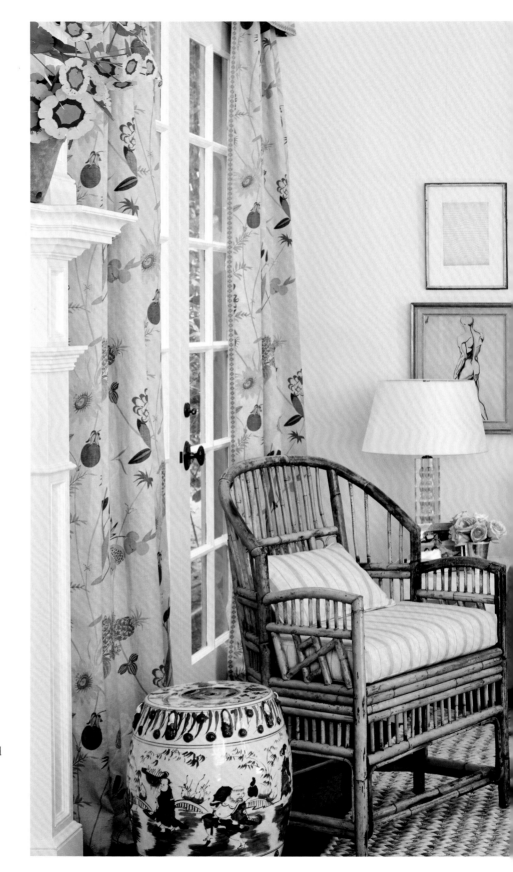

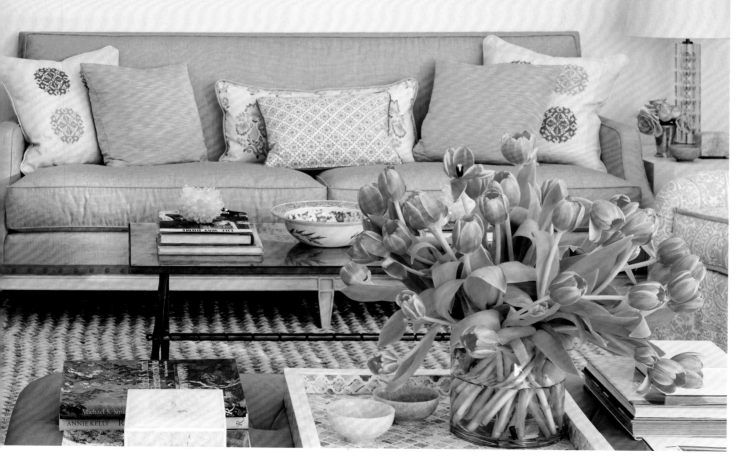

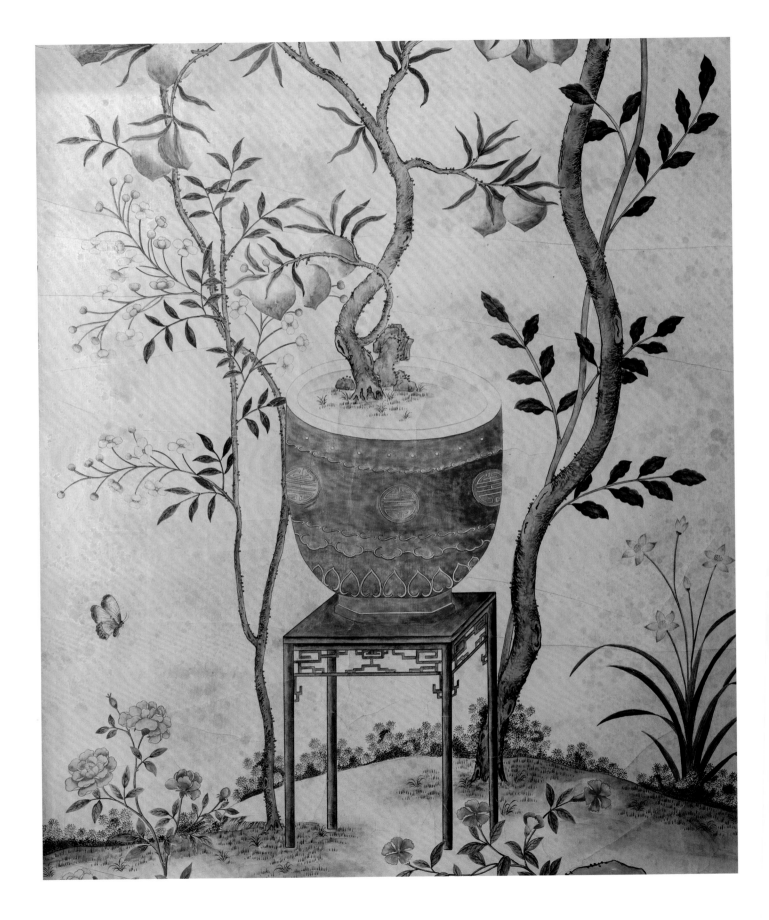

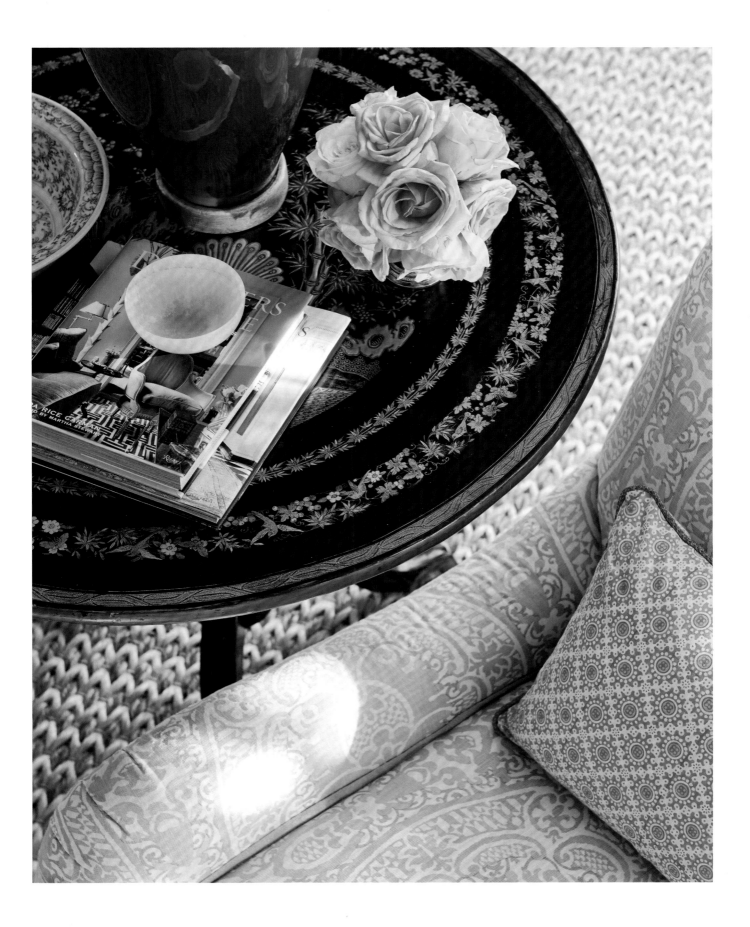

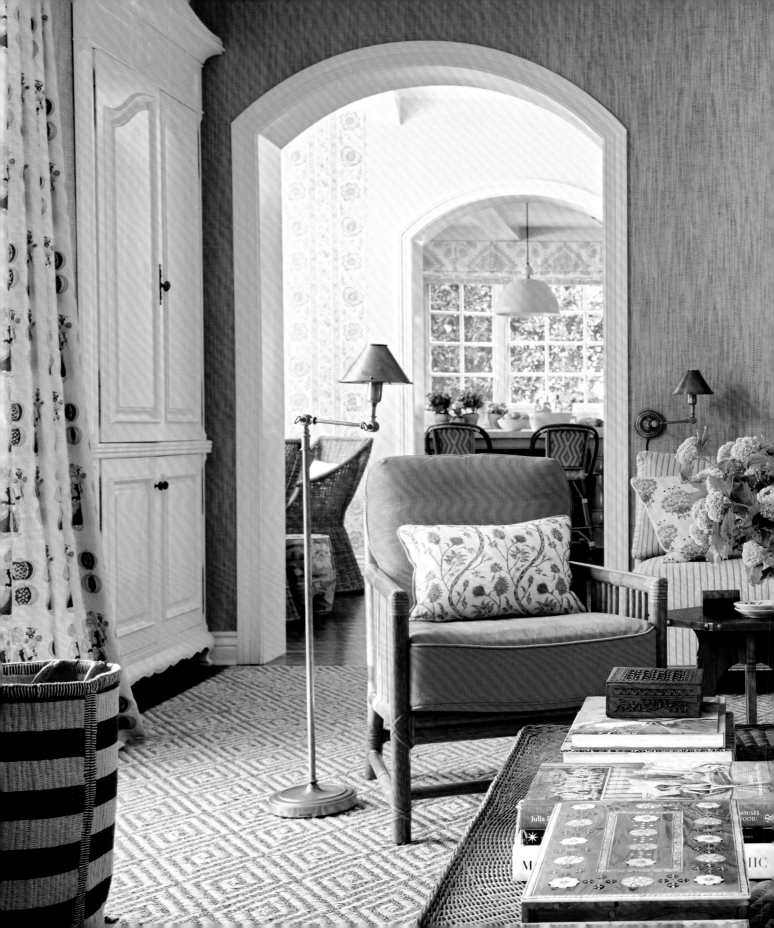

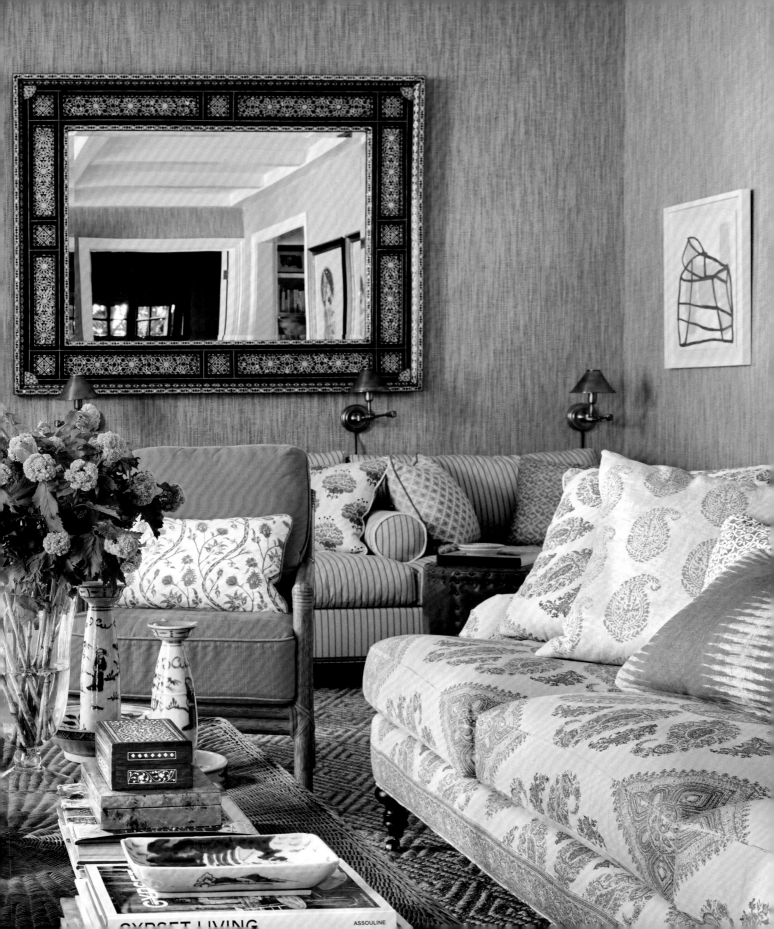

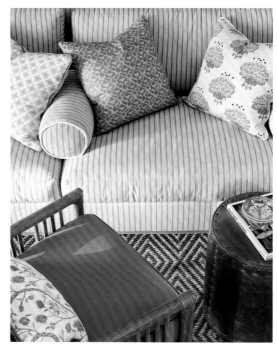

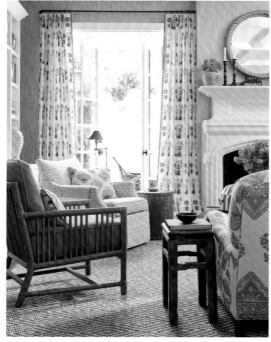

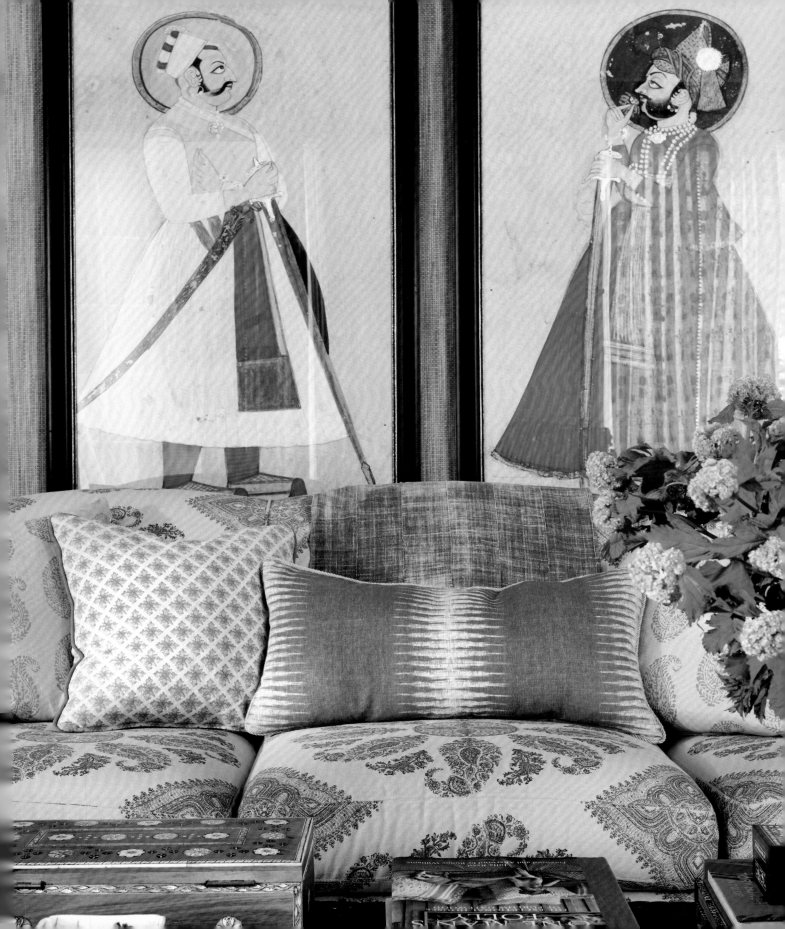

Fruit and flowers bring color
into the kitchen of this Pacific Palisades home (above). OPPOSITE: The bright turquoise pattern on the French bistro stools turns a simple white kitchen into an exciting place to be.

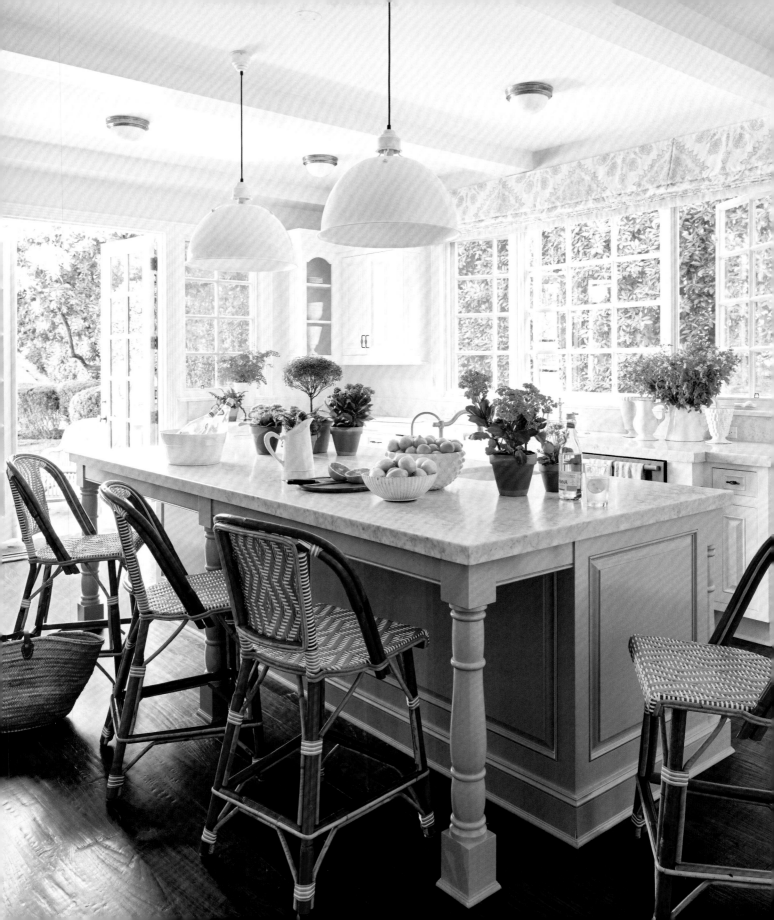

Some people are shy about using bright colors in their homes, fearing the tones will feel gaudy, fussy, or overly feminine. But I like brights that are more colorful than electric: fuchsia, Kelly green, coral, and turquoise. Setting intricate patterns against a solid color or a geometric pattern can help ground them. And I always work neutral, natural elements, such as wicker chairs, rattan baskets, natural-fiber rugs, and bamboo shades, into a colorful room. White is another powerful ally in a room with a lot of color, whether it is used on the furniture or on the walls, or as the background for a wild pattern.

Brights and sunshine are natural mates for homes in temperate climates where windows can be left open all year-round. And although brights have potent associations with pleasant weather and indoor/outdoor living, they can also enliven dark woods with contrast. Using vivid colors in a dark wood-paneled library or alongside a mahogany bed frame in a bedroom adds unexpected playfulness and insouciance, giving an otherwise straitlaced room a more carefree feeling.

Bright is more sensation than color. A "bright" room isn't necessarily dripping with fuchsia and neon. A great, bright space is a cheerful and inviting one with a sense of ease, but one that also draws depth from countless layers of fabrics and textures. Individually eye-catching elements—ornate prints, whimsical chintz, suzanis, artwork, and flowers in nature's expressive, joyous colors—beautifully come together not exactly in harmony, but in a carefree juxtaposition. It's hard not to feel happy in a bright room. The good-natured liveliness that these tones convey makes them well-suited for the homes of families with small children—or for anyone who is young at heart.

The bedroom of this Montecito beach house shows off a range of pretty pinks. Rather than pulling in many different brights and breaking them up around the room, I stuck with a single color and used a range of patterns, which creates depth and intrigue without making the room feel too loud. In addition to India-inspired florals and prints, I included a painting of two salmon-colored birds.

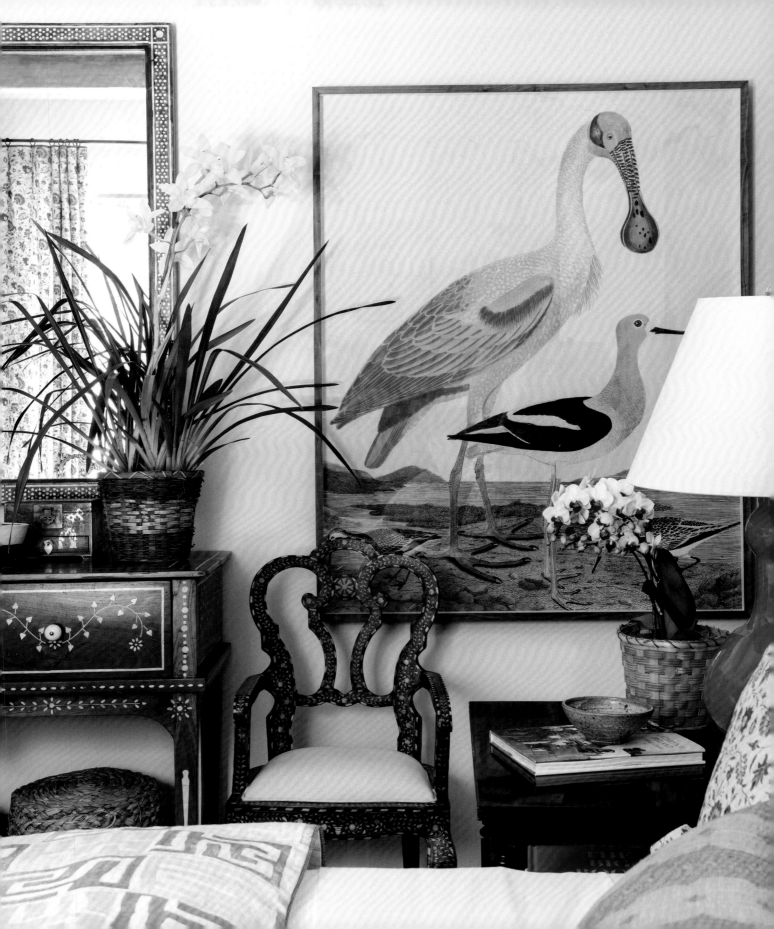

The inspiration for this bedroom is the rose garden outside the window; I used colors from the roses and wood to draw in the natural beauty. The botanical prints on the wall create a foundation for various patterns (the striped dhurrie rug, geometric bedspread, and floral chairs, window treatments, and pillows). FOLLOWING: China blue slipcovers contrast beautifully with deep mahogany bookshelves in the library, while suzani curtains cheerfully play off the mix of color on the books on display.

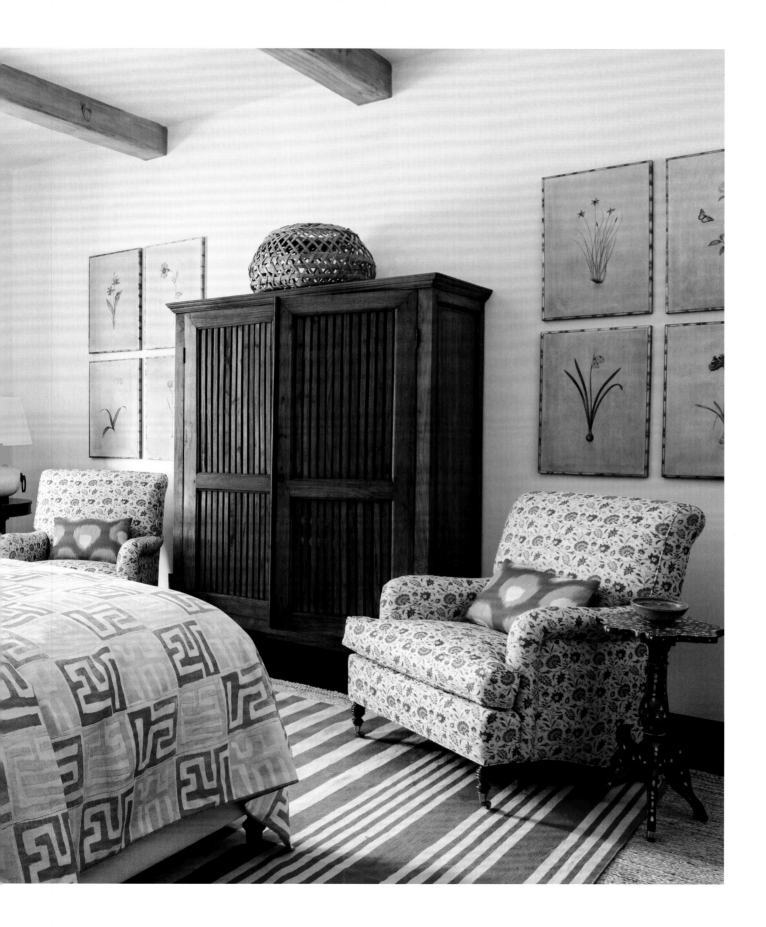

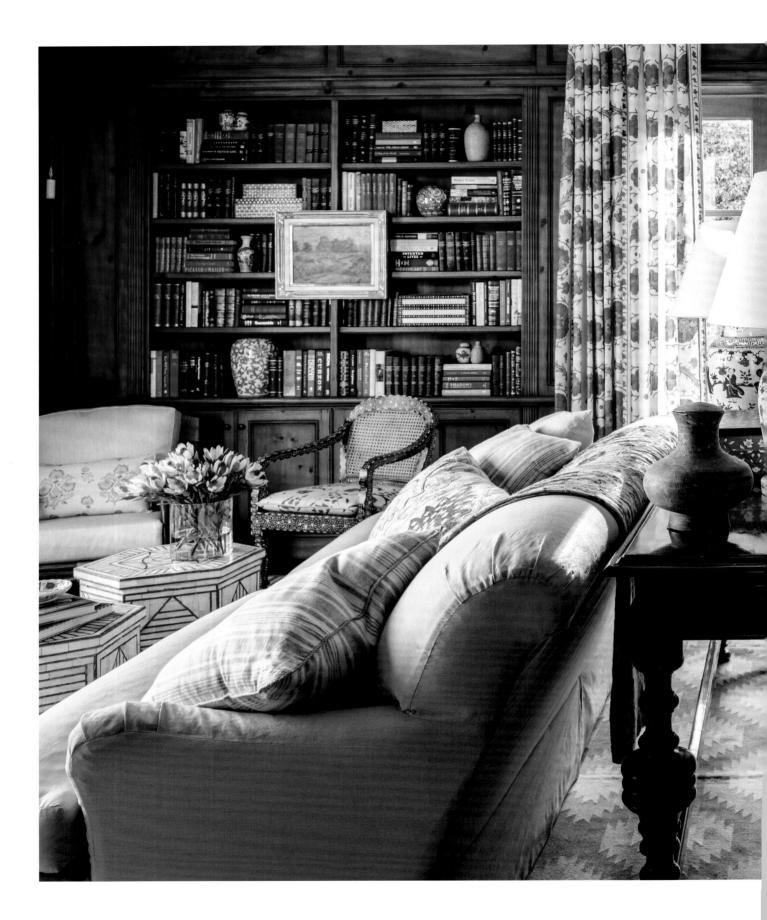

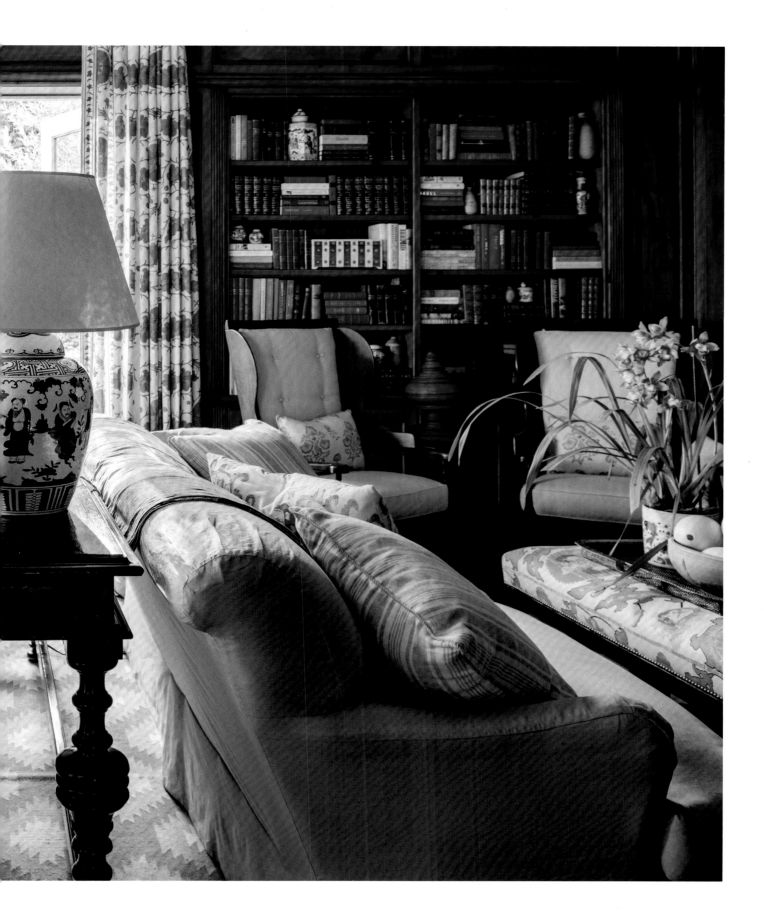

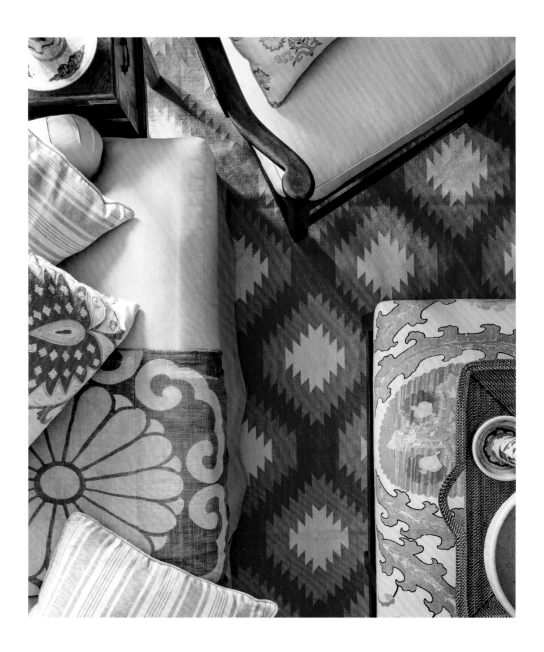

Bright color and comfortable

seating keep the library from feeling too serious. OPPOSITE: Blue-and-white
porcelain and bone-inlay chairs add color and texture. The hexagonal shape
of the tables (also bone inlay) echoes the pattern in the dhurrie rug.

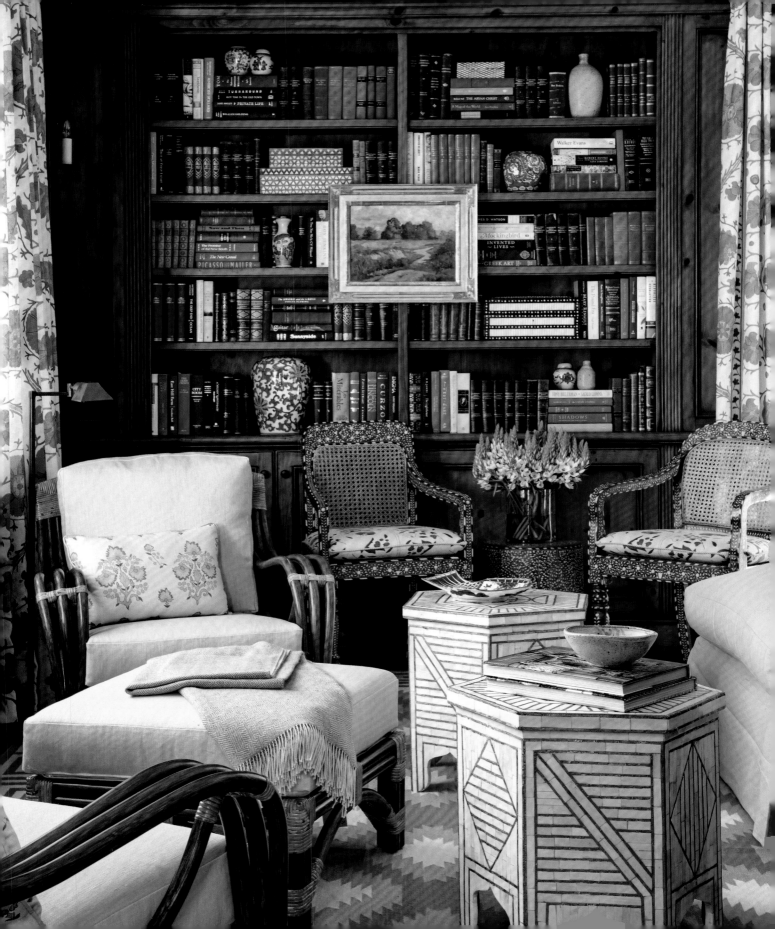

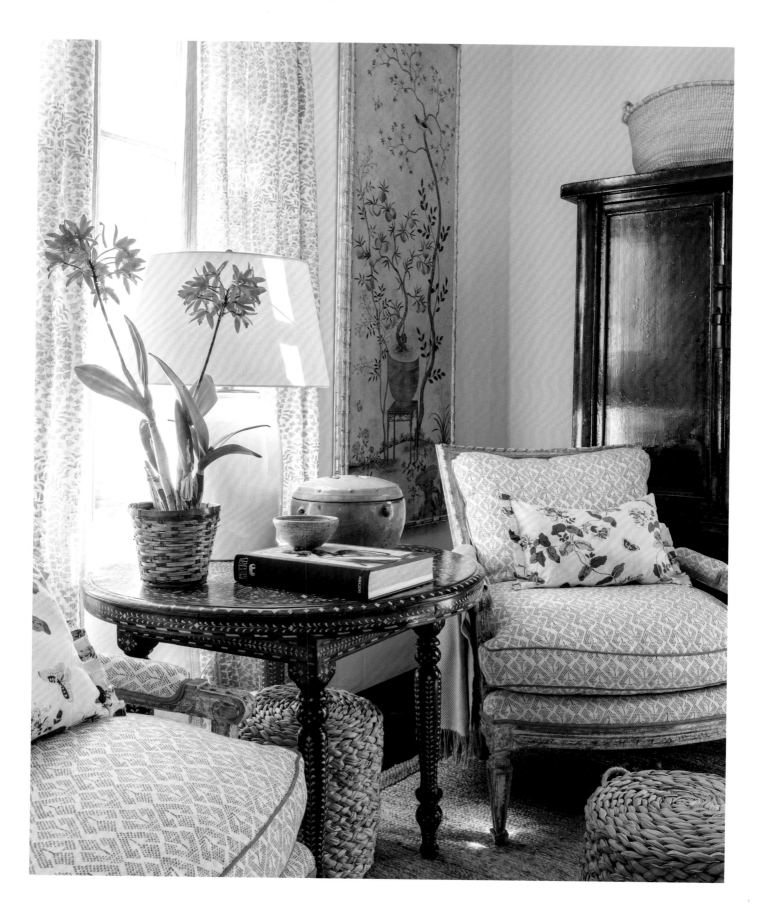

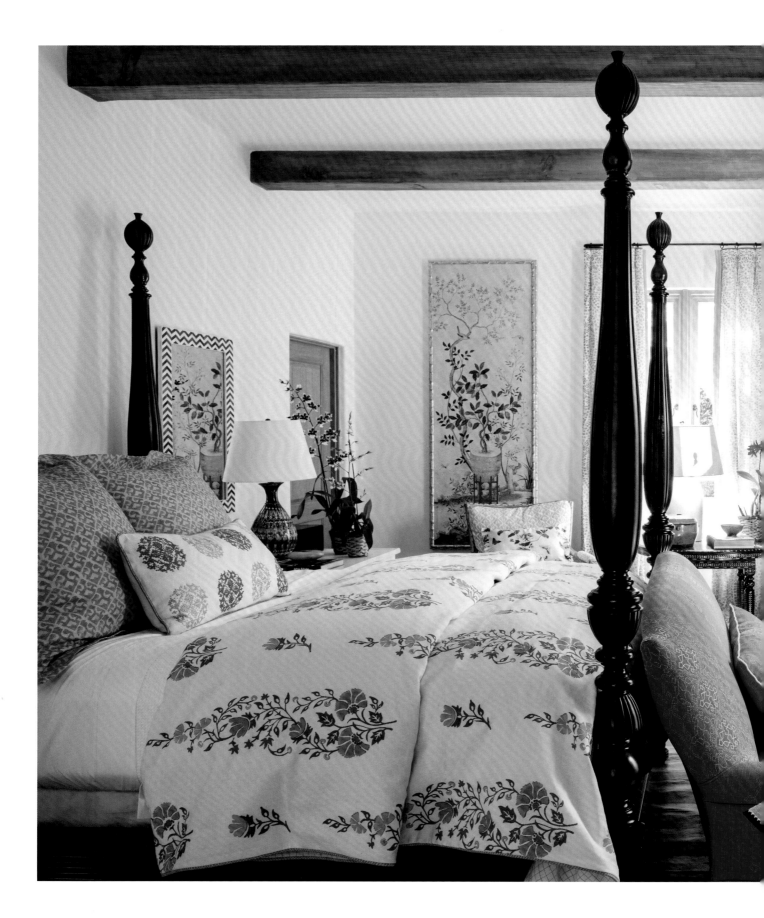

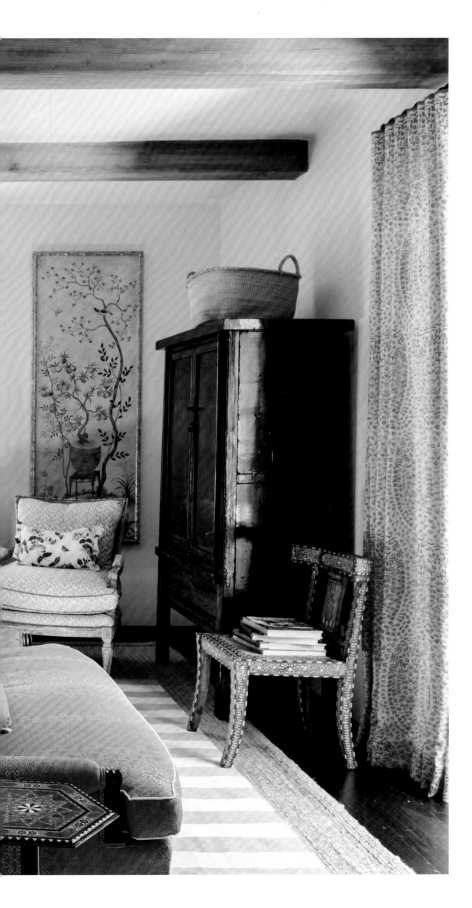

The palette and tone of this bedroom were inspired by the view through the window of a citrus garden. The mahogany bed, the wood beams on the ceiling, and the Chinese armoire provide a strong foundation for color and pattern. Potted orchids on the bedside table and a round occasional table bring to life the foral motifs of the chinoiserie panels and bedspread. PREVIOUS, LEFT: Detail of the bone-inlay side table. PREVIOUS, RIGHT: Rush stools and a natural fiber rug let the coral patterns of the upholstery and curtains shine in a bedroom sitting area.

SUN-FADED HUES
WORN AND WEATHERED BEAUTY

Being at the beach is the closest thing to heaven, I think, especially taking long walks along the shore on Point Dume in Malibu and Butterfly Beach in Montecito. For me these are places of renewal, natural sanctuaries that feed the soul. Beaches delight with simple, calming beauty: the soft contrast of sea, sky, and sand; shells in every shape you can imagine; willowy grasses swaying in the breeze; sunrises and sunsets along the horizon. They invite your cares to drift away. The sensation of being on a beach is one of complete relaxation—what better atmosphere to bring into a home? In the rooms in this chapter, I've used my favorite colors and qualities from the beach to channel that wonderful feeling of sitting on the sand, staring at the sea. These are rooms of ease and languor, beautiful in their rich yet subtle color and filled with natural materials.

I love the depth of things that have been aged by the elements, and like to bring elements that have a sun-faded patina into a home. Weathered woods, distressed stones, and handmade ceramics in earthy tones like taupe, flax, and gray, are some of my favorite ways to evoke textures and hues of the beach indoors. Though I incorporate organic materials into all of my interiors, here they play a leading role. Instead of accenting a room with a single natural-fiber rug or set of natural-woven shades, I use an abundance of natural elements in these rooms, which include reclaimed wood, zinc details, potted succulents, stone and iron tables, and furniture made of wicker and rattan.

Beach-inspired rooms contain some of my most interesting furniture finds. The inside of this Swedish armoire gets a whiff of the ocean from an interior of painted sea-foam blue. White ceramics, wooden bowls, and neutral linens complete the relaxing tableau. FOLLOWING: A lanai in Northern California feels even more idyllic when outfitted with wicker, iron, and stone, as well as beautiful weathered elements, such as distressed wood. The floor is textured limestone.

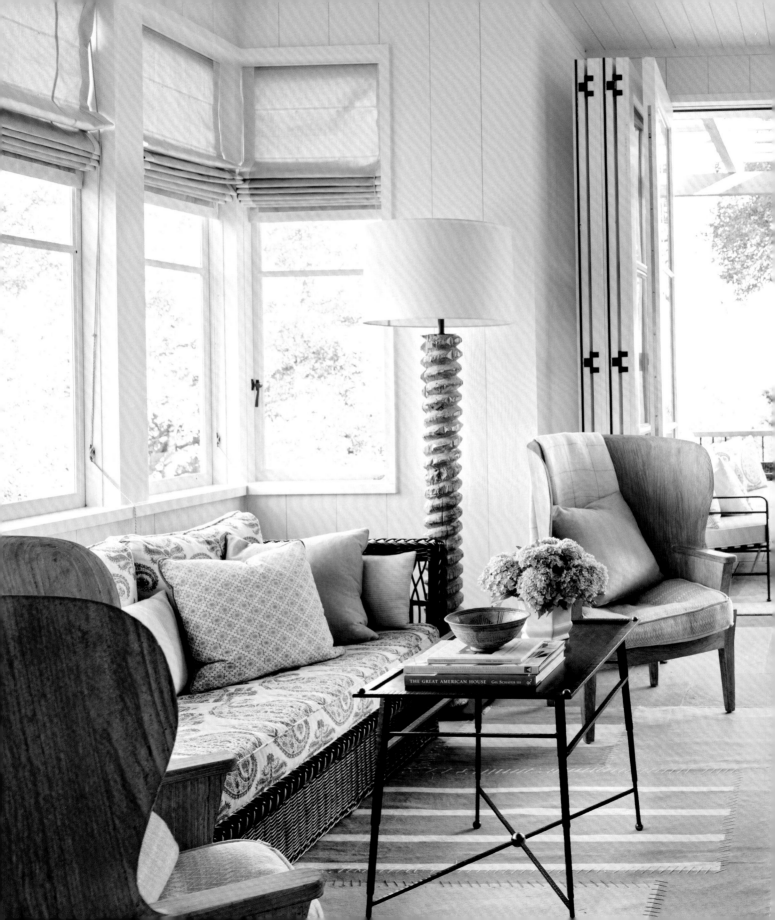

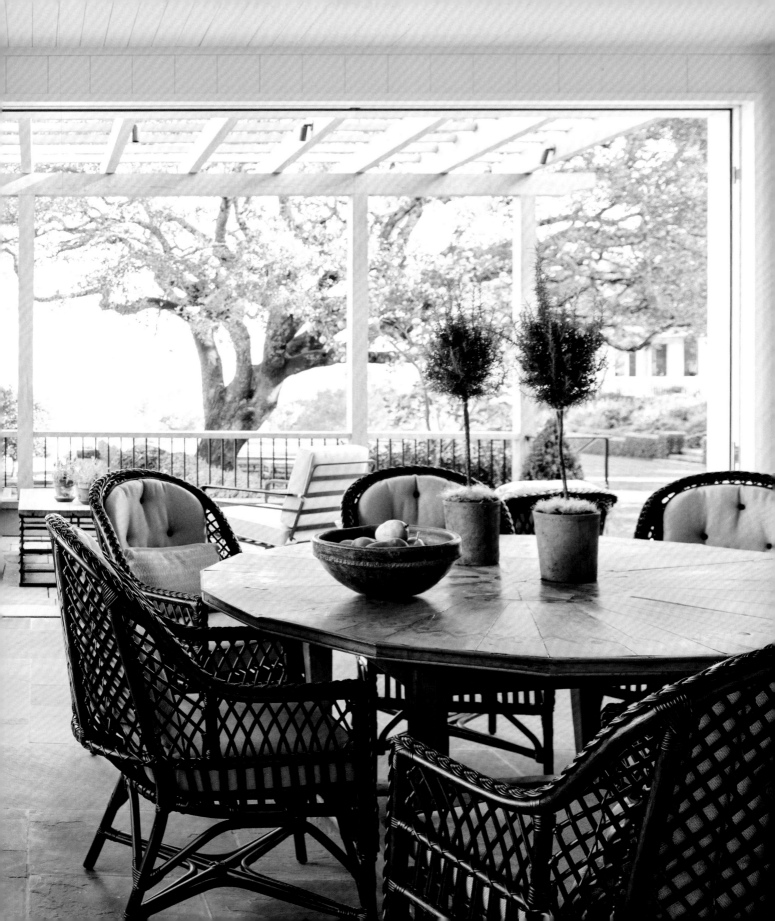

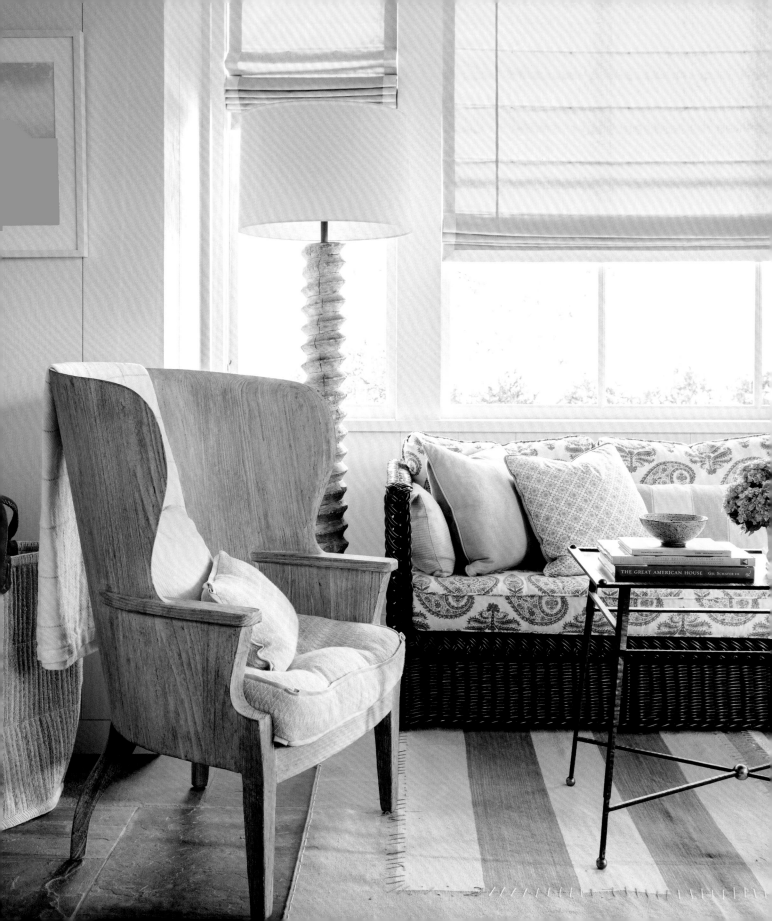

A trio of pillows recalls the beach

with colors of the sand, water, and sky (above). OPPOSITE: A wingback chair with a weathered look sits next to a wicker daybed in a sun-faded paisley. FOLLOWING, LEFT: Wooden bowls mirror the patina of a nineteenth-century Italian fruitwood table. FOLLOWING, RIGHT: The zinc mirror hanging over the blue-stone Belgian oak buffet brings in the sunshine.

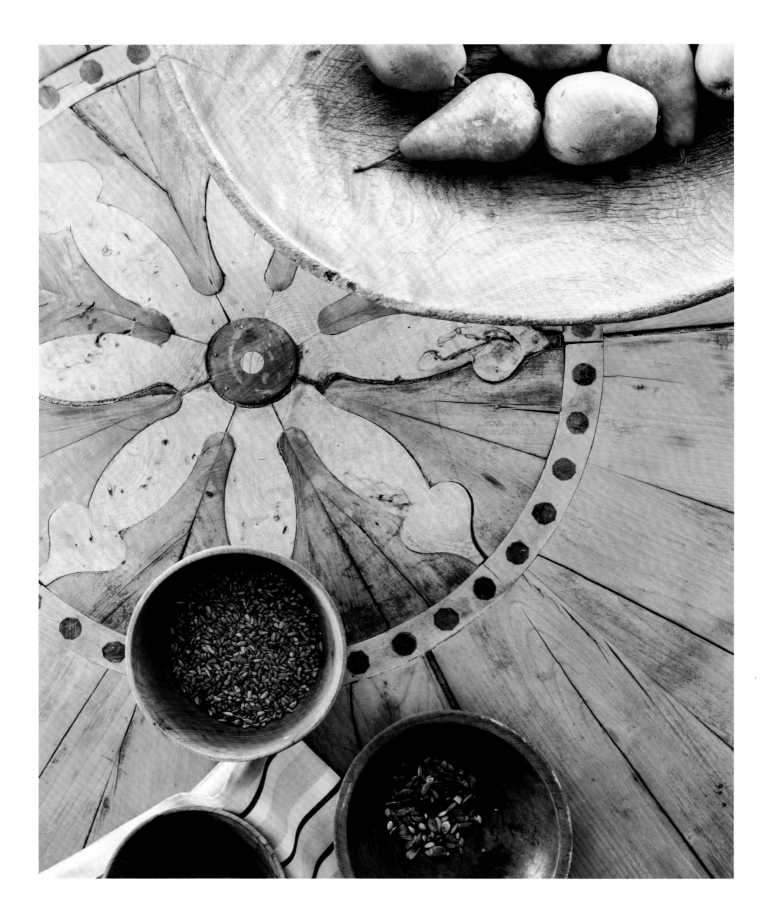

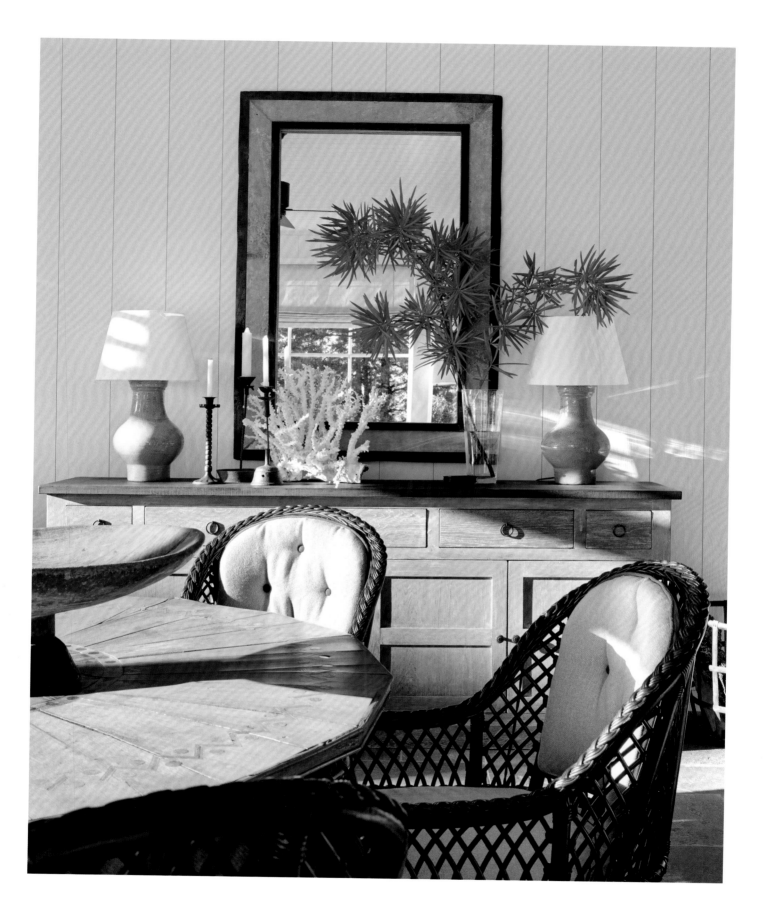

Though many of these rooms are exclusively neutral—save for the occasional spot of ocean blue or mossy green—they contain some of the most interesting pieces of furniture, such as sofas and dining chairs with frames made of rope, a seventeenth-century Italian wood inlaid dining table, and a Swedish armoire whose interior is painted a surprising sea-foam blue. The simple, muted color scheme makes these wonderful places for displaying large abstract watercolors, such as the work of minimalist painter Agnes Martin, or large-scale beachscape photography.

The prints and textiles I use in these spaces are similarly subtle, and draw on the same organic and weathered notes to bring the seaside atmosphere indoors: a wicker sofa upholstered in gray paisley, or a throw pillow covered in two shades of blue, one on the front and the other on the back. There are small, shimmery details that you discover in the sunlight, like jute trims on the leading edge of a curtain, braided cords on pillows, and contrast welts on sofas. I also like to bring in textiles that recall the clothing one might wear on the beach, like chambray (there's a classic photo of a young Lauren Hutton leaning against a wooden wall wearing a chambray button-down over her bikini that comes to mind), or soft, faded fabrics that feel like the well-worn sweatshirt you'd pull on just as the sun starts to go down.

Underneath it all, the floors—either wood or stone—are bare, or simply covered with thin natural-fiber rugs. These are all spaces for walking barefoot (preferably with sand between your toes), rooms to sweep you away, rooms that turn everyday living into a day at the beach.

A breakfast nook made cheerier by ocean blue fabrics, a rattan-wrapped table, and tortoise blinds that filter sunlight. FOLLOWING: A great room that exudes comfort and ease. The soft oceanic palette gets texture from the woven rope sofa and chairs. PAGE 212, CLOCKWISE FROM TOP LEFT: Details on a covered terrace furnished with wrought iron, antique stone tables, a rustic bench, and pillows with a block print. PAGE 213: Robert Kime printed fabric window treatments and John Himmel rope chairs surround an eighteenth-century oak farmhouse table.

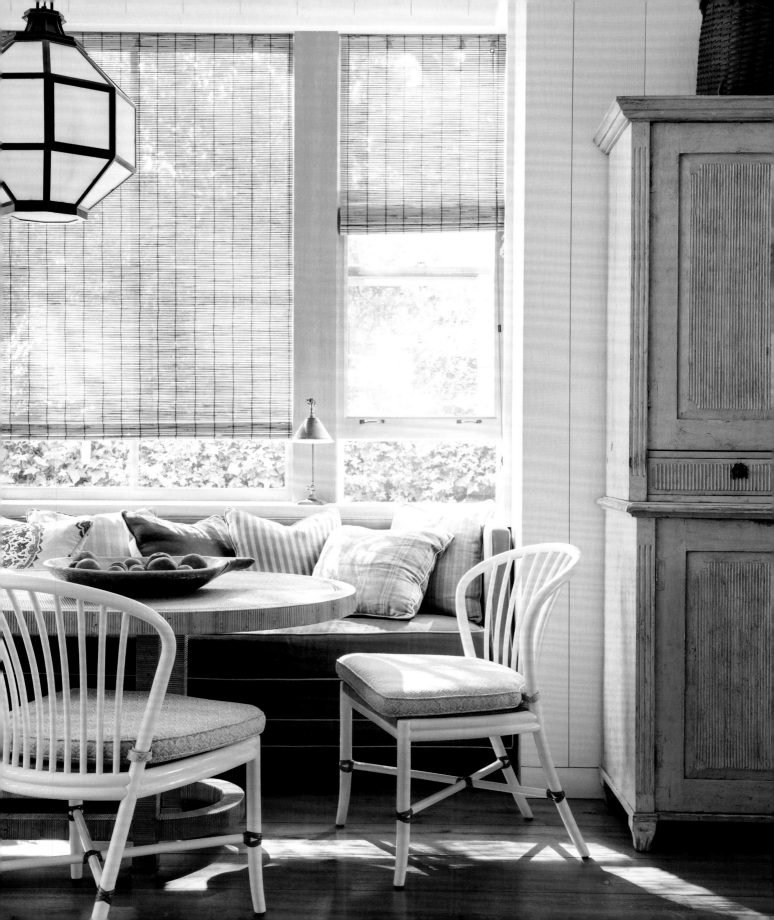

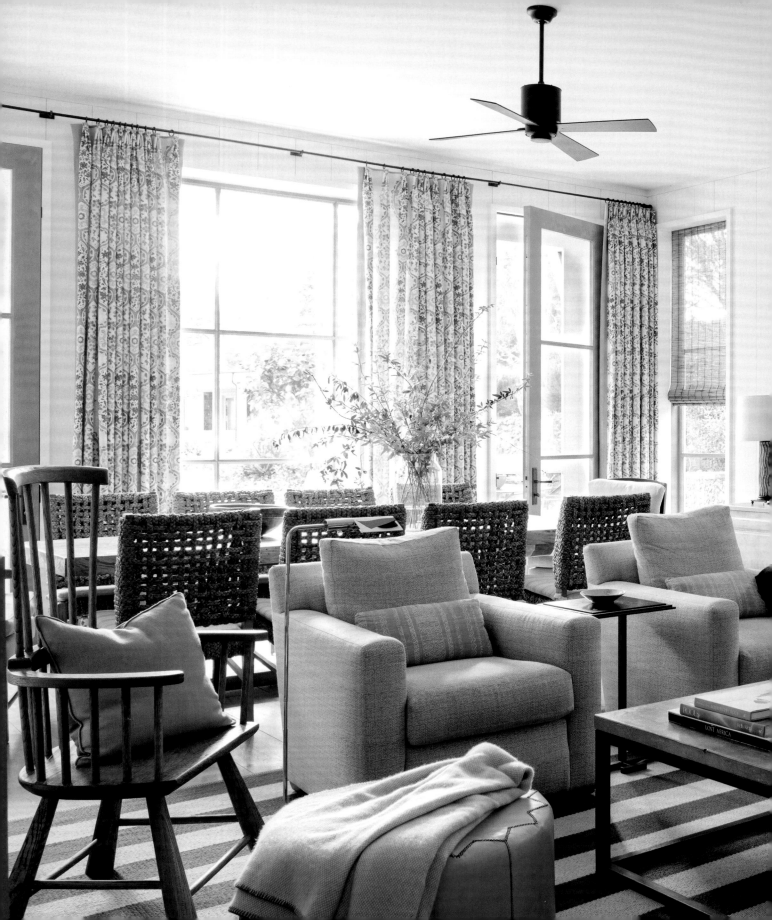

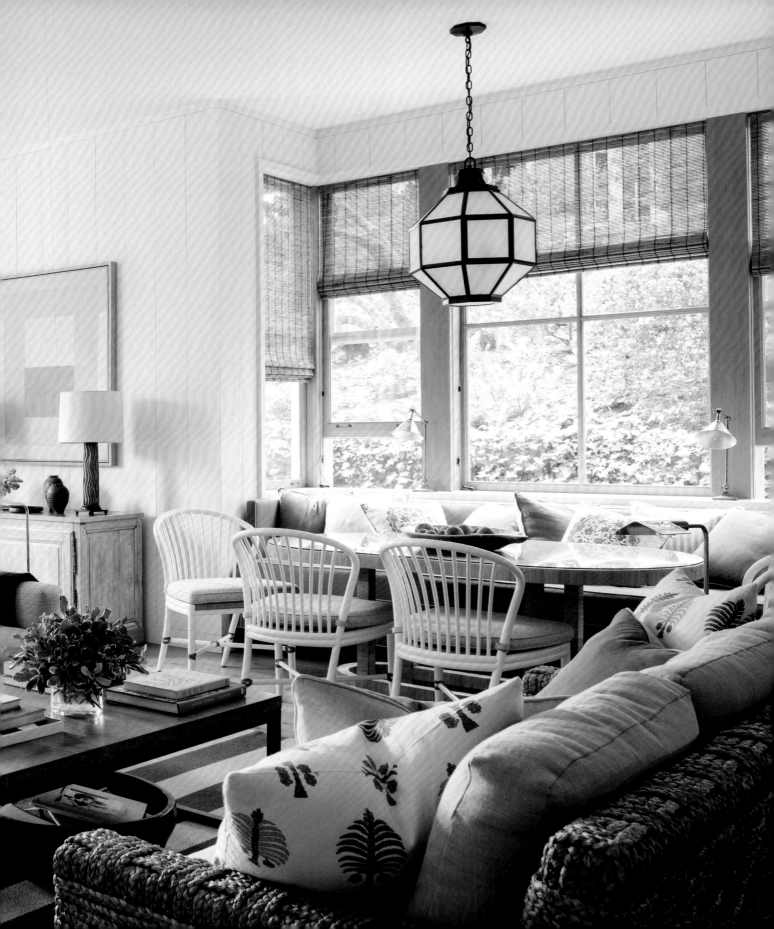

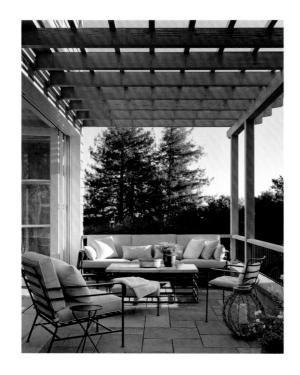

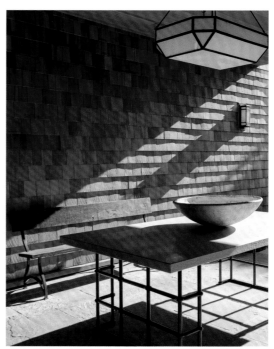

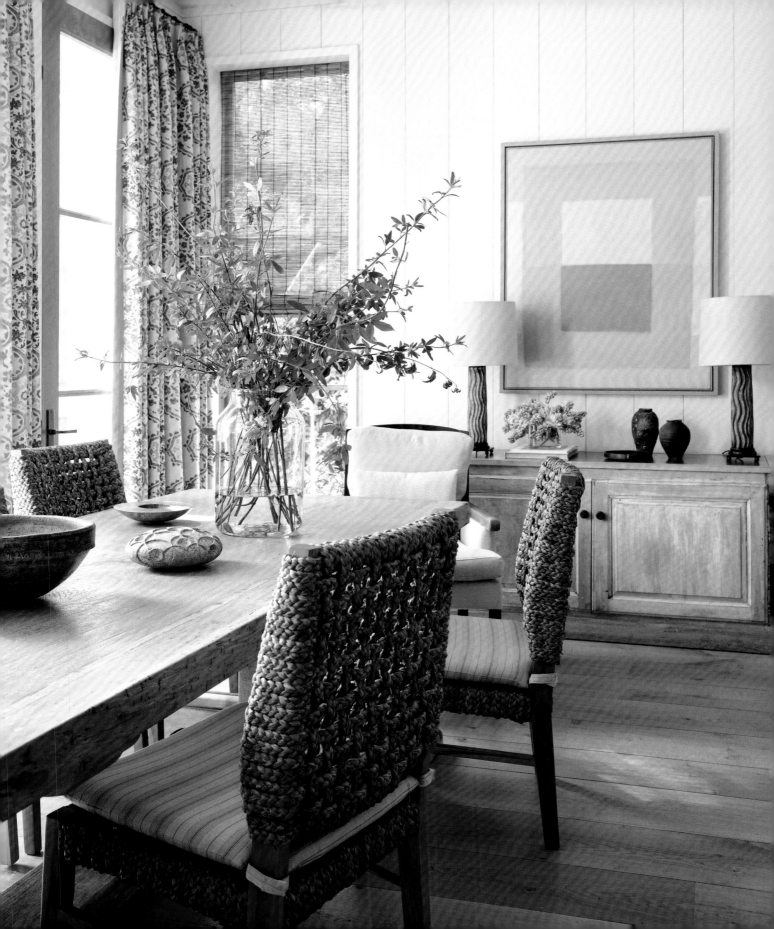

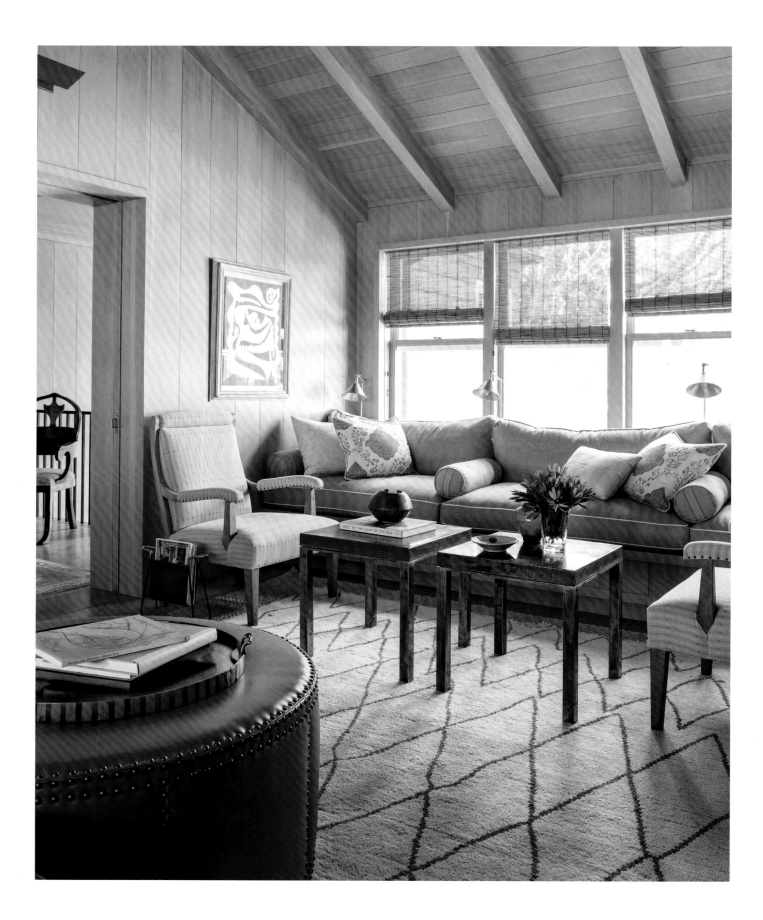

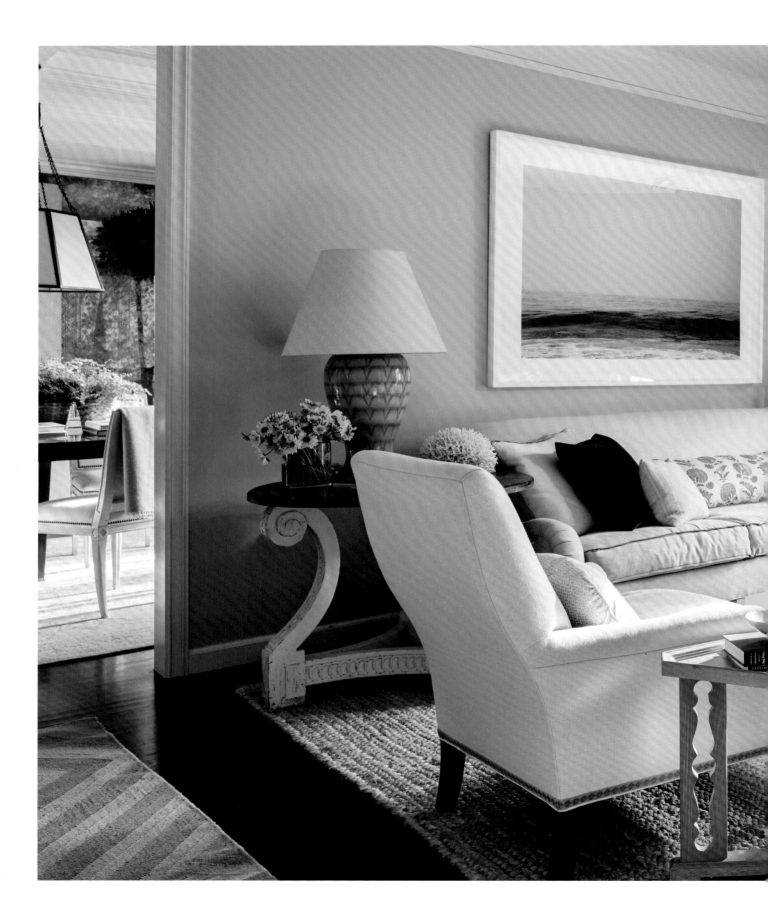

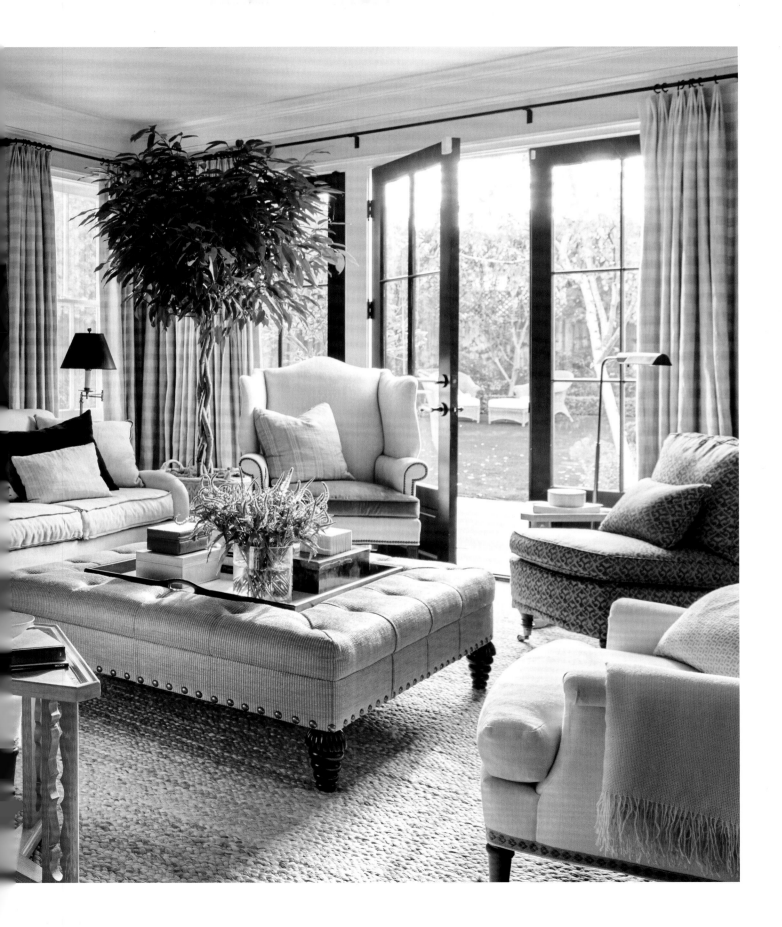

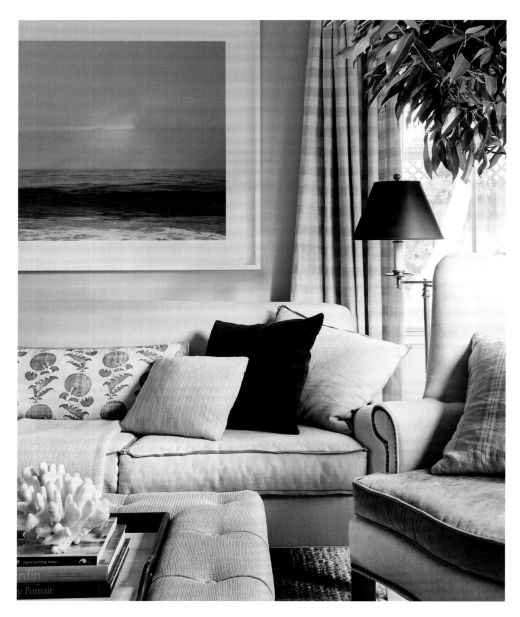

A beachscape brings the ocean into a Pacific Palisades family room (above). OPPOSITE: A custom bronze and parchment pendant anchors the dining room/library. PAGE 214: A paneled sitting room with a built-in banquette softened by misty gray pillows and a Moroccan rug. PAGE 215: Precious metals, leather, and cashmere add luxury. PREVIOUS: The family room features ocean blues and calming neutrals.

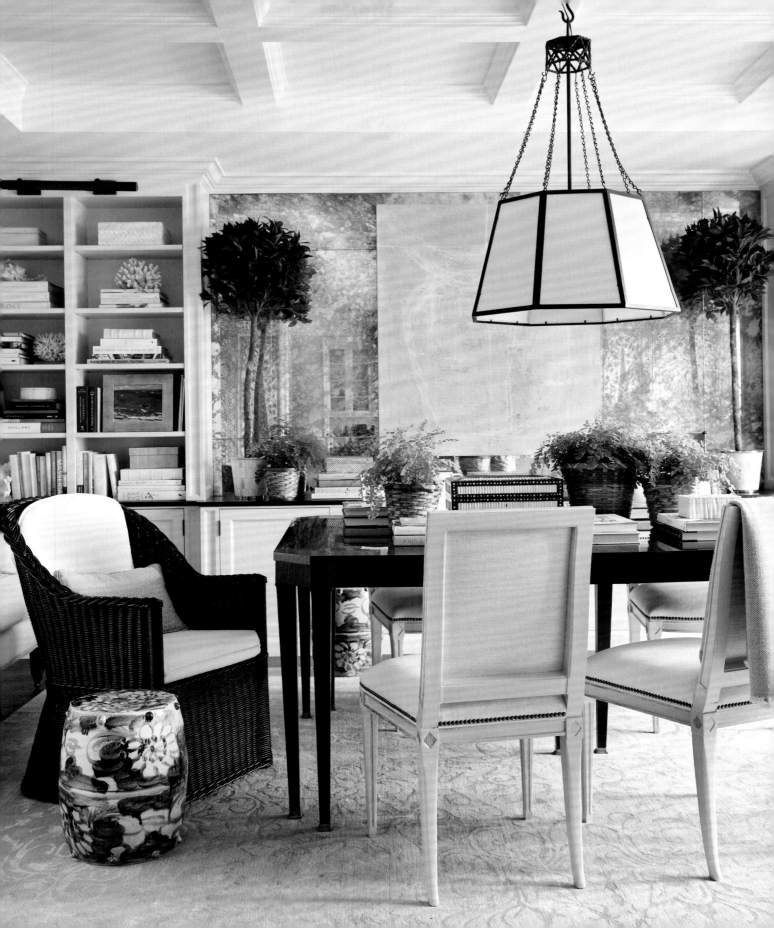

RED MY WAY
THE LOOK OF GLAMOUR

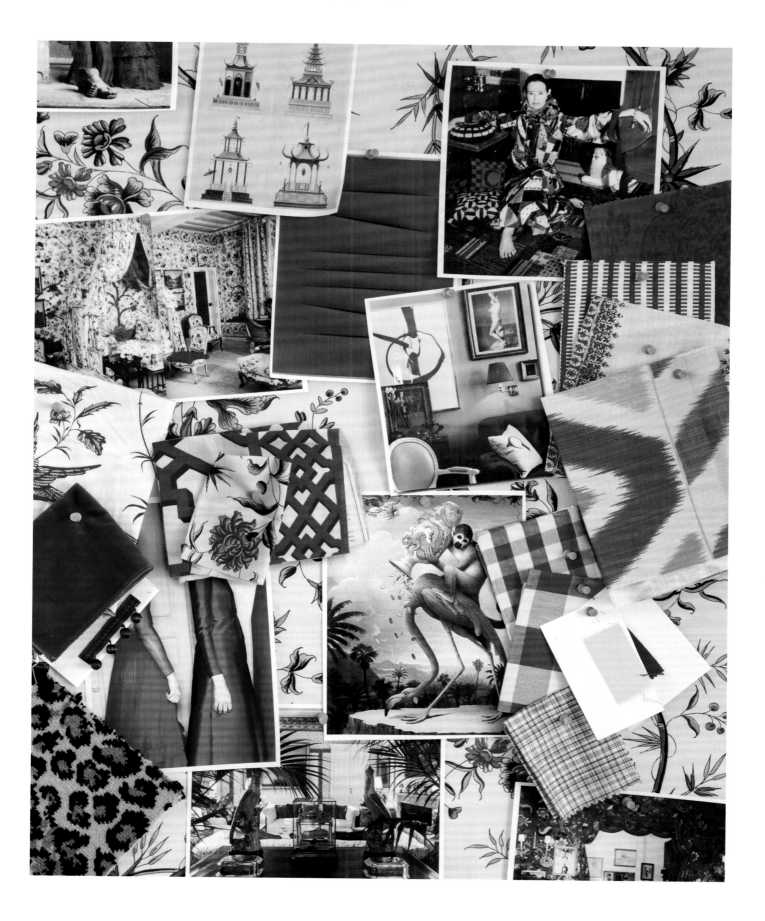

Diana Vreeland once said of red, "It makes all colors beautiful. I can't imagine being bored with it. It would be like becoming tired of the person you love." Red was the legendary *Vogue* editor's signature and the color of her famous Park Avenue living room decorated by Billy Baldwin. This striking hue was also a decorating favorite of Marella Agnelli, the Italian aristocrat and style icon. She cleverly paired chic wicker furniture with bright red cushions in her many homes and villas, creating a beautiful look that was both fresh and surprising. In fashion, no designer is more associated with red than Valentino, so much so that the particular eye-catching shade of his famous evening gowns is now simply known as "Valentino red."

Red's power to mesmerize, to entice, and to command attention is what I find so exciting about using it in a room. Red is a daring color, no question about it. But it's also approachable in the sense that it draws the eye and doesn't take no for an answer. When I use red in a room, I like to work in a bold pattern (such as Braquenié's tree-of-life fabric, also a favorite of Hubert de Givenchy) to break up the palette. Small touches in various shades of blue—turquoise, robin's egg, china,

Leopard print and robin's egg blue play up red accents in an Upper East Side foyer, hinting at glamour and intrigue. FOLLOWING, LEFT: Ikat and blue-and-white ceramics complement bold juxtapositions of red and various prints. The red telephone table is covered in embossed leather. FOLLOWING, RIGHT: Details of the entryway, clockwise from top left, include Iksel wallpaper on the ceiling, an eighteenth-century tilt-top chinoiserie table, a red-and-white marbleized Christopher Spitzmiller lamp, and an Italian gilt console.

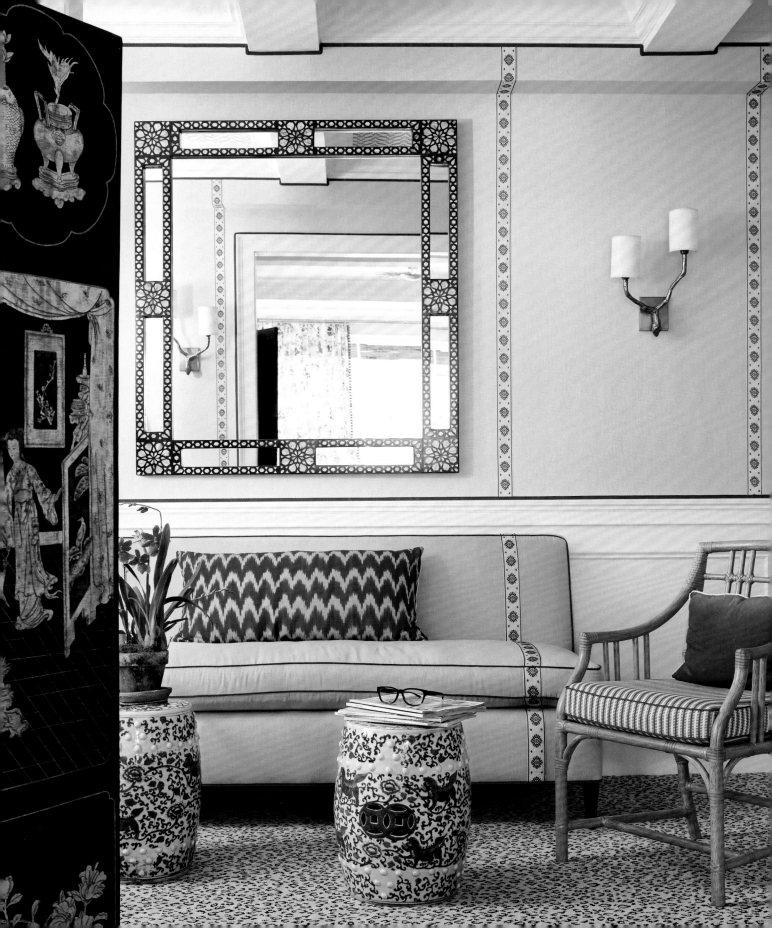

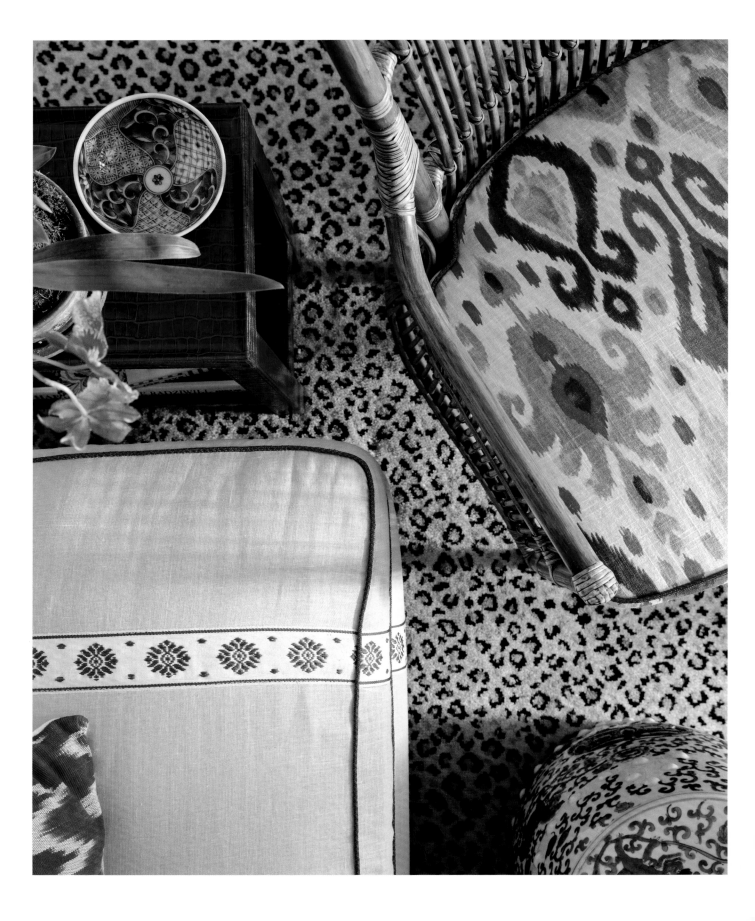

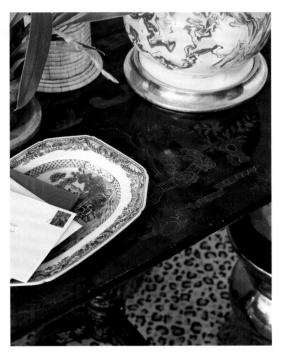

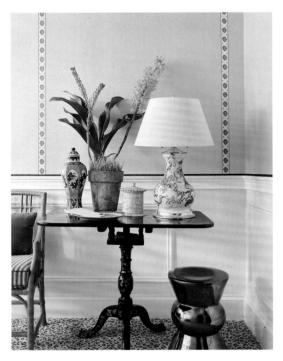

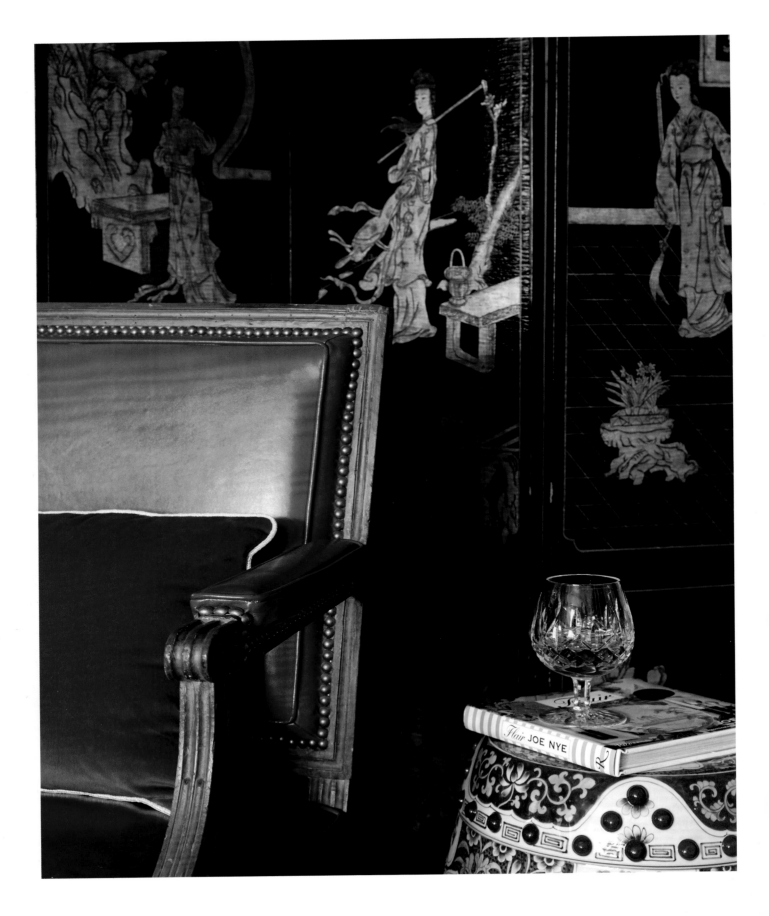

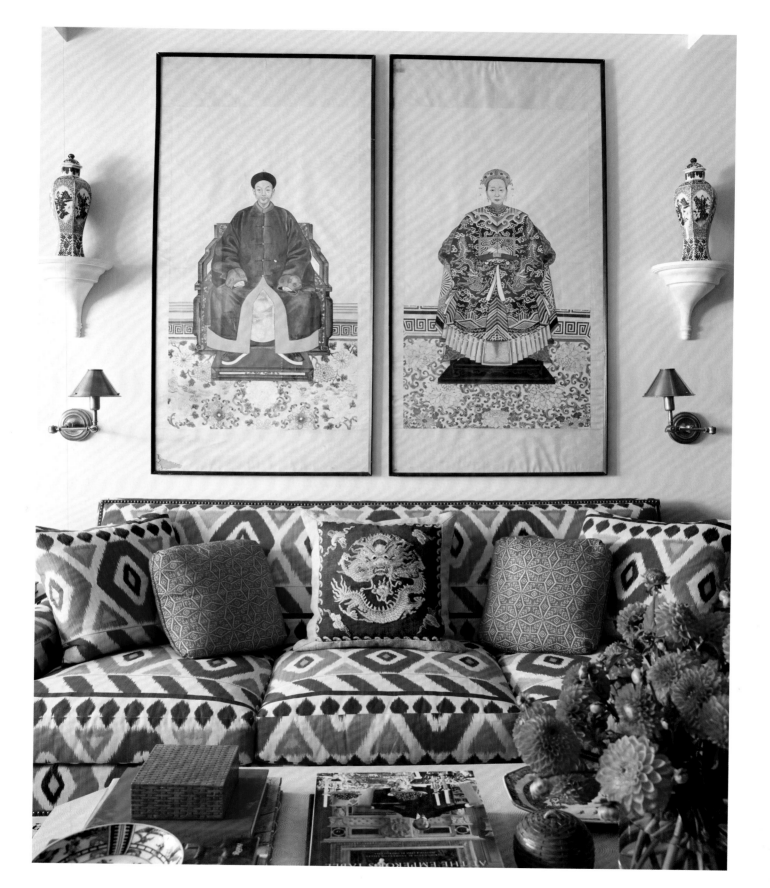

This living room is grounded by a red velvet tufted banquette that in turn anchors ikat, chintz, and animal prints.
PREVIOUS, LEFT: A masculine French leather armchair is fine company for an eighteenth-century coromandel screen, while a ceramic garden stool stands in as a drink table.
PREVIOUS, RIGHT: Pale lilac walls show off a pair of antique Asian panels and a vibrant silk ikat sofa.

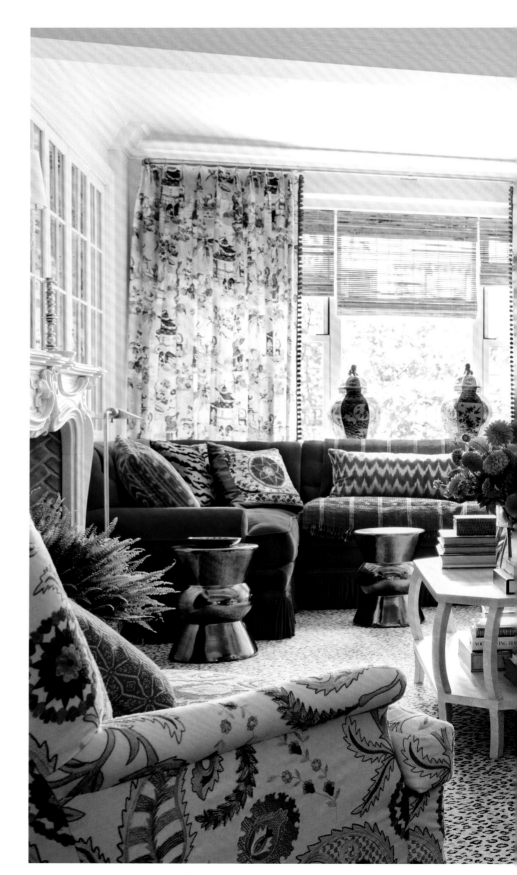

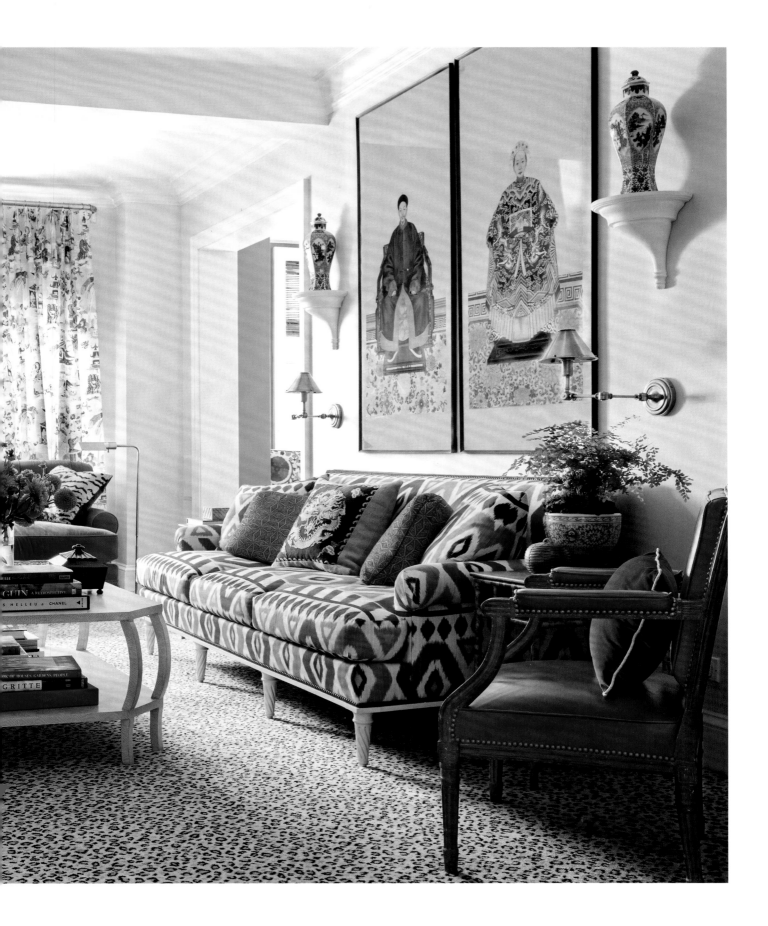

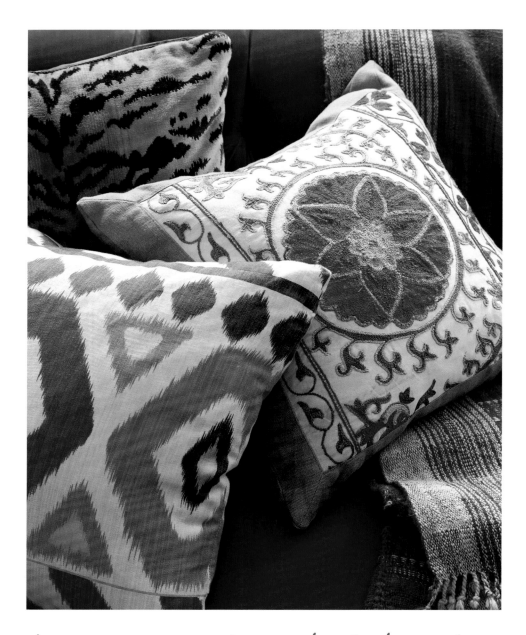

Suzani, animal print, ikat, and velvet: some of my favorite partners for red (above). OPPOSITE: Glass-front bookshelves and whimsical chintz window treatments make a glamorous room feel comfortable. FOLLOWING, LEFT: Hand-painted de Gournay wallpaper and elegant bamboo chairs set a chic but approachable mood. FOLLOWING, RIGHT: Red accents provide continuity—and intrigue.

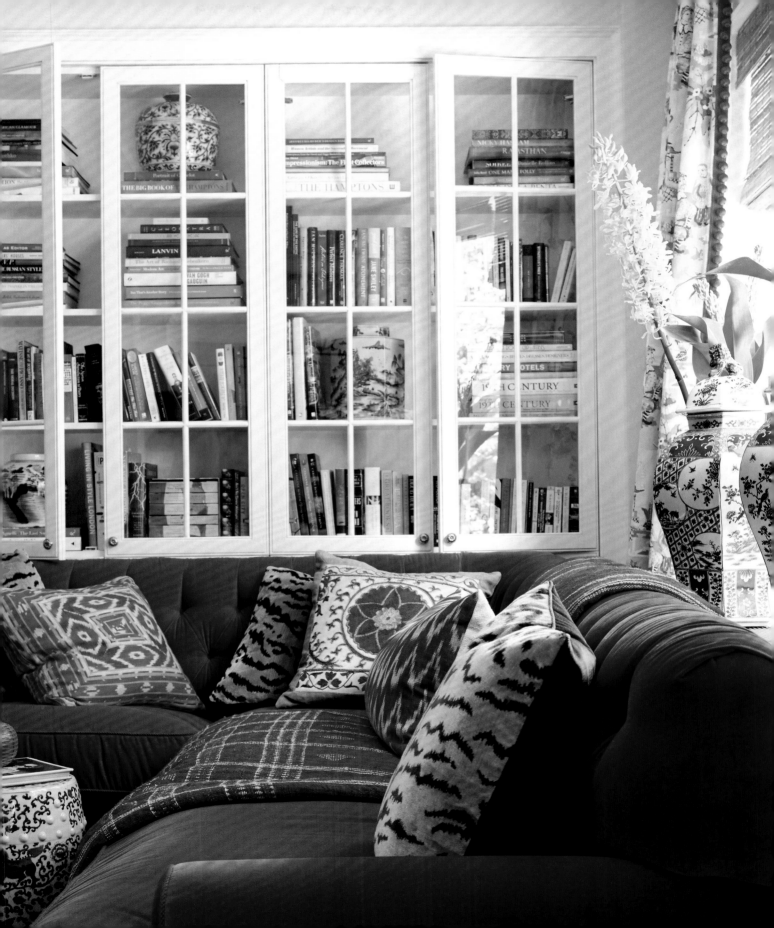

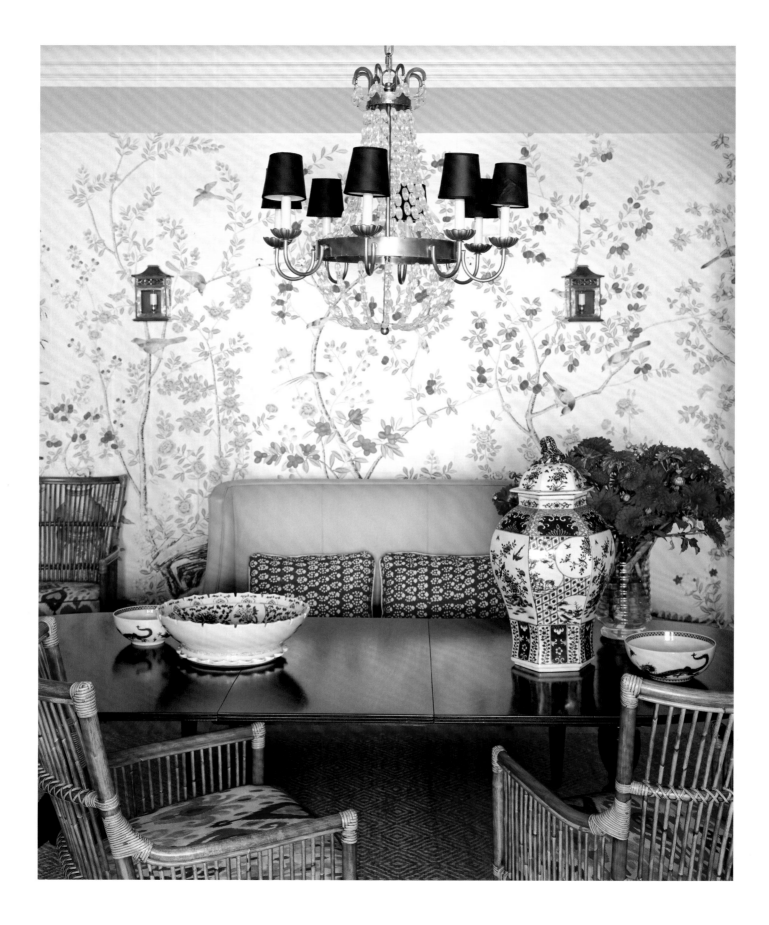

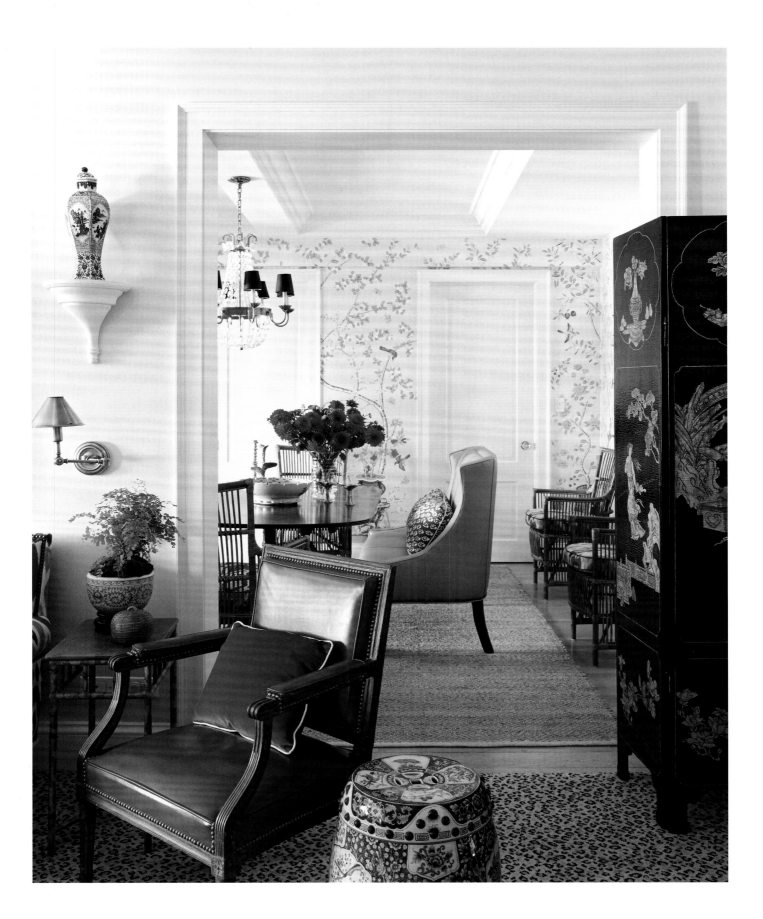

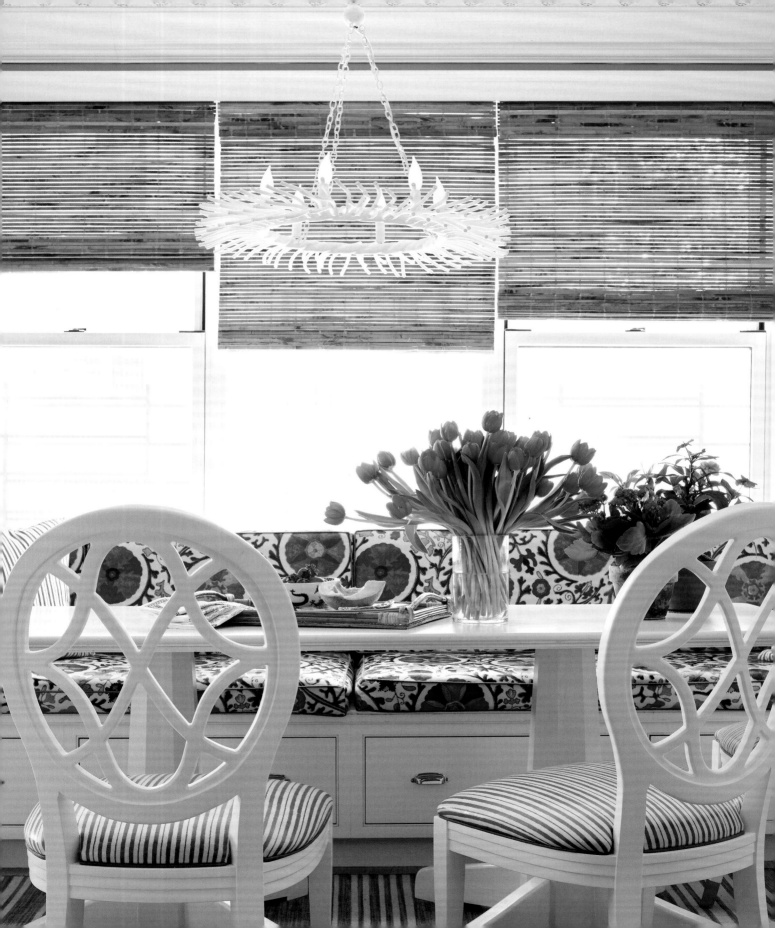

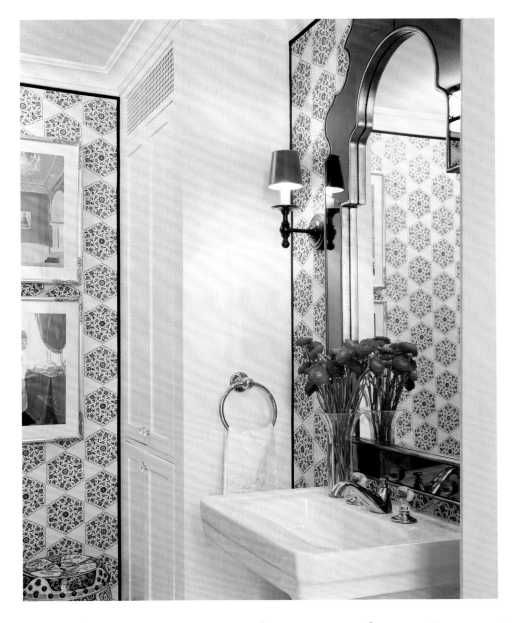

In the breakfast room, touches of
lapis, white, and bamboo open up the color story (opposite). Blue-and-white stripes on the seat cushions and dhurrie rug contrast with the suzani-covered banquette. ABOVE: The Iksel wallpaper on the powder room walls resembles blue-and-white Portuguese tiles and serves as an alluring backdrop for red sconces, artwork, and flowers.

A testament to the power of red:
among the mix of prints, finishes, and textures, a red book spine commands focus (above).
OPPOSITE: Casual blue-and-white upholstery is elevated by an animal-print rug.
FOLLOWING: Neutral-colored suede walls and navy-lacquered woodwork set a strong, sexy
tone for the library—but hints of red keep the room from feeling too serious.

46 *American Flamingo*
Ciconiiformes Phoenicopteridae *Phoenicopterus ruber*

II

FOWL

MARK D. SIKES
Est. 2012

~Thursday
POST ON FLAMOUR
• RED
• ANIMAL PRINTS
• AUDUBON PRINTS

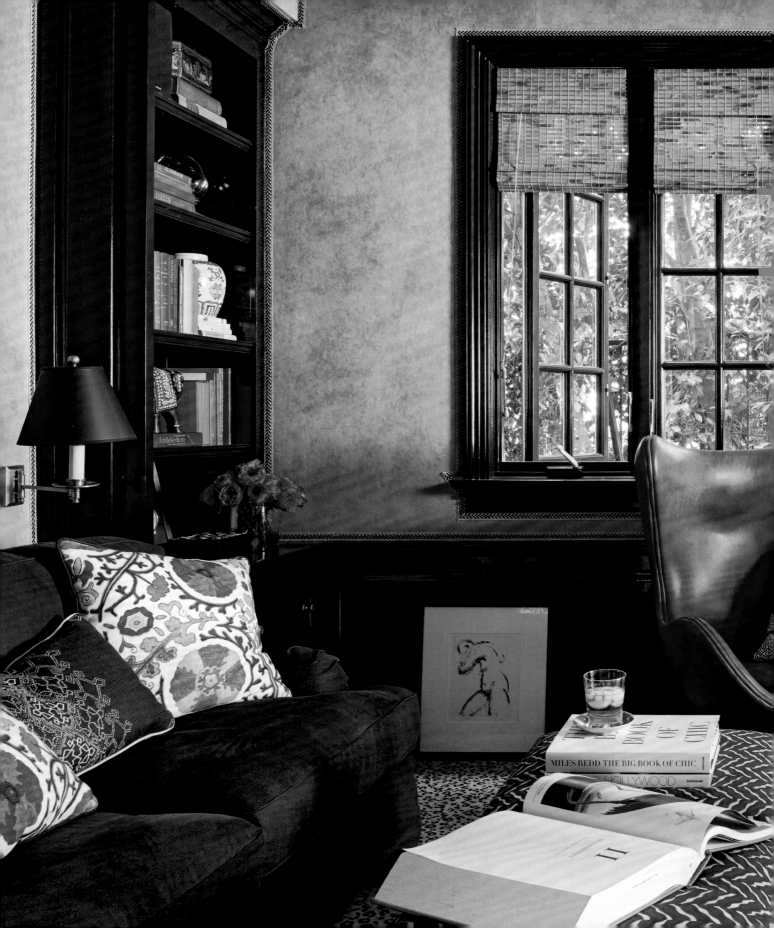

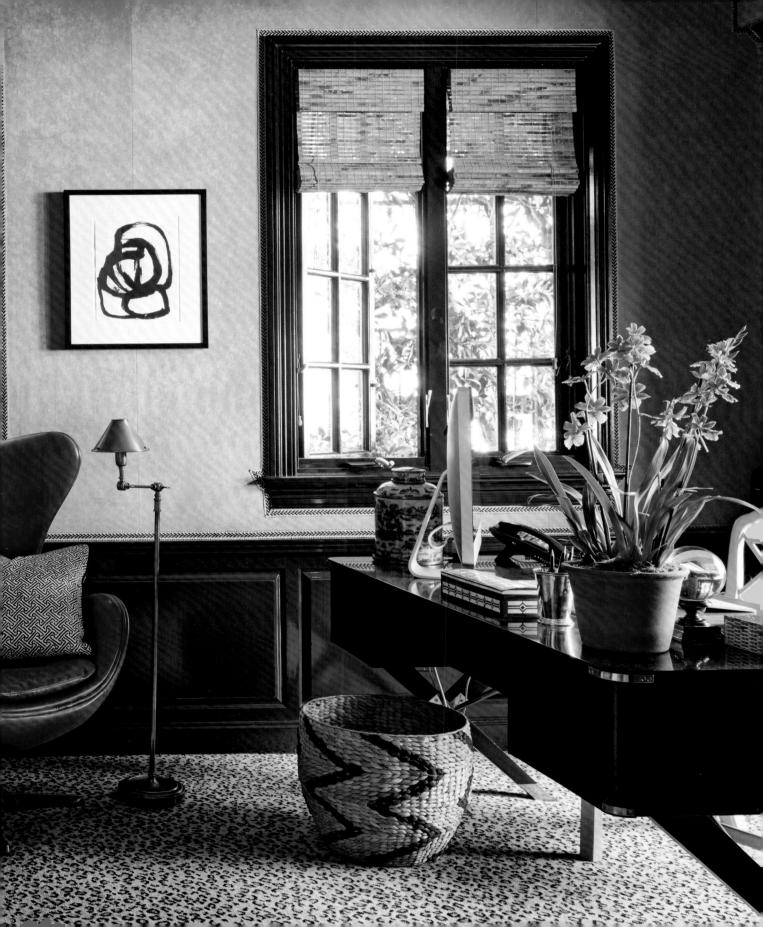

and royal—also provide unexpected accents, whether in an accessory like a porcelain lamp, a trim on a curtain, or the upholstery of a piece of furniture. (I especially like placing a robin's egg blue leather side chair in a room full of red-dominant patterns, prints, and textures.)

Though this idea may seem counterintuitive, precisely because red is such a strong color, it can support a wide variety of elements that could seem excessive in spaces with a more restrained decor. This makes it a fascinating color with which to layer. Paisley, suzani, ikat, animal prints, and all-American checks mingle effortlessly in many of my red rooms. And while this vibrant design scheme can work in all sorts of different environments, I particularly love using it in rooms for formal entertaining, where the strong colors stand up beautifully to a black-tie dress code.

No matter where, how, and how much red is used, it adds liveliness and intrigue to a space. These are rooms for memorable gatherings, rooms that invite you to put on that Valentino gown, accept a flute of Champagne, and embrace the spirit of adventure. "When in doubt, wear red," said Bill Blass, another iconic designer who was an expert in glamour. I agree—whether on a gown or in a room, red has a unique allure. Red my way is vivacious, brilliant, and enticing, with an unapologetic desire to be noticed. Its special beauty is impossible to ignore.

A china blue linen lining is serene against patterned bed hangings. FOLLOWING: A Pierre Frey Braquenié tree-of-life print decorates a guest room, adding vitality. Red trim on pillows and curtains anchors the pattern-heavy look. PAGE 244, CLOCKWISE FROM TOP LEFT: Pops of color on a bedside table. The black lacquer door adds drama. The color palette is continued in the adjoining bathroom. An antique coromandel screen lives happily with the room's other prints. PAGE 245: I love a comfortable chair in a bathroom—it's a welcome and practical touch.

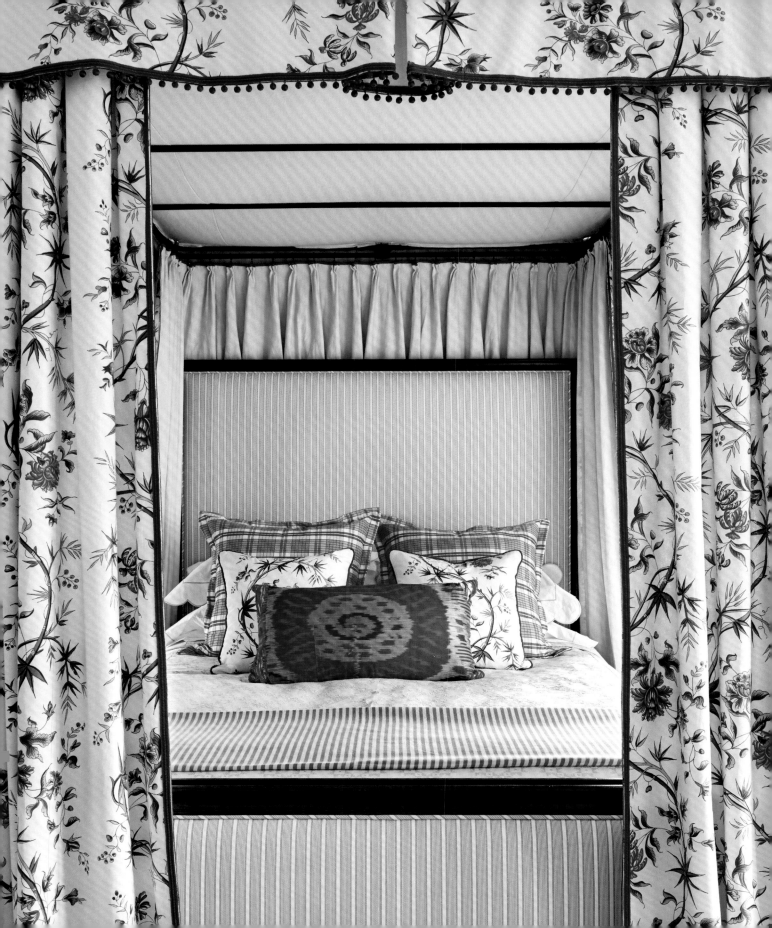

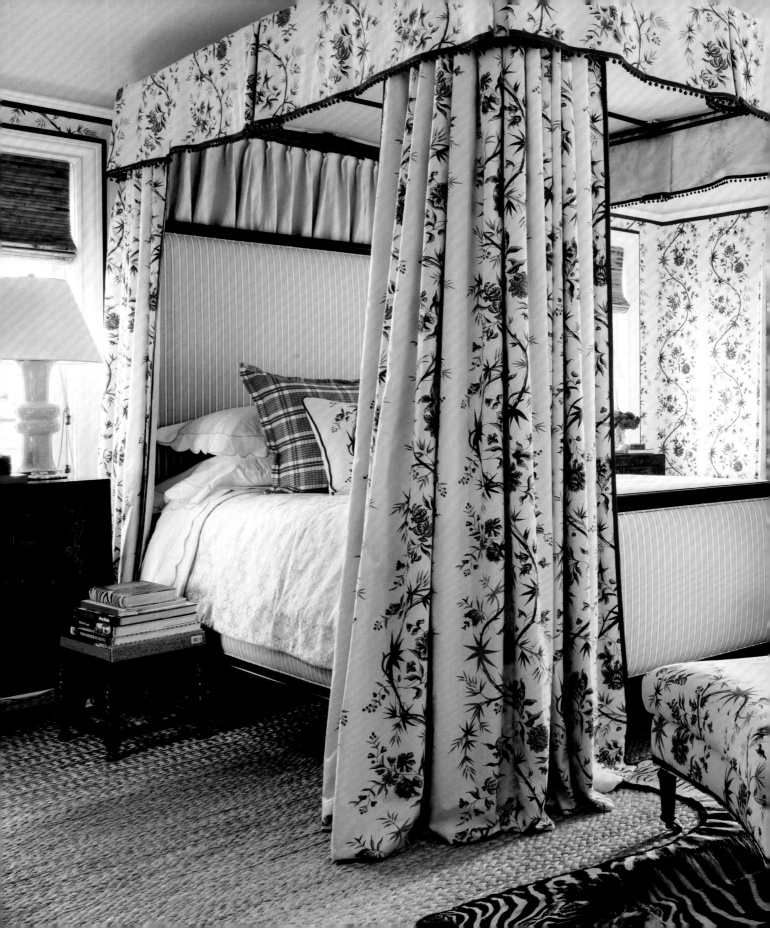

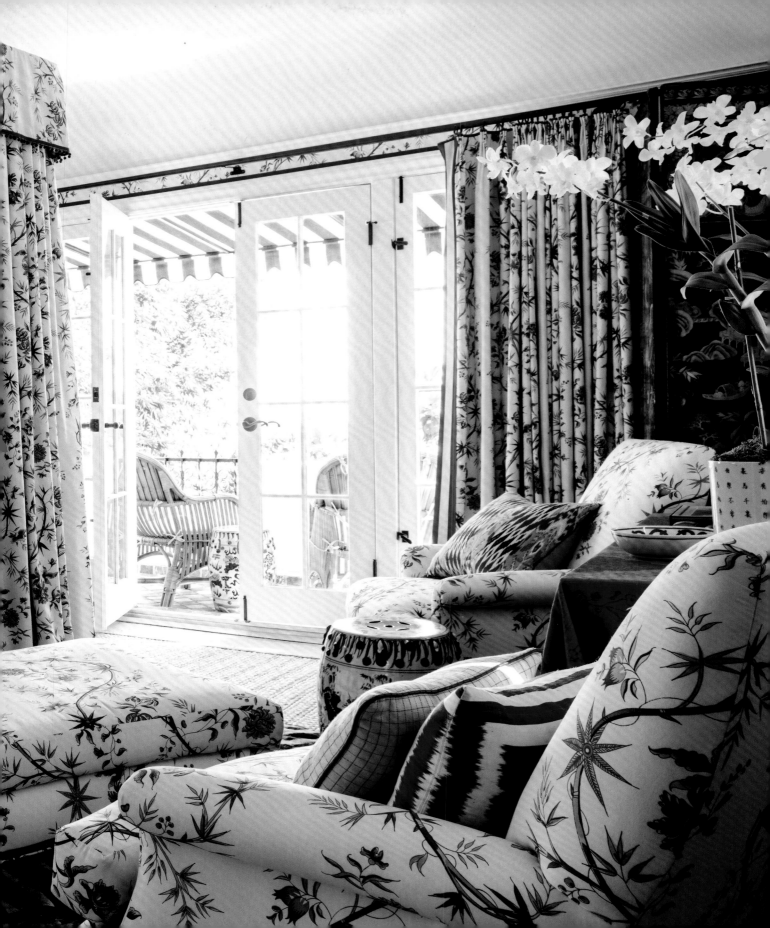

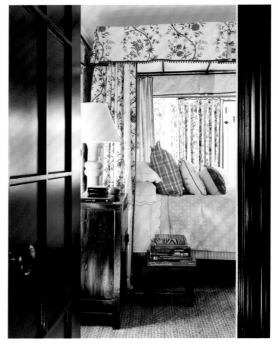

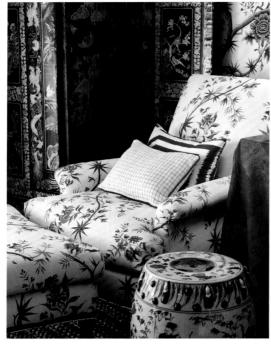

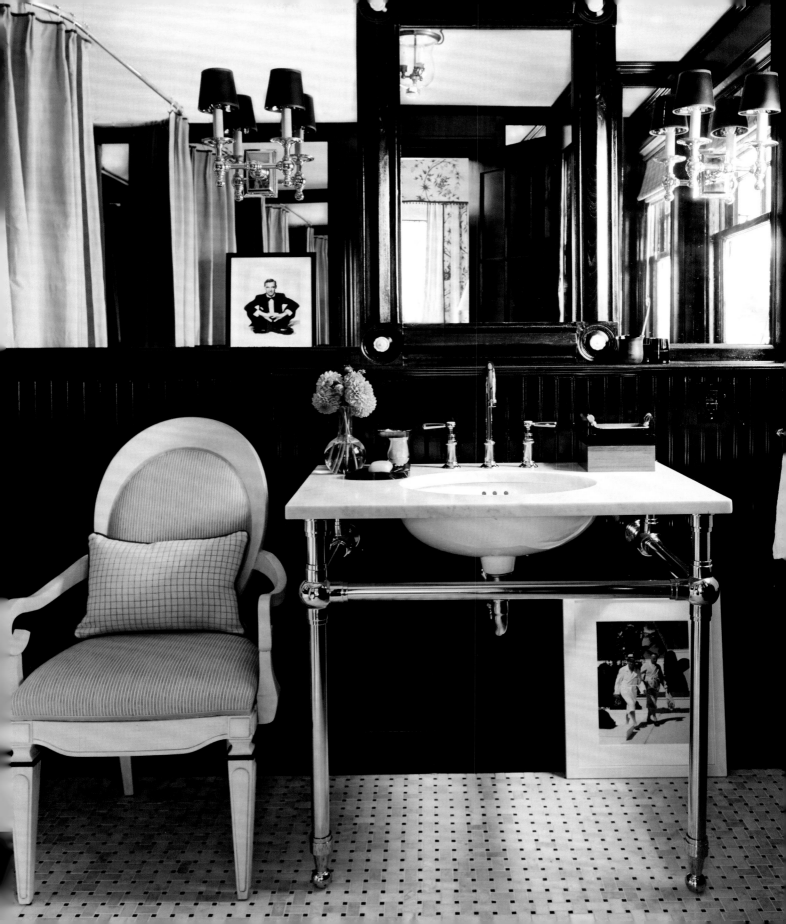

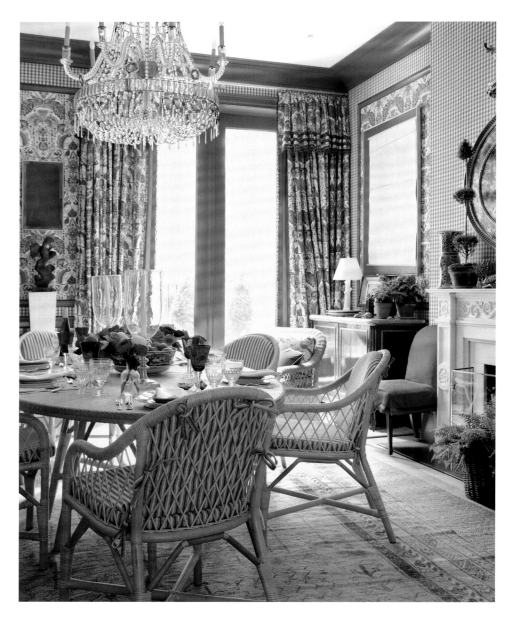

An Upper East Side formal dining

room gets a breath of fresh air from red-and-white patterns and prints and a
rattan dining table and chairs (above). OPPOSITE: A mélange of checks, stripes,
and paisley serve as an unexpected backdrop for an eighteenth-century
Dutch school painting and a Regency mahogany sideboard.

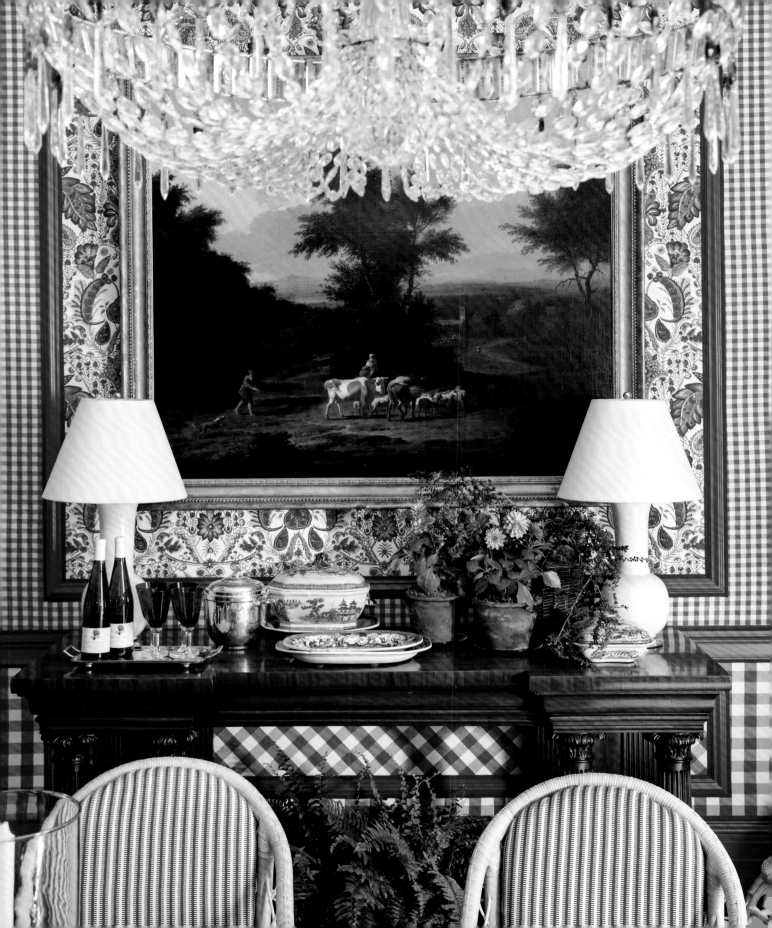

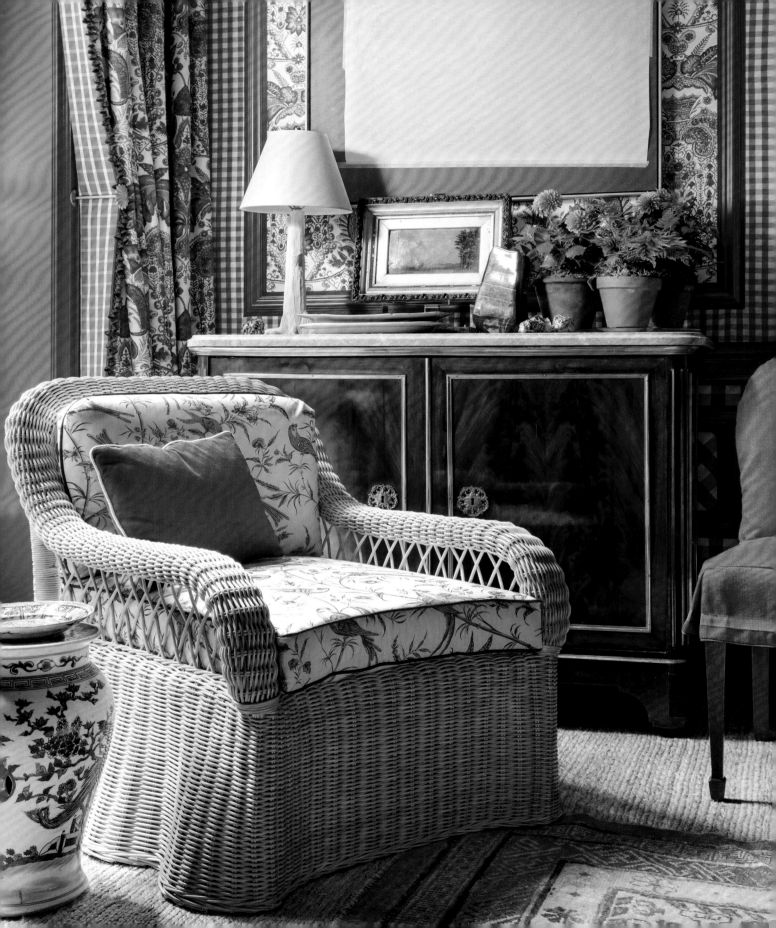

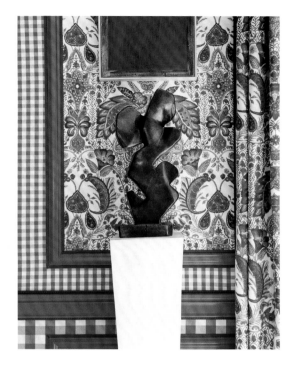

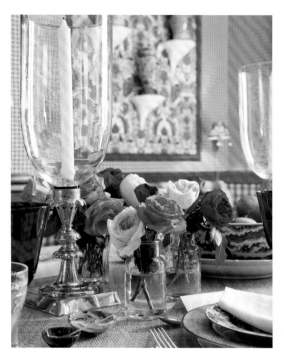

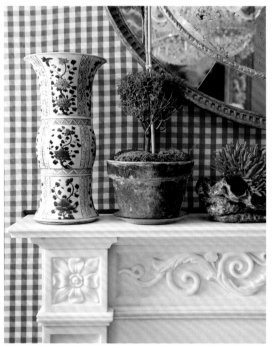

The showstopping drama of a nineteenth-century Directory-style chandelier with red and blue crystals is balanced by the room's contemporary mix of patterns and colors. PREVIOUS, LEFT: Beneath a magnificent Harry Cushing abstract painting, an eighteenth-century landscape and a faux bois plaster lamp sit atop a neoclassical Charles X cabinet. PREVIOUS, RIGHT, CLOCKWISE FROM TOP LEFT: the room's details include a bronze sculpture, gilded hurricane candles, a red Christopher Spitzmiller lamp, and potted myrtle topiaries.

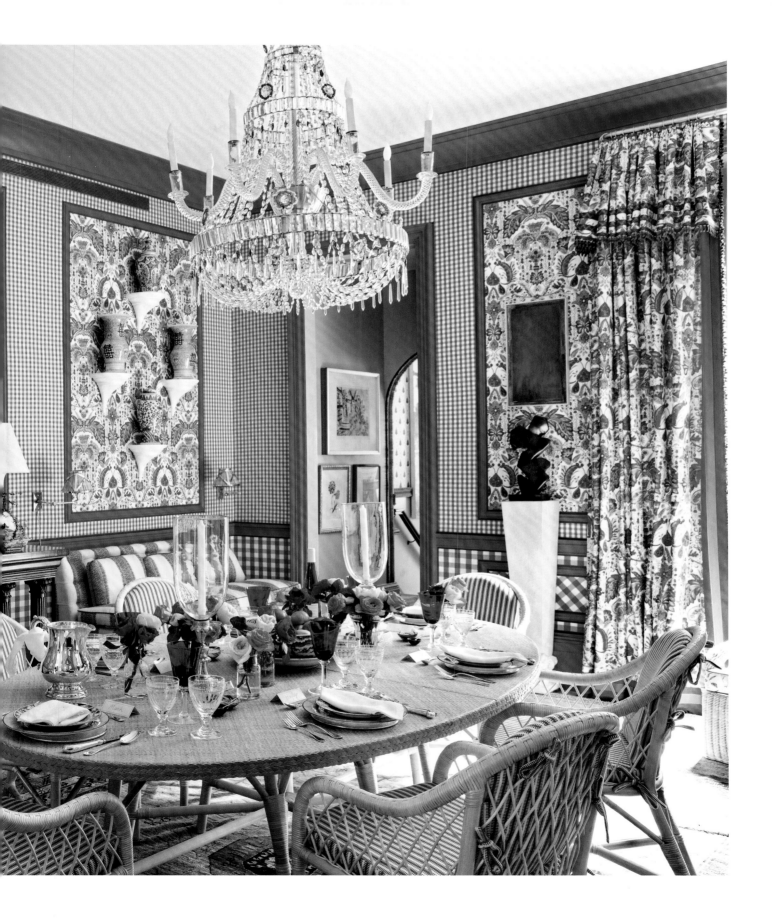

RESOURCES

ANTIQUES

CHARLES JACOBSEN
5833 Perry Drive
Culver City, CA 90232
310 815 9250
www.charlesjacobsen.com
also furniture

GERALD BLAND
232 East 59th Street, 6th Floor
New York, NY 10022
212 987 8505
www.geraldblandinc.com

JAMES SANSUM
33 East 68th Street, 6th Floor
New York, NY 10065
212 288 9455
www.jamessansum.com

JF CHEN
1000 North Highland Avenue
Los Angeles, CA 90038
323 463 4603
www.jfchen.com

**JOHN ROSSELLI ANTIQUES
& DECORATIONS**
306 East 61st Street, Ground Floor
New York, NY 10065
212 750 0060
www.johnrosselliantiques.com

LIEF
646 North Almont Drive
Los Angeles, CA 90069
310 492 0033
www.liefalmont.com

LUCCA ANTIQUES
744 North La Cienega Boulevard
Los Angeles, CA 90069
310 657 7800
www.luccaantiques.com

OBJETS PLUS
306 East 61st Street, 3rd floor
New York, NY 10065
212 832 3386
www.objetsplus.com

THERIEN & CO.
716 North La Cienega Boulevard
Los Angeles, CA 90069
310 657 4615

TOD CARSON
449 North Robertson Boulevard
West Hollywood, CA 90048
310 271 1947
www.todcarson.com

FURNITURE, LIGHTING, AND ACCESSORIES

BIELECKY BROTHERS
979 Third Avenue, Suite 911
New York, NY 10022
212 753 2355
www.bieleckybrothers.com

BUNNY WILLIAMS HOME
232 East 59th Street, 3rd Floor
New York, NY 10022
212 935 5930
www.bunnywilliamshome.com

**CHRISTOPHER
SPITZMILLER**
979 Third Avenue, Suite 1818
New York, NY 10022
212 563 3030
www.christopherspitzmiller.com

DENNIS & LEEN
8720 Melrose Avenue
Los Angeles, CA 90069
310 652 0855
www.dennisandleen.com

FORMATIONS
8732 Melrose Avenue
Los Angeles, CA 90069
310 659 3062
www.formationsusa.com

GALERIE DES LAMPES
9 Rue de Beaune
75007 Paris
+33 1 40 20 14 14
www.galeriedeslampes.com

GEORGE SMITH
804 North La Cienega Boulevard
Los Angeles, CA 90069
310 360 0880
www.georgesmith.com

HENREDON
1925 Eastchester Drive
High Point, North Carolina 27265
800 444 3682
www.henredon.com

HOLLYHOCK
927 North La Cienega Boulevard
Los Angeles, CA 90069
310 777 0100
www.hollyhockinc.com
also antiques and textiles

HOLLYWOOD AT HOME
703 North La Cienega Boulevard
Los Angeles, CA 90069
310 273 6200
www.hollywoodathome.com
also antiques and textiles

JASPER
8525 Melrose Avenue
West Hollywood, CA 90069
310 315 3028
www.michaelsmithinc.com/jasper-home
also antiques, textiles, and rugs

**JOHN HIMMEL
DECORATIVE ARTS**
333 West Hubbard Street
Chicago, IL 60654
312 670 5000
www.johnhimmel.com

MARCH
3075 Sacramento Street
San Francisco, CA 94115
415 931 7433
www.marchsf.com

MECOX
919 North La Cienega Boulevard
Los Angeles, California 90069
310 358 9272
www.mecox.com
also antiques

PAUL FERRANTE
8464 Melrose Place
Los Angeles, CA 90069
323 653 4142
www.paulferrante.com

ROSE TARLOW
8540 Melrose Avenue
Los Angeles, CA 90069
323 651 2202
www.rosetarlow.com
also textiles

SOANE BRITAIN
50-52 Pimlico Road
London SW1W 8LP
+44 20 7730 6400
www.soane.co.uk
also textiles and wallcoverings

WILLIAM LAMAN
1496 East Valley Road
Montecito, CA 93108
805 969 2840
www.williamlaman.com
also antiques

PAINT

FARROW & BALL
Uddens Estate Wimborne
Dorset BH21 7NL
1 888 511 1121
www.farrow-ball.com

TEXTILES, RUGS, AND
WALLCOVERINGS

BENNISON FABRICS
232 East 59th Street
New York, NY 10022
212 223 0373
www.bennisonfabrics.com

C & C MILANO
Via Bernardino Zenale, 3
20123 Milan
+39 02 48015069
www.cec-milano.com

CAROLINA IRVING
TEXTILES
719 South Los Angeles Street,
Suite 428
Los Angeles, CA 90014
646 688 3365
www.carolinairvingtextiles.com

ELIZABETH EAKINS
5 Taft Street
South Norwalk, CT 06854
203 831 9347
www.elizabetheakins.com

GRACIE
979 Third Avenue, Suite 1411
New York, NY 10022
212 924 6816
www.graciestudio.com
also furniture and antiques

KERRY JOYCE
2900 Rowena Avenue
Los Angeles, CA 90039
323 660 4442
www.kerryjoycetextiles.com

MATOUK
925 Airport Road
Fall River, MA 02720
508 997 3444
www.matouk.com

MERIDA
1 Design Center Place
Boston, MA 02210
800 345 2200
www.meridastudio.com

PIERRE FREY
21 Rue de Longchamp
75116 Paris
+33 1 47 04 32 30
www.pierrefrey.com
also furniture

QUADRILLE
50 Harrison Street, Suite 119
Hoboken, NJ 07030
201 792 5959
www.quadrillefabrics.com

RAOUL TEXTILES
136 State Street
Santa Barbara, CA 93101
805 899 4947
www.raoultextiles.com
also furniture

ROBERT KIME
121 Kensington Church Street
London W8 7LP
+44 20 7229 0886
www.robertkime.com
also furniture

ROGERS & GOFFIGON
41 Chestnut Street
Greenwich, CT 06830
203 532 8068
www.rogersandgoffigon.com

SCHUMACHER
979 Third Avenue, Suite 832
New York, NY 10022
800 523 1200
www.fschumacher.com
also furniture

TONY KITZ GALLERY
300 Kansas Street, Suite 101
San Francisco, CA 94103
415 346 2100
www.tonykitzgallery.com

TRIMMINGS

SAMUEL & SONS
983 Third Avenue
New York, NY 10022
212 704 8000
www.samuelandsons.com

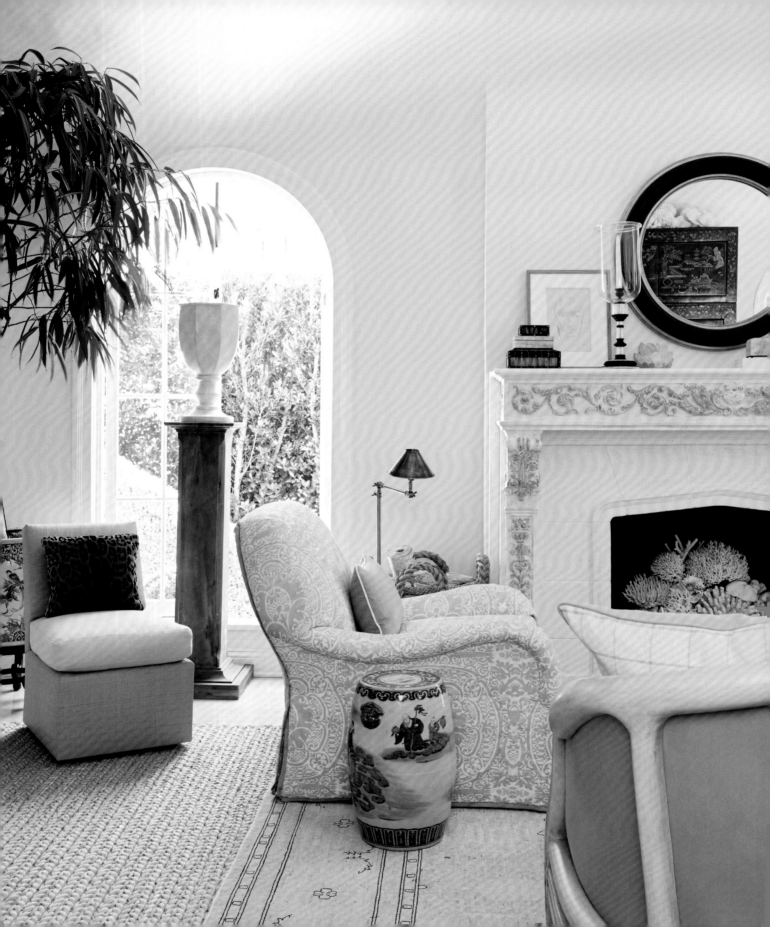

ACKNOWLEDGMENTS

Creating a book that combines my interior design work with my lifelong inspirations has been a dream come true. I could not have done this on my own, and have so many people to thank:

Amy Neunsinger, the brilliant photographer who shot this book. It all started with a *House Beautiful* cover in 2011, and what a beautiful journey it's been. I couldn't ask for a more wonderful creative partner. What a joy it has been to work alongside one of the most special people I've ever known. You have an inner light that makes everything beautiful.

Nancy Meyers, the Nancy Meyers. If you would have told me five years ago that my favorite moviemaker would become a dear friend, let alone write a foreword for my book, I would have said you were nuts. I'm so thankful. Life is beautiful!

Jill Cohen, the best of the best. You listened to me and trusted me, then with a singular goal, you made it happen.

Caitlin Leffel, my writer; Kathleen Jayes, my editor; and Rizzoli's publisher, Charles Miers, who believed in me and my book. Thank you for letting me tell my story.

Doug Turshen, our designer, and Steve Turner, who made this book more beautiful than I ever could have imagined. I hope to do this again and again with you guys.

To my clients, thank you for letting me into your houses and into your lives. Truly, creating beautiful homes with each of you is the most rewarding and fulfilling thing I could ever do. For those of you that let me photograph your homes for this book, I'm forever grateful.

To my blog readers, you are my true inspiration. Thank you for encouraging me to keep my eyes open; there is so much beauty around us every minute of every day.

Our wonderful staff at Mark D. Sikes Inc: Justin, Laura, Becky, Corinne, Wisit, and Abby. You guys make it happen. Thank you for your commitment. I learn so much from each of you every day. A special thanks to Rebecca de Ravenal for all your help with the book.

To my entire family, but especially to my Aunt Sue and Aunt Nancy, you both have a special place in my heart, and to Matt and Annie, my nephew and niece, you are loved.

I'm so thankful to have a wonderful group of friends. You all know who you are. You are very dear to me, especially Doug and Jenn, who have been a part of this journey from almost the very beginning, and know the story better than anyone.

To my parents, Donna and Ralph Sikes, thank you for encouraging me to pursue my dreams, and to be myself and more importantly, thank you for reminding me every day that I am blessed. I know from whom all blessings flow.

And finally, to Michael, my better half, you believe enough for both of us. Your love and support make it happen every day. This beautiful book is for you, and of course, for H.R.H Lily!

First published in the United States of America in 2016
by Rizzoli International Publications, Inc.
300 Park Avenue South
New York, NY 10010
www.rizzoliusa.com

Principal photography by Amy Neunsinger
Page 2: Jacqueline Kennedy on Horseback: Ray Bellisario/
Popperfoto/Popperfoto/Getty Images
Page 3: Oscar de la Renta: Slim Aarons/Premium Archive/
Getty Images; Guinness Family: Slim Aarons/Masters/Getty Images
Page 29: Jane Birkin: AFP/AFP/Getty Images
Page 55: Vanity Fair 1930: Edward Steichen/Conde Nast Collection/
Getty Images; Katherine Hepburn: Popperfoto/ Popperfoto/Getty Images
Page 116: Grace Kelly (left) Archive Photos/Moviepix/Getty Images;
Grace Kelly (right) Sharland/The LIFE Images Collection/Getty Images
Page 143: Peter Beard: Time & Life Pictures/The LIFE Picture Collection/
Getty Images; Lying giraffe: Friedrich Seidenstuecker/ullstein bild/Getty Images
Page 171: Maharaj and Jacqueline Kennedy: Art Rickerby/
The LIFE Picture Collection/Getty Images
Page 199: Lauren Hutton (top): Terry O'Neill/Iconic Images/Getty Images;
Lauren Hutton (bottom): Brian Hamill/Premium Archive/Getty Images
Page 221: Vogue 1970: Horst P. Horst/Conde Nast Collection/Getty Images

Design by Doug Turshen with Steve Turner

2021 2022 2023 / 18 17 16

Distributed in the U.S. trade by Random House, New York

Printed in China

ISBN-13: 978-0-8478-4892-8

Library of Congress Catalog Control Number: 2016938941

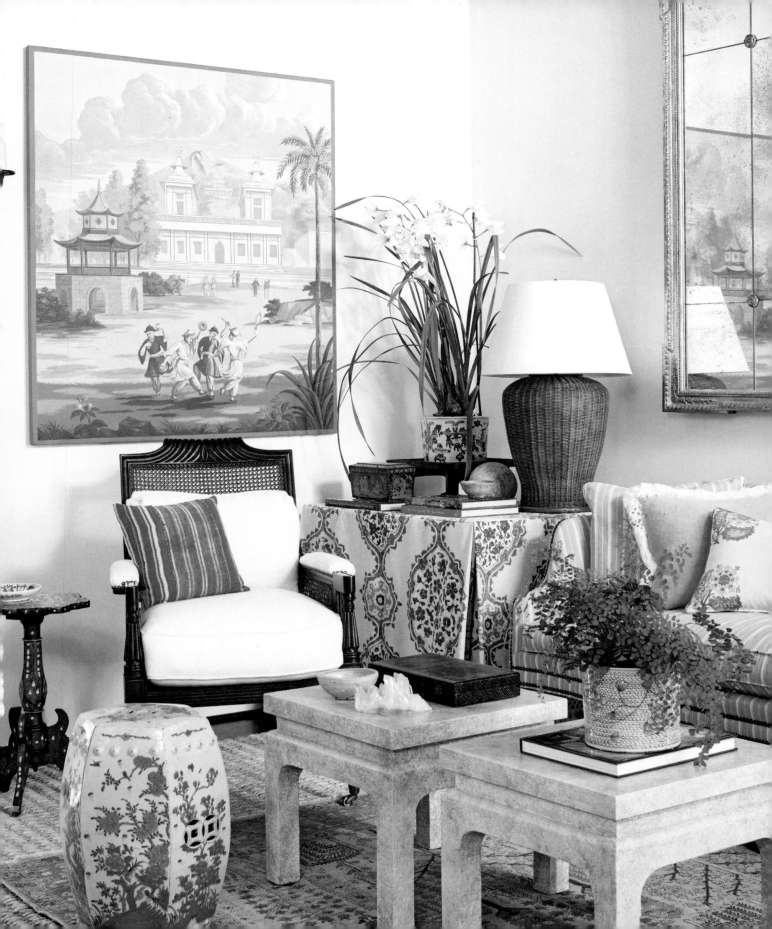

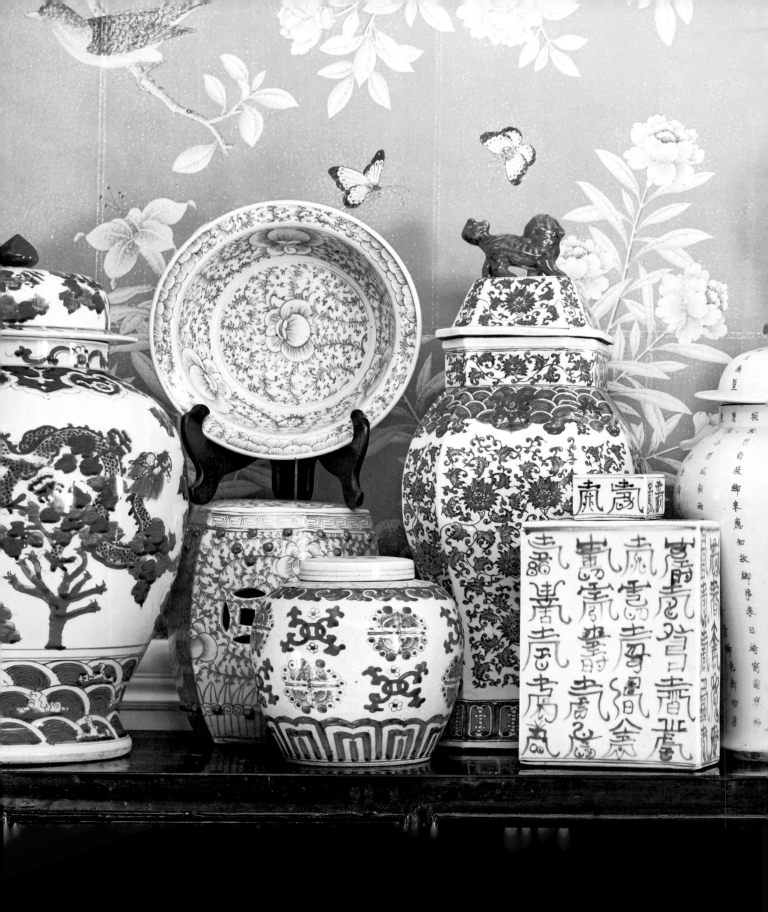